FLORA

AN ILLUSTRATED HISTORY OF THE GARDEN FLOWER

Published by Firefly Books Ltd. 2003 First published in 2001 by Scriptum Editions Reprinted in miniature in 2003 565 Fulham Road, London SW6 1ES in association with The Royal Horricultural Society.

Created by Co & Bear Productions (UK) Ltd. Copyright © 2001 Co & Bear Productions (UK) Ltd. Text copyright © Co & Bear Productions (UK) Ltd. Preface copyright © Sir Simon Hornby, Sir Simon Hornby asserts his moral rights. Photographs and illustrations copyright © The Royal Horticultural Society, Lindley Library.

Co & Bear Productions (UK) Ltd. identify Dr Brent Elliott as author of the work.

All rights reserved. No part of this publication may be reproduced, stored in a retrieval system, or transmitted in any form or by any means, electronic, mechanical, photocopying, recording or otherwise, without the prior written permission of the Publisher.

First printing

Publisher in Cataloguing-in-Publication Data (U.S.) (Library of Congress Standards)

Elliott, Brent. Flora: an illustrated history of the garden flower : compact edition / by Brent Elliott / preface by Sir Simon Homby–1st ed. [336] p. : ill. (chiefly col.) ; em. Originally published: 2001. Includes index. Summary: History of botanical illustration accompanied by 300 color illustrations, and biographies of their illustrators. Illustrations from the Royal Horticultural Society's Lindley Library collection. ISBN 1-55297-832-X 1. Botanical illustration-History. 2. Flowers–Pictorial works. I. Title. 580/022 21 OK98.15.E55 2003

National Library of Canada Cataloguing in Publication Data

Elliott, Brent Flora : an illustrated history of the garden flower / Brent Elliott ; preface by Simon Hornby. — Compact ed. Includes index. Illustrations from the collection of the Lindley Library of the Royal Horticultural Society. ISBN 1-55297-832-X I. Flowers—Pictorial works. 2. Botanical illustration. 3. Flowers—History. I. Lindley Library. II. Title. QS98.15.E44.2003 582.13/022/2 C2003-901114-3

Published in the United States in 2003 by Firefly Books (U.S.) Inc. P.O. Box 1338, Ellicott Station Buffalo, New York 14205

Published in Canada in 2003 by Firefly Books Ltd. 3680 Victoria Park Avenue Toronto, Ontario, M2H 3K1

Printed and bound in Italy at Officine Grafiche De Agostini Colour separation Bright Arts Graphics, Singapore

FLORA

AN ILLUSTRATED HISTORY OF THE GARDEN FLOWER

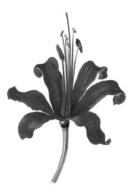

WRITTEN BY BRENT ELLIOTT

WITH A PREFACE BY SIR SIMON HORNBY

Cyclamen, from Abraham Munting's Phytographia Curiosa (1704).

CONTENTS

PREFACE	6
INTRODUCTION	8
1. Europe	14
2. Jurkish empire	84
3. Africa	134
4. The americas	192
5. Asia & Australasia	262
ON PLANT NAMES	322
SELECTED BIOGRAPHIES	326
LIST OF ILLUSTRATIONS	330
INDEX AND ACKNOWLEDGMENTS	334

The royal autograph of Queen Victoria, prepared for the Royal Horticultural Society, incorporating a depiction of *Victoria amazonica*.

PREFACE

BY SIR SIMON HORNBY

PRESIDENT OF THE ROYAL HORTICULTURAL SOCIETY

he passion for plant hunting, while never reaching the scale of the Gold Rush in California, has engendered manic characteristics among botanists over centuries. There have been distinct breeds of botanical adventurers: true botanists spurred on by scholarship, the thrill of the chase and breathtaking delight in the beauty of their discoveries; collectors, particularly the orchid hunters, driven by rivalry and the desire to claim a new species before anyone else; and commercial exploiters whose motive was greed – to make money by introducing new plants to an enthusiastic and increasing band of amateur gardeners all over Europe.

Books have already been written about the plant hunters – for much of the time operating in very tough and difficult conditions – yet this story is about the plants they brought to Europe. It is a story not only of plant discovery but also of the changing fashions in gardening that drove the demand for new introductions. From the early nineteenth-century onwards, the successful breeding of hybrids in large quantities by commercial growers added still further to the increasing number of new plants. Over the years, too many plants have been lost in cultivation as the drive to gain commercial advantage from new introductions has intensified. Today, a study of the RHS Plant Finder shows how out of hand this drive has become with some genera, but it is symptomatic of an obsession that has existed for hundreds of years.

The art of botanical drawing has a tradition of minute accuracy combined with freshness, portraying the beauty of nature in the colour and form of its plants. New introductions have been recorded with superb skill and artistry over the centuries, creating a significant historical record. That tradition continues today, as all over the world artists of outstanding ability record the introductions of plant breeders as well as species. In Flora, Brent Elliott uses illustrations from collections in the RHS Lindley Library to trace the introduction of plants over four and a half centuries. The combination of outstanding illustrations and fascinating text has produced a book of beauty and considerable horticultural significance.

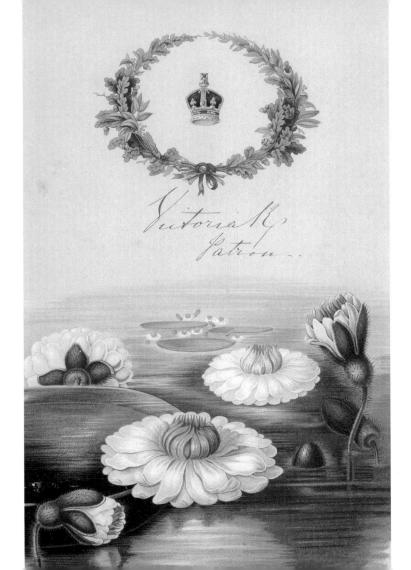

The frontispiece to Jacob Breyne's *Exoticarum* (1678), depicting Solomon, Theophrastus, Dioscorides, Pliny, and Cyrus, contemplating a seventeenth-century introduction, a South African succulent, the Cape mesembryanthemum (now *Conicosia pugioniformis*).

\mathcal{J} NTRODUCTION

The properties of the second s

The first great wave of plant introductions to reach western Europe came from the Turkish empire. From the 1560s onward, crocuses, leucojums, erythroniums, ornithogalums, cyclamens, hyacinths, lilies, fritillaries, ranunculus, and above all tulips, flowed into Europe. This influx of new flowers prompted the first organised programmes for selecting and marketing flower varieties. The interest in oddities and colour variations, already evident with European plants like primulas and carnations, was reinforced by tulips, which produced new colour patterns with great ease (as a result of viral infection). Tulips were not the only flowers to excite the passions of plant enthusiasts. Hyacinths, too, became extraordinarily popular.

Not all these flowers were strictly speaking for garden use: the enthusiasts for new varieties – 'florists', as they were then called – were dedicated more to the show bench than to the flower garden. During the seventeenth and eighteenth centuries, societies sprang up –

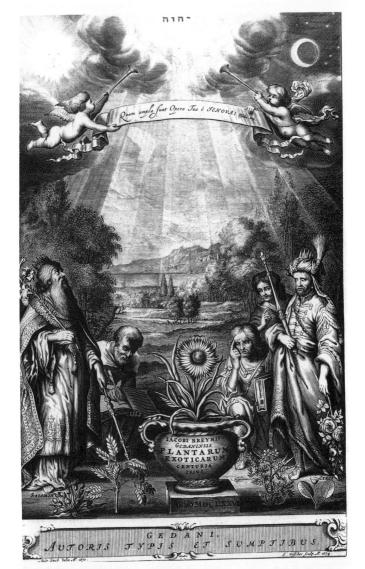

first in England, and later on the continent – for the specific purpose of competing in the production and display of new varieties. There came to be eight accepted categories of 'florists' flowers', which had their attendant societies of competitive growers: tulips, hyacinths, auriculas, polyanthus, carnations, pinks, anemones, and ranunculus. These continued to exercise the talents of gardeners well into the early nineteenth century.

Some American plants, among them the sunflower, had already arrived in Europe before 1600, but the real flood of ornamental plants from the New World began in the 1620s and continued for almost a century, bringing tradescantias, evening primroses, American strawberries, Virginia creeper, trilliums, rudbeckias, spiraeas, and Michaelmas daisies.

Gradually the North American introductions changed in emphasis, and trees and shrubs became the primary focus. But for the flower garden the major source of new plants was the Dutch colony at the Cape of Good Hope, and Leiden and Amsterdam became the centre of introduction to Europe. Most of these plants moved straight into the new greenhouses that the wealthy were building. Here crassulas, mesembryanthemums, stapelias, and other Cape succulents were grown, along with proteas, pelargoniums, and Cape heaths, and a range of large-flowered amaryllis and crinums.

Many of the popular introductions of the eighteenth century were confined to the glasshouse, and flowers grown outside fell from fashion. This was the heyday of the English landscape garden, when a pastoral scene of rolling lawn and water replaced flower beds as the means of organising the precincts of a country house. Tree introductions were compatible with the landscape garden, but flowers were to a great extent irrelevant, and flower gardens were

European gardens of the sixteenth and seventeenth centuries: a garden design by Vredeman de Vries, dating from 1583 (left); a garden featuring recently introduced bulbs, drawn by Crispijn van de Passe in 1614 (right).

kept away from the principal views. This fashion spread throughout Europe from the 1770s and remained dominant in the early nineteenth century, when English gardeners began to bring back the flower garden near the house.

The eighteenth century had seen the development of the scientific expedition, with botanists and zoologists equipped to collect and bring back interesting new finds, so Australian plants began to enter cultivation even before any substantial European settlements were made. The name 'Botany Bay' indicates the importance ascribed to plant introductions from the new territory. As with South African plants, most of the Australian introductions went straight into the greenhouse and never emerged. Banksias, grevilleas, melaleucas, metrosideros, chorizemas, gompholobiums – all flourished as part of domestic horticulture for those who could afford to grow under glass.

The greatest period in the improvement of greenhouses began in 1817, when the great horticultural authority John Claudius Loudon invented the wrought-iron glazing bar. Loudon had initially looked forward to the day when everyone could have a collection of tropical plants, but by the 1830s he had become chastened, and was recommending that 'oranges, lemons, camellias, myrtles, banksias, proteas, acacias, melaleucas, and a few other Cape and Botany Bay plants, are all that can with propriety be admitted into a small conservatory'. So, while the fashion for Australian plants faded, its legacy continued in the English greenhouse throughout the century.

By 1820 the nursery trade had become a significant commercial force, and the largest nurseries, like Loddiges' of Hackney and Veitch's of Chelsea, were able to mount their own collecting expeditions. The introduction in the 1830s of the Wardian case, a closely glazed case in which plants could be placed with some earth and water, forming a self-sustaining environment, revolutionised the business of transporting plants overseas. New plants began to flood into Europe. From the British colonies in India came rhododendrons; from the west coast of America came conifers and a slough of ornamental annuals; from Mexico came

INTRODUCTION

European gardens of the seventeenth and nineteenth centuries: the garden of Pieter de Wolff, in Amsterdam, 1676, showing greenhouse plants set out for the summer (left); the garden at Dirleton Castle, Scotland, in the 1870s, with bedding plants including pelargoniums, petunias and verbenas (right).

fuchsias and dahlias; from China came varieties of chrysanthemums, peonies, and camellias, the legacy of a long tradition of cultivation. And eventually, after opening to the West in 1854, Japan began to yield new irises and maples. Dahlias and chrysanthemums became the new florists' flowers of the age, sparking competitive societies into existence.

Just as important as the number of new species introduced was the sheer number of specimens. Once plants that had been regarded as rare specimens became sufficiently numerous, gardeners could take risks with them, exposing some to the winter to see how hardy they would prove. And so plants that had once been confined to the greenhouse, like rhododendrons and camellias, began to move permanently outdoors, and many half-hardy plants moved into the flower garden for the summer season, to return to protective cultivation in the winter. Meanwhile, the older florists' societies were dying out, despite periodic attempts to revive them. They were replaced by horticultural societies devoted to the newer introductions and less concerned with competitive variation.

A new concept had now been added to the plant enthusiast's repertoire: breeding. Once the existence of sexual reproduction in plants was established, its experimental use was initiated in the early eighteenth century, with Thomas Fairchild creating the first documented artificial hybrid ('Fairchild's mule' – a cross between a carnation and a sweet william). The first extensive programme for breeding new ornamental plant varieties was begun in the 1790s by William Rollisson, who produced Cape heaths for the greenhouse.

In the 1840s, selective breeding hit the flower garden in a big way. Authorities like John Claudius Loudon were calling for flower beds to be arranged as solid masses of colour, spurring a demand for plants that would have a larger proportion of flower to foliage. The first bedding varieties of pelargoniums from South Africa, and petunias, verbenas, and calceolarias from South America, began to appear.

About 1870, continental gardeners developed an interest in English-style bedding, particularly in the latest fashion for 'carpet bedding', the use of low-growing foliage plants to

create flat patterned beds. But, while in England carpet bedding and flower bedding were seen as two distinct styles, on the continent gardeners felt no hesitation about mixing them together, and the resulting composite style spread around the world during the 1880s. Parallel to this development was an interest in restoring and replicating the formal garden designs and plantings of the sixteenth and seventeenth centuries. Once again, this fashion developed first in England, but by the beginning of the twentieth century it had spread to the continent and beyond.

In recent years, new introductions for the garden have dwindled – the focus of plant exploration these days is medicinal plants, not ornamental plants. Novelty in the garden has therefore had to be satisfied by hybridisation. Begonias, impatiens, hostas, hemerocallis, and of course roses, have been the subject of major programmes of breeding. But, gradually coming to rival the breeding of novelties, revivalism has increased its hold on the plant world. The revival of old roses began between the world wars, and reached a peak with the work of Graham Stuart Thomas at Sunningdale Nurseries in the 1960s. Auriculas, which had come close to disappearing from cultivation, became the subject of a major fashion in the 1980s. There is now widespread interest in the range of cultivated varieties that formerly existed, and attempts are being made to protect and rediscover them. Perhaps in the future this interest will spread to the vanished Victorian bedding plants, to the varieties of hyacinths, anemones, and ranunculus that were grown in the eighteenth century, or to the curiosities of the Elizabethan garden.

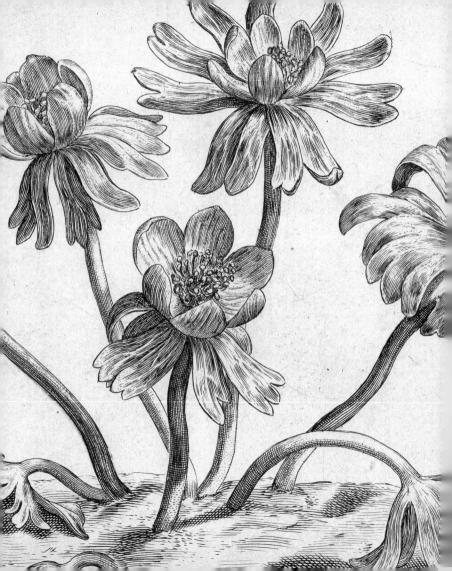

. Aconitum lut : hyem : . . Tue lup jaune . e. Winter geel Wolfswortel.

CHAPTER ONE

WINTER ACONITE

A seventeenth-century illustration from the *Hortus Floridus* of Crispijn van de Passe.

EUROPE

The first printed English books on gardening were published in the late sixteenth century. By that time garden plants from Asia had long since taken up residence in European gardens and the first introductions from the New World were appearing. But the native flora of Europe had not yet lost its predominance in the gardens of western Europe and of England. John Gerard was the first Englishman to publish a catalogue of his garden, and his *Herball* of 1597, although in principle devoted to the medicinal uses of plants, is our major source of information on what was grown in Elizabethan gardens. From Gerard we learn that sixteenth-century garden owners were enthusiastic about variegation and double flowers (a term that includes everything from flowers with more petals than usual, to 'hose-inhose' flowers, with additional corollas growing from the centre of the main corolla). Drawing on the native flora alone, Gerard grew ajuga, double aquilegias, double cheiranthus, double silenes, lily of the valley, variegated fritillaries and wood anemones of many colours. Of introductions from the continent, Gerard grew acanthus, red and yellow adonis, achilleas, single and double hollyhocks, thirteen sorts of allium, snapdragons, delphiniums, dictamnus, *Erythronium denscanis*, eight forms of verbascum, and seventeen sorts of narcissus and daffodils.

John Parkinson's *Paradisi in Sole Paradisus Terrestris* of 1629 was the first English gardening book to describe the full range of available garden plants instead of merely offering generalised cultivation instructions. Parkinson was still growing acanthus and adonis; he had snapdragons in white, purple, yellow, and red, striped auriculas, and twenty-four sorts of roses. He devoted twenty-four pages to hyacinths, and forty-two to daffodils. The interest in double forms continued; he was enthusiastic about double calendulas, daisies, wallflowers, and daffodils.

During the seventeenth and eighteenth centuries, societies sprang up – first in England, and later on the continent – for competitively producing and displaying new floral varieties. Known as florists' societies ('florist' meaning a raiser of new varieties, not, as in later years, a floral decorator), they were devoted to eight categories of flowers: tulips, hyacinths, auriculas, polyanthus, carnations, pinks, anemones, and ranunculus. Of European origin were auriculas

and polyanthus (both forms of Primula), and carnations and pinks (both forms of Dianthus).

Some forms of pinks were native to Britain, including the now endangered Cheddar pink (*Dianthus gratianopolitanus*). But the species that were to become most popular were continental introductions: the carnation (*D. caryophyllus*) from southern France, already fashionable by the reign of Edward III; the pink (*D. plumarius*) and the sweet william (*D. barbatus*) from the Mediterranean, which arrived during the sixteenth and early seventeenth centuries. Gerard described four sweet williams, twelve pinks, and single and double clove gilliflowers; Parkinson increased the numbers to eight sweet williams, fourteen pinks, nineteen carnations, and twenty-nine clove gilliflowers. Carnations and pinks became the clear favourites later in the century, when John Rea, in his *Flora, seu de Florum Cultura* (1676), listed 360 varieties.

Gerard knew two forms of the native British *Primula veris*, seven forms of cowslip and oxlip (the latter a natural hybrid) and eight auriculas, which had recently arrived from the continent. By Parkinson's time, the auriculas in particular were on the increase; striped varieties had appeared and doubles were as popular as the double-flowered forms of other plants. By the time Samuel Gilbert published his *Florist's Vade-mecum* in 1682, striped and double-striped auriculas had become the most popular forms. In the middle of the eighteenth century, edged auriculas (called English auriculas on the continent) appeared, and doubles faded from fashion. Striped auriculas had vanished by the nineteenth century and have never been redeveloped. Meanwhile, by the 1680s, a red-flowered form had appeared. It became known as the polyanthus, and in the eighteenth century gold-laced varieties were developed – within decades it was the most popular English exhibition flower.

The late eighteenth and early nineteenth centuries were the golden age of the auricula and polyanthus. They continued to be grown as plants for exhibition rather than for the garden. A collector might display them on a purpose-built stage known as an auricula theatre, a nineteenth-century example of which survives at Calke Abbey in Derbyshire. But, during the later nineteenth century, the florists' societies that had once flourished in England began to

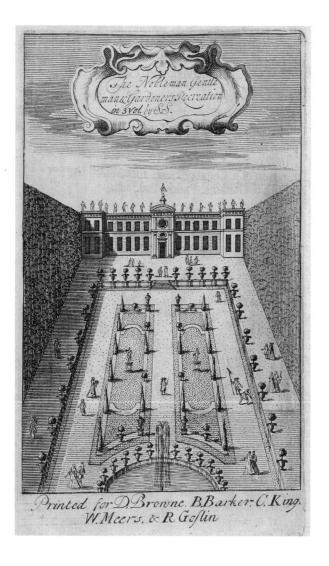

EUROPE

An early eighteenth-century formal garden, which shows the typical layout and plantings of the period, from Stephen Switzer's *Ichnographia Rustica: or, the Nobleman, Gentleman, and Gardener's Recreation* (1718).

diminish in number, and most of them had been wound up by the early twentieth century. Influencing this decline was the nineteenth-century rise of local horticultural societies devoted to growing the latest exotic introductions. These drew the well-to-do away from the traditional limited range of exhibition flowers.

In the early eighteenth century the flower garden profited from the introduction of the sweet pea, several species of *Cistus, Helianthemum umbellatum*, and the most important forms of *Cytisus*. Most of the older border plants continued their popularity, and colour variations were still eagerly sought. Double flowers were falling from fashion in England and France, though not in Germany, which since the Thirty Years' War had tended to be a generation behind western Europe in horticultural fashions. Johann Wilhelm Weinmann's *Phytanthoza* (published 1734–1747) reveals ranges of variation in poppies, rocket, wallflowers, scabious and lychnis that have not been explored in modern times. And, while in the early nineteenth century exotic introductions seemed to garner the largest press, certain plants of European origin flourished through the discovery of hybridisation techniques. There was a boom in hollyhock breeding from the 1830s; striped snapdragons emerged in the 1850s; and the pansy was developed in the 1820s and 1830s, followed by the garden viola in the 1860s.

Of all the garden plants of European origin, by far the most popular and esteemed was the rose. The ancient Romans had grown roses on a large scale, for the production of scent as well as for garden decoration. In the Middle Ages roses were considered as important for their medicinal uses as for their beauty. Many of the roses that were thought of as different species were in fact garden hybrids of long standing, their garden origin having been undocumented or forgotten. The Gallicas were sufficiently popular in England to yield the red rose of Lancaster, and the Albas, the white rose of York. During the sixteenth century, the Centifolias or cabbage roses appeared, probably the result of accidental crossing between Albas and Damask roses. These, with the sweetbrier or eglantine, remained the basis of European rose growing until the introduction of vellow roses from China in the early nineteenth century.

EUROPE

The martagon lily (opposite) is native to Europe. It was grown in seventeenth-century gardens, as shown here in a period illustration, and by 1800 there were twenty varieties. Today there are no more than half a dozen varieties available.

The nineteenth century was the great age of historical revivalism. Garden designs from the past and from different national styles were rediscovered and experimented with, first in Britain and then across the continent. As early as the 1820s some writers, such as John Claudius Loudon, recommended Parkinson's *Paradisus Terrestris* as a guide for planting a herbaceous border, and in the 1860s a stronger interest emerged in trying to replicate seventeenth- and early eighteenth-century planting in designs modelled on those periods. The 'old-fashioned garden' of the last third of the century eschewed modern bedding plants, and concentrated on larkspurs, rocket, hollyhocks, and other border plants used two centuries earlier. The immediate consequences were the attempt to grow improved varieties of these plants, and the attempt to recover once popular plants that seemed to have vanished.

Another trend emerged in the late nineteenth century that has carried through to the present day. In 1870 William Robinson, the most influential British gardening journalist of the late nineteenth century, published his book The Wild Garden, coining a name for a trend that had been slowly developing over the preceding quarter-century. In Robinson's hands, the wild garden had a quite specific meaning: it was a garden of self-maintaining plants, a form of laboursaving garden, composed of plants (often exotics such as Chinese rhododendrons or Japanese knotweed) that could naturalise in the local climate. However, the concept also extended to the specialist collection of native plants, to which Robinson himself devoted a chapter. In one form or another, wild gardening spread throughout northern Europe and America between the 1880s and 1930s. While the woodland garden, planted with exotic plants, absorbed the attention of early twentieth-century gardeners, the second half of the century saw a reaction in favour of native plants. The waning of many once-frequent species of birds, mammals, and insects reinforced this movement, with the widespread encouragement of gardening for wildlife. And so many native European, and specifically British, plants that had been relegated to subordinate positions since the beginning of large-scale plant exploration in the eighteenth century returned to prominence at the end of the twentieth century.

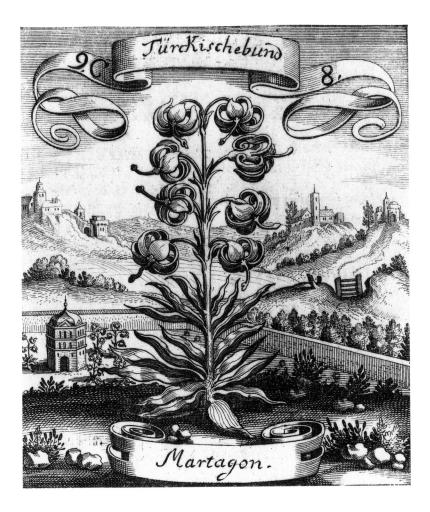

(TRUM MACULATUM & (TRUM ORIENTALE SSP. ENGLERI

The native English Arum maculatum (above) was only the most familiar of a range of plants with flowers in the form of a spathe. Arum orientale (right) was introduced by the German botanist Marschall von Bieberstein from the Crimea in the eighteenth century. Well into the nineteenth century, Arum was an accepted name for a wide variety of aroids from around the world (later separated into Dracunculus, Arisaema, and other genera), which were grown as ornamental curiosities.

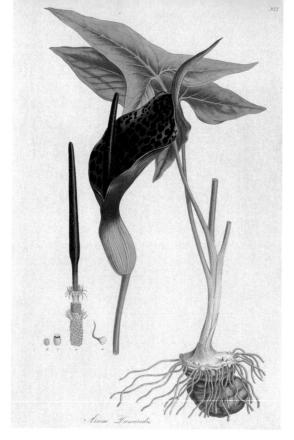

(RUM DIOSCORIDIS

Named by John Sibthorp, the Oxford botanist who travelled to Greece in the 1780s in order to identify the plants in Dioscorides' first-century treatise on medicinal plants. Highly variable in its colouring and markings, it exists in several recognised varieties. The eighteenth century saw the introduction of several aroids, originally grouped together and only later separated into genera such as *Calla & Zantedeschia*.

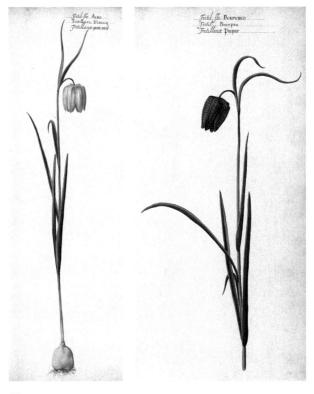

FRITILLARIA MELEAGRIS

Fritillaria meleagris was introduced into England from France in the sixteenth century, and only two centuries later was discovered to be native, though rare, in England. It was much admired by early collectors for the chequered patterns on its petals. Eight forms – white, yellow, in different shades of purple, as well as double-flowered – were still extant in the late nineteenth century, when William Robinson recommended it as a plant for the wild garden.

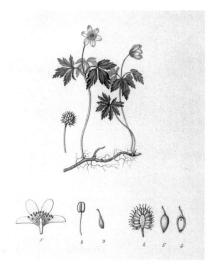

(INEMONE NEMOROSA

The British wood anemone, *Anemone nemorosa*, is now considered an indicator plant for ancient woodlands. It is highly variable, and in the sixteenth and seventeenth centuries English gardeners grew purple, blush, and double white forms. It underwent another vogue in the late nineteenth century, when the snowdrop hybridist James Allen raised the blue form 'Allenii', and his friend E. A. Bowles collected or developed several forms, which he described in his 1914 book *My Garden in Spring*.

ADONIS ANNUA

'I brought the seede, and haue sowen it in my garden for the beautie of the flowers sake,' said John Gerard in 1597 of the red-flowered *Adonis annua*; he also knew of a yellow-flowered form, not to be confused with the yellow *Adonis vernalis*, only introduced in the seventeenth century.

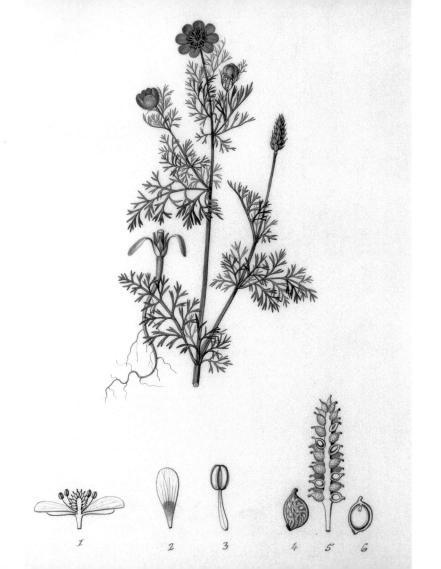

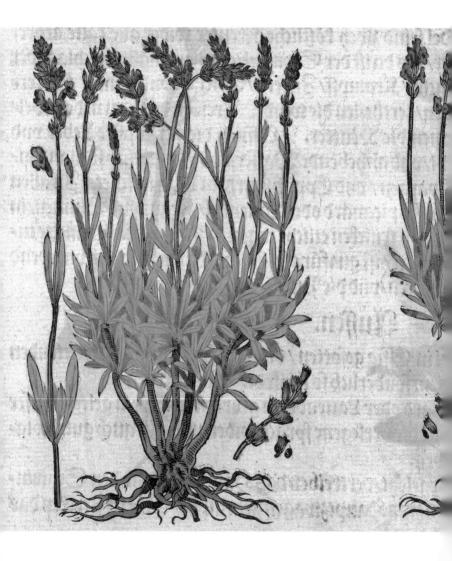

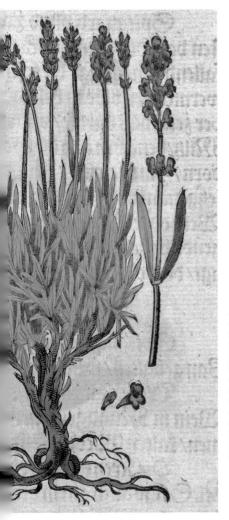

PAVANDULA

Lavender was introduced to Britain during the Middle Ages, if not earlier, and by the Elizabethan period was being used not only as a herb for flavouring and medicine but as a border plant, a means of edging flower beds, as a substitute for grass in lawns, and even as a shrub for shaping into topiary. In the late nineteenth century, it enjoyed renewed popularity as an 'old-fashioned' flower, cultivated for its Tudor associations, and was once again used for edging flower beds. This illustration comes from the *Kreutterbuch* (1586) by Pierandrea Mattioli.

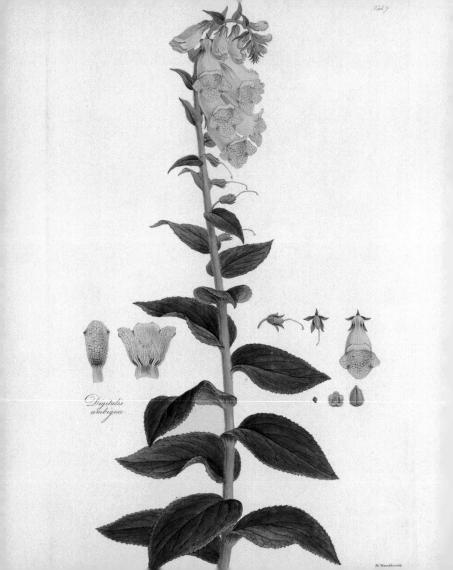

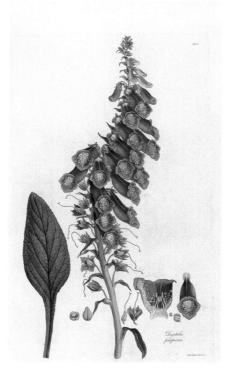

\mathfrak{G} igitalis grandiflora & \mathfrak{G} igitalis purpurea

The native foxglove, *Digitalis purpurea* (above), was long grown in English gardens both for ornament and medicine. In the 1590s, John Gerard was growing two foreign species, and the number of species available increased steadily throughout the seventeenth and eighteenth centuries, until John Lindley's *Digitalium Monographia* of 1821 could list twenty-three (not all now recognised). Among these was *Digitalis grandiflora* (left), known to Lindley as *D. ambigua*. The native foxglove returned to popularity in the late nineteenth century as an 'old-fashioned' flower for the herbaceous border.

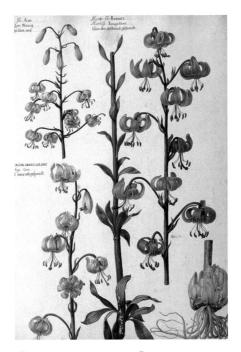

$\mathfrak{L}^{\mathrm{ilium}}$ martagon & $\mathfrak{L}^{\mathrm{ilium}}$ candidum

Martagon lilies (above) and the Madonna lily *Lilium candidum* (opposite) are native in Europe, and martagons have been claimed to be native to the British Isles. John Parkinson recorded five forms of martagons in his garden in 1629, and at the beginning of the nineteenth century over twenty cultivars were available; but their popularity waned as tiger lilies and other new species arrived from Asia. In the 1890s, William Robinson recognised only three varieties, of which the white variety *alloum* was the most popular.

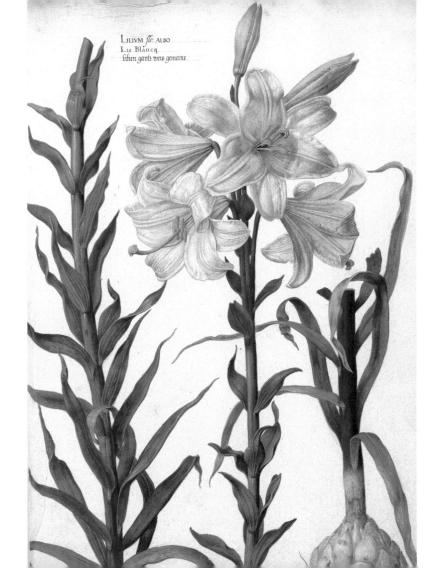

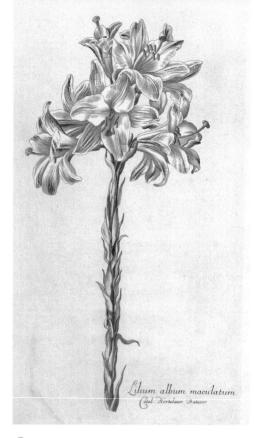

Lilium candidum var. purpureum

Lilium candidum was traditionally known as the white lily, until other white species were introduced in the nineteenth century; it then became known as the Madonna lily, because of its association with the Virgin Mary in Renaissance paintings, and because of the Victorian interest in exploring, and sometimes inventing, medieval folklore.

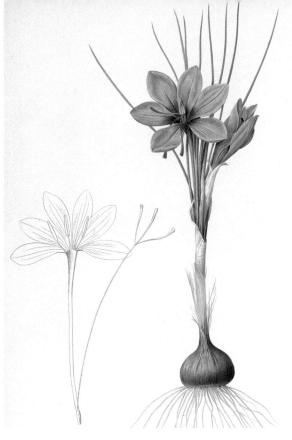

$\mathcal{C}_{\mathrm{rocus\ sativus}}$

The saffron crocus was introduced, or re-introduced, into Britain in the Middle Ages, and became the basis of an industry; the town of Saffron Walden takes its name from the dye industry which grew up around this flower. As foreign crocuses with a wider colour range were introduced, the popularity of the saffron crocus steadily waned during the nineteenth century.

EUROPE

\mathbb{S} cilla liliohyacinthus

Scillas experienced their greatest popularity in the sixteenth and seventeenth centuries, when John Parkinson could list fourteen different sorts. *Scilla peruciana* (a Spanish species, despite the name) arrived in the early seventeenth century, followed by *Scilla iliohyacinthus*, shown here from *Hortus Romanus* (1772–1784).

${\mathfrak B}$ ellis perennis cultivars

Some two dozen forms of *Bellis perennis*, the common British daisy, exist today. Double forms, and the hen-and-chickens form (bottom centre), were collected by Elizabethan gardeners. A dozen different forms were grown in the eighteenth century, including long-petalled forms and doubles.

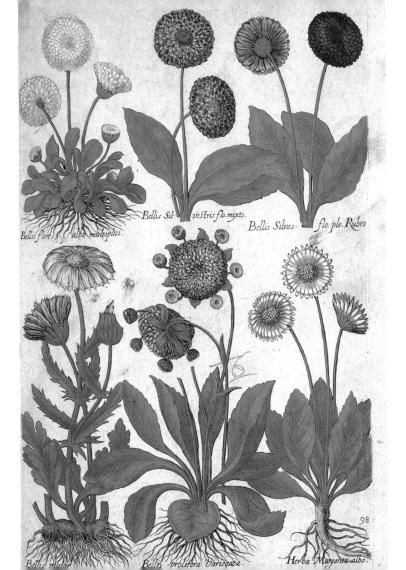

CURICULAS

Gerard knew two forms of the native *Primula veris*, seven forms of cowslip and oxlip (the latter a natural hybrid), and eight auriculas, which had recently arrived from the continent. By Parkinson's time, auriculas in particular were on the increase, striped varieties had appeared, and doubles were popular. By 1682, striped and double-striped auriculas had become the most popular forms, but by the mideighteenth century these were being displaced by edged auriculas.

Berties' 'Royal Sportsman' Auricula

In the mid-eighteenth century, a new development took place in auriculas: the development of green edges to the petals. The first edged variety to receive publicity was 'Rule Arbiter' in 1757; but within a short time edged auriculas had become the most popular form in England. On the continent, where they never reached such popularity, they were known as 'English auriculas', as were the grey-edged forms.

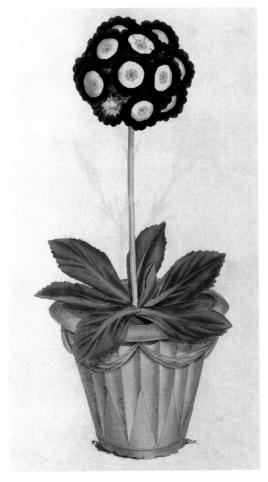

Redman's 'metropolitan' auricula

While striped and edged auriculas took the English fancy, petals of solid colour remained more popular on the continent. These were largely disregarded in England, where they were known first as 'shaded' and then as 'alpine' auriculas, until the 1860s, when Charles Turner of the Royal Nurseries, Slough, England began to breed improved varieties. Alpine auriculas managed to escape the general twentieth-century decline of auriculas, and continued to be raised by amateurs throughout the middle of the century. The auricula shown here (and the one opposite) was illustrated by James Sowerby for The Florist's Delight (1789-1791).

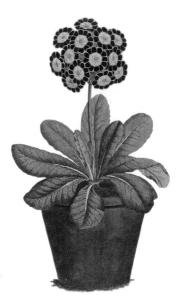

WILLETT'S 'DUKE OF CUMBERLAND' POLYANTHUS

Red-flowered auriculas appeared by the 1680s, becoming known as the polyanthus, as illustrated here by James Sowerby. During the eighteenth century gold-laced varieties were developed, and within decades had come to rival auriculas as the most popular English exhibition flower. Their peak period lasted from the 1780s to the 1830s, when they were once again overtaken by auriculas.

(LPINE AURICULA 'A. F. BARRON'

By the 1950s the only English nursery with a large stock of edged auriculas was James Douglas and Son of Great Bookham, who had been breeding them since the 1890s. Auriculas made a major comeback in the 1980s after Brenda Hyatt, who had taken over Douglas's stock, began exhibiting them. The illustration shown here was by John Nugent Fitch for the *Floral Magazine* in 1880.

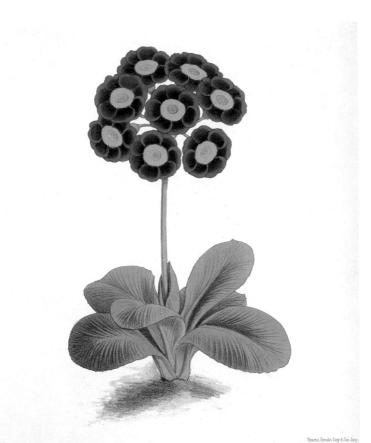

J.Nugent Fitch del et lith

ALPINE AURICULA A.F. BARRON.

FLORAL MAGAZINE NEW SERIES. L. Resve & C. 5. Herrietta, St. Covent Garden.

\mathscr{G} rimula vulgaris

The native English primrose, *Primula vulgaris*, has had a long career as a garden flower. Double-flowered forms were available in yellow and white in Gerard's time; in the mid-seventeenth century, blue and purple double forms were introduced from the continent. Late in the century, there were rumours about double red forms, but these only became available in the eighteenth century.

\mathfrak{E} rythronium denis-canis

The dog's-tooth violet may have been introduced into Britain by Mathias de Lobel in the 1580s. There was much confusion over its status, since it was initially thought to be an orchid. A decade after its introduction, John Gerard knew two forms with different coloured flowers: white and purplish-white. By the 1620s Parkinson was growing red, purple, and white varieties.

Dens caninvs Dent de chien Pourpre. Sundesan letblazb

\mathfrak{E} rythronium denis-canis

Nearly a dozen forms of dog's-tooth violet were available by the time William Hanbury published his *Complete Body of Planting and Gardening* in 1770. About the same number of forms are available today. By Hanbury's time, new species of *Erythronium* were being introduced from America, but none of them has produced as many varieties as the European species. This illustration of *Erythronium* comes from the *Hortus Floridus* (1614) of Crispijn van de Passe.

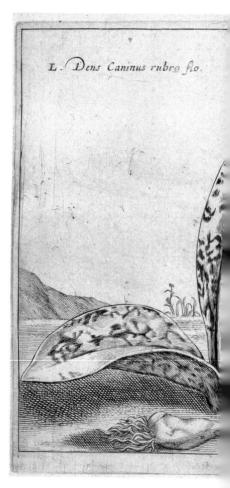

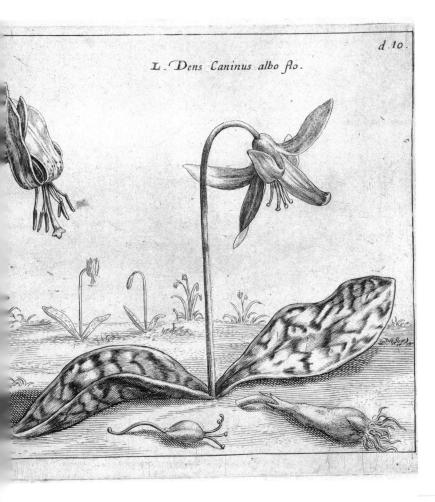

ORNITHOGALUM NUTANS

Orninogalum unmolitatum, the Star of Bethlehem, was introduced into England in the sixteenth century from France, but before long other species arrived which attracted greater attention, even though they required greenhouse cultivation. Among these was Ornithogalum nutans, treated as a greenhouse plant in the eighteenth century despite being hardy (and indeed becoming naturalised in England). But the intensity of interest these other species provoked died down, and O. umbellatum and nutans remain the most frequently grown today.

Marcissus Jonquilla

The jonquil's graceful shape and powerful sweet scent meant that it enjoyed a distinct reputation from other sorts of daffodil. The species is found in Spain and Portugal, and was introduced into northern Europe late in the sixteenth century; by the 1620s it was being grown in England, and a large number of different varieties became available.

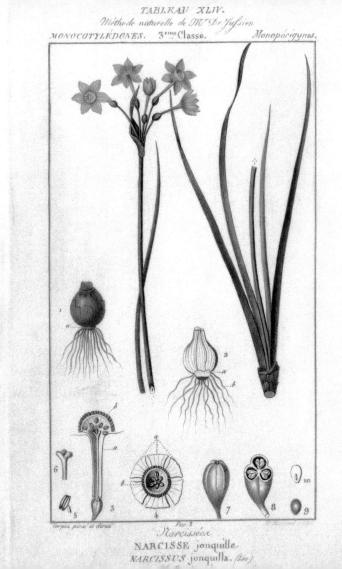

MARCISSUS

In the 1540s William Turner listed twenty-four species and varieties of *Narcissus* known to him; by 1629, John Parkinson had produced a descriptive list of nearly a hundred, and his names were widely accepted. These included the traditional narcissus, with its pure white petals and multicoloured corona, and the pseudonarcissus, or yellow trumpet daffodil. (Jacques Barrelier, in whose posthumous *Plantae per Galliam, Hispaniam et Italiam Observatae* of 1714 these engravings were first published, proposed many alternative names, but none were widely adopted.)

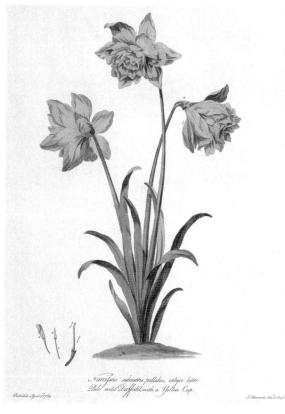

Marcissus pseudonarcissus

Daffodil breeding began in the 1830s, with the work of William Herbert, Dean of Manchester; but daffodils played only a minor role in the High Victorian flower garden. Their revival was largely the work of the Covent Garden seedsman Peter Barr, who began a search for all of Parkinson's daffodils, refusing to believe they had vanished. This was enough to bring them back into fashion in the late nineteenth century.

$\mathfrak{R}_{\mathrm{ARCISSUS}} \times \mathrm{incomparabilis}$

From the 1870s on, the breeding of daffodil cultivars gathered speed, and different categories were devised for exhibition purposes. Today there are Trumpet daffodils, derived from *Narcisus pseudonarcisus*, large- and small-cupped daffodils, from *N. × incomparabilis*; Triandrus, Cyclamineus, Bulbocodium, Tazetta, and Poeticus daffodils, from their respective species; as well as doubles and split-corona varieties.

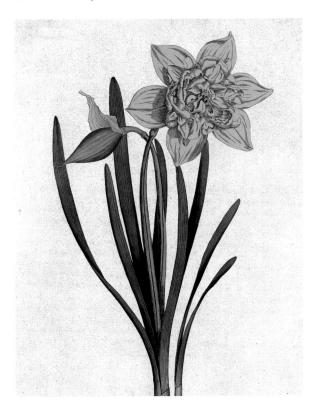

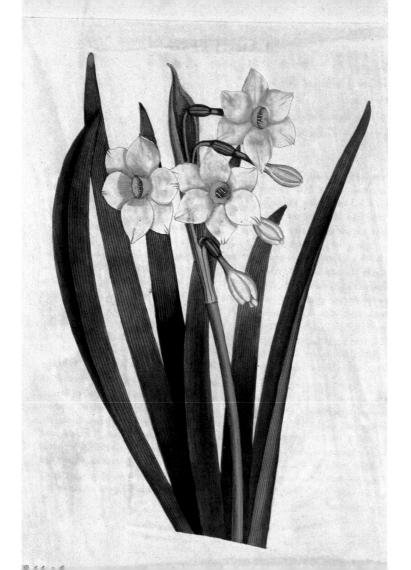

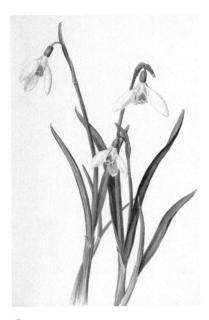

${ m g}_{ m alanthus\ `atkinsii'}$

The name 'snowdrop' first appears in the seventeenth century; before that *Galanthus nicalis* was known as a 'bulbous violet'. The late nineteenth century saw a spurt of interest in snowdrops, partly because new species were being introduced from eastern Europe. 'Atkinsii', shown here, was introduced by Peter Barr in the 1870s from southern Italy.

\mathfrak{N} arcissus tazetta

Narcissus tazetta, of Mediterranean and Asian origin, was exploited for garden use on the continent more than in England. Tazetta cultivars bear multiple flowers on a stem and tend to be strongly scented. *Narcissus poeticus*, with a natural distribution ranging from the Mediterranean to northern Europe, was popular in England and the continent.

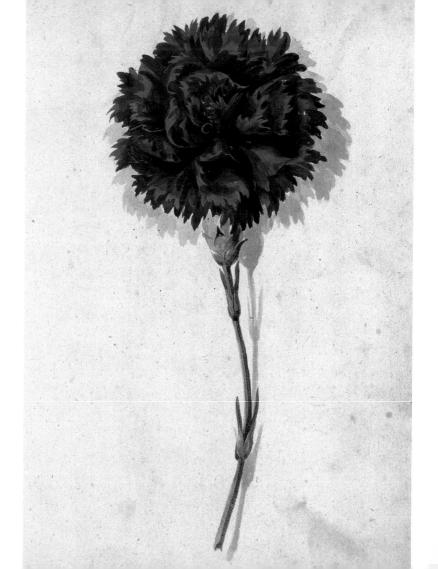

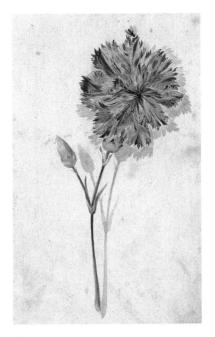

$\mathcal{C}_{\text{ARNATION CULTIVARS}}$

The first record of cultivated carnations, as distinct from the wild *Dianthus caryophyllus*, dates from Spain in 1460. By the 1620s, Parkinson knew nineteen carnations and twenty-nine gilliflowers (a common term for the smaller forms). Ever since, in addition to the florists' carnations grown for the show bench, there have been categories of garden carnations developed, such as Malmaison carnations in the 1850s, grown for greenhouse and indoor display, and the perpetual-flowering carnations of the mid-twentieth century.

Sequents Impial. Conyophylle Hortexser. Sequents Impial. Schöre Belene. 16 Picolomini Belene. Segone Obrefer Mage. Latripuz.

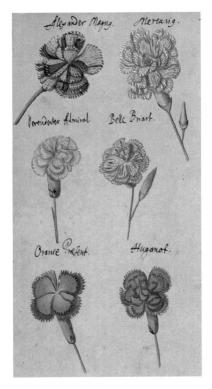

\mathfrak{D} ianthus cultivars

The anonymous German illustrations on these pages show some of the variety of dianthus (a term which includes carnations and pinks) grown in the seventeenth century. They show the serrated edges that were still standard, but which were soon to fall from favour; but the tendency can already be seen in these varieties to produce larger, rounder petals that would eventually become smooth-edged. EUROPE

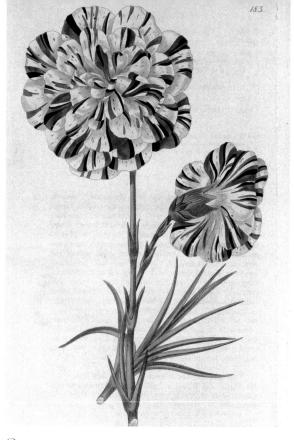

${\it G}$ ould's 'duke of York' carnation

'Duke of York' is a good example of an early nineteenth-century 'bizarre' carnation, with stripes of red and dark purple in the petals. If the colour had been confined to the edges instead of longitudinal stripes, the flower would have been called a 'picotee'.

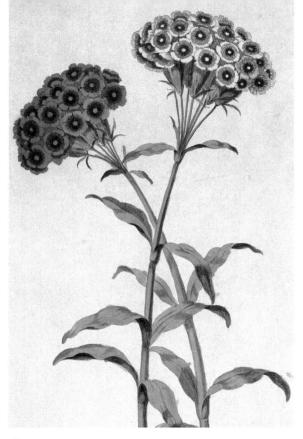

\mathfrak{D} ianthus barbatus

Despite a modern myth connecting it to the battle of Culloden, the name 'sweet william' dates back to the sixteenth century at least; Gerard also used 'sweet john' and 'will william' for related plants. In the early seventeenth century, forms were developed with a distinct central eye, and 'auricula-eyed' plants continued to be grown thereafter.

EUROPE

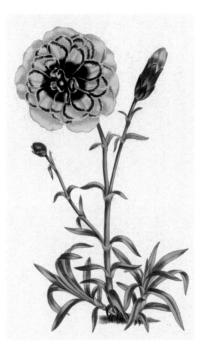

Davey's 'Juliet' pink & Ford's 'William of Walworth' pink

Pinks are derived from *Dianthus plumosus*, probably crossed with other species. Already popular in Gerard's time, they were not accepted as a category of florists' flower until the late eighteenth century, when laced pinks, with a narrow band of colour around the petals, were developed. Throughout the early nineteenth century, the race was on to produce cultivars with smooth-edged petals; once this was achieved, the pink was the leading florist's flower, from the 1830s to 1860s. The pinks 'Juliet' (above) and 'William of Walworth' (opposite) were illustrated by Edwin Dalton Smith.

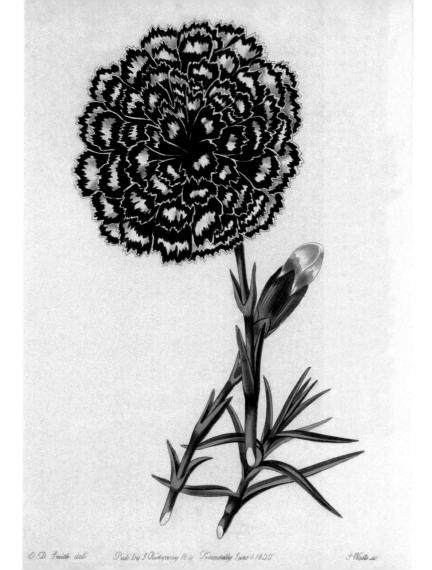

EUROPE

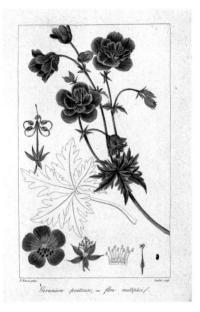

${\mathbb G}$ eranium pratense

The geraniums, or cranesbills, of Europe number almost forty species, of which Herb Robert (*G. robertianum*) and the meadow cranesbill (*G. pratense*) have been the most widely grown. In the second quarter of the nineteenth century, the hardy geraniums were popular for growing as standards, but then experienced a phase of comparative neglect, ousted by their African relatives the pelargoniums, before returning to favour in the twentieth century.

${ m I}$ quilegia vulgaris var. flore-pleno

The columbine is native to Britain, and one of the oldest of British garden flowers. In the 1860s and 1870s, new species such as *Aquilegia chrysantha* were introduced from North America, and stimulated the breeding of new hybrids with longer spurs.

Aquilegia flore Pleno inverso. Columbine with a Double inverted Flower . Aquiligia valgaris, Ver? Sp. pl. 2. 752.

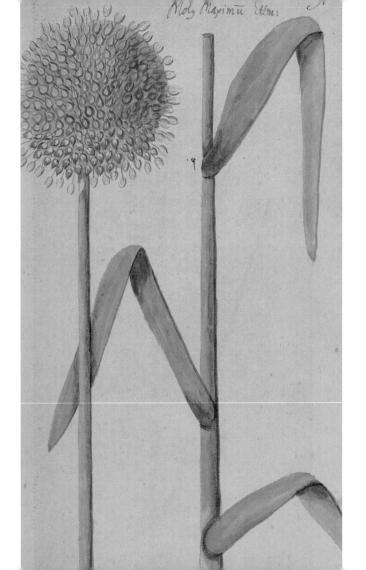

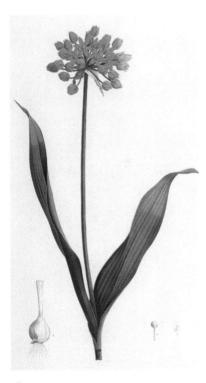

CLLIUM MOLY

The name 'Moly' was used by John Gerard and his contemporaries for any species of *Allium* grown for ornamental rather than culinary purposes; he grew five sorts, and Parkinson fourteen. What we now consider the true *Allium moly* was not grown in England until 1604, when Edward, Lord Zouche, introduced it.

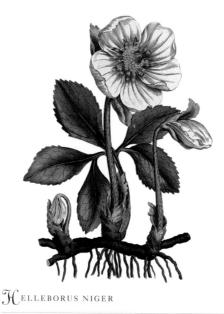

Helleborus niger, the Christmas rose, was a popular garden plant for generations before exotic species were introduced commercially in the nineteenth century. In the 1870s, nurseryman Peter Barr, botanist F. W. Burbidge, and amateur gardener T. H. Archer-Hind began to breed new varieties, and hellebores enjoyed a heyday, though most of the nineteenthcentury cultivars have disappeared.

Gagea lutea & Armeria Maritima

The sca-pink or thrift, Armeria maritima (opposite left), was one of the first plants used in England for planting as edging in knot gardens, and continued to be used for that purpose even after box was introduced in the late seventeenth century. It was reported in the 1710s that 'both the English and the Dutch adom their Courtyards with this plant'.

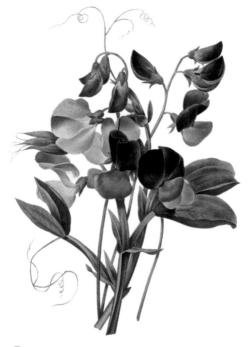

\mathfrak{L} athyrus odoratus

The first sweet pea arrived in England in 1699, in the form of seeds sent from Sicily by the Abbé Francisco Cupani to Robert Uvedale, an Enfield schoolmaster and collector of exotic plants. Little attempt at breeding was made until the nurseryman Henry Eckford began to concentrate on them about 1870, producing hundreds of varieties, including the Grandiflora range. In 1901, Silas Cole, the head gardener at Althorp in Northamptonshire, raised 'Lady Spencer', the first sweet pea with a waved edge to the petals. Throughout the Edwardian period sweet peas created more enthusiasm than any other garden flowers; in 1911, to celebrate the first ten years of the Sweet Pea Society, the *Daily Mail* offered a \$1000 prize for the best group of sweet peas.

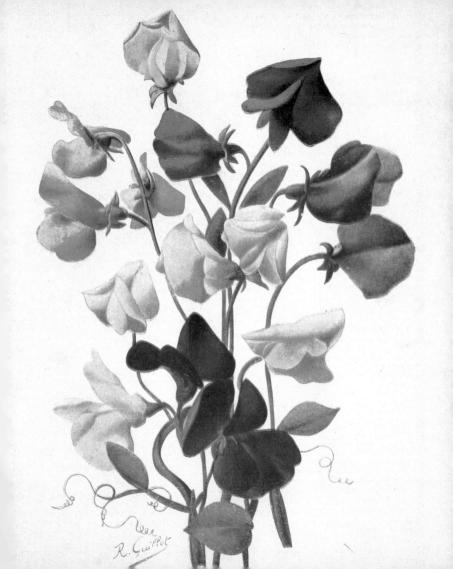

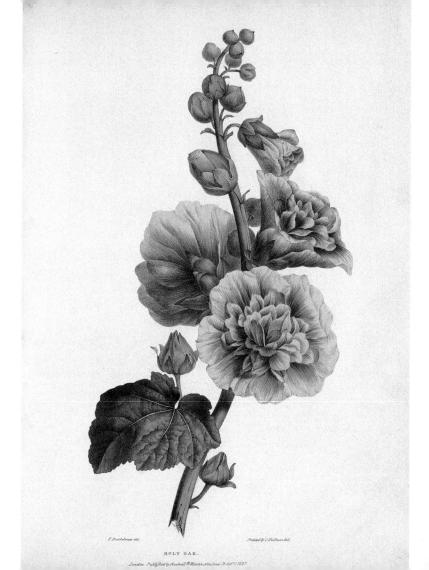

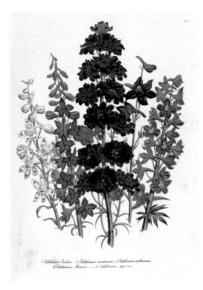

DELPHINIUM

Not so long ago the genus *Delphinium* included both annual and perennial species, all of which were called larkspurs. But the older separation between the two has now been revived, and only the perennials remain in *Delphinium*; the annuals, to which the name 'larkspur' originally applied, have returned to their older generic name of *Consolida*.

Hollyhock

Hollyhocks were already well-known in England in the early sixteenth century, and in the eighteenth century hollyhocks with variegated flowers were introduced from Asia. In the early nineteenth century they became a sort of florists' flower, but after the arrival of hollyhock rust in the 1870s, the cult of the hollyhock declined, surviving only as a 'cottage garden flower'.

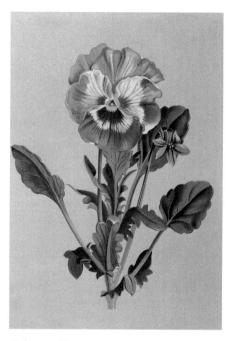

PANSY & OIOLA TRICOLOR

Viola tricolor, native to England, was known in Elizabethan times in three colours (purple, yellow, and white), and called the heartsease or pansy. It was not until the nineteenth century that it attracted the attention of breeders. Hybrids of *Viola tricolor* and *Viola lutea*, with large petals, almost circular in shape, and varying colour patterns, were developed by different growers from the 1810s, and took the name of pansy (the cultivar *Viola tricolor* 'Grandiflora' is shown opposite). In the 1860s, the Scottish nurseryman James Grieve crossed pansies with *Viola cornuta*, and produced the first violas, although the journalist William Robinson campaigned for the name 'tuffed pansy'.

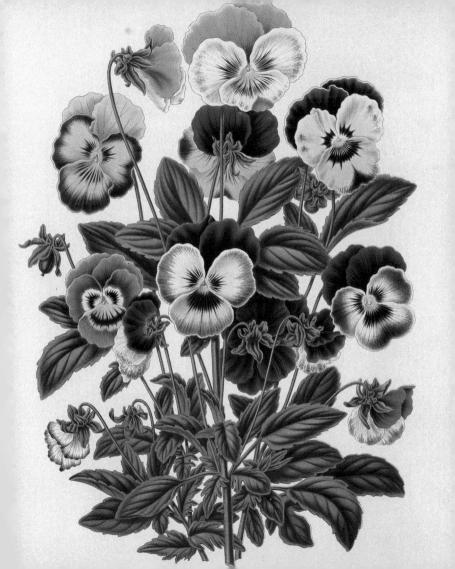

Carlina acanthifolia

Thistles, teazels, and similar plants entered gardens because of their medicinal uses, but by Parkinson's time several were being grown as ornamental plants. Parkinson, who regarded thistles as beautiful, grouped them together with acanthus, and offered advice for growing a dozen different sorts. While never among the most popular of border plants, various species formed a part of 'old-fashioned' gardens in the late nineteenth century, precisely because of Parkinson's use of them. *Eryngium* giganteum became known in the early twentieth century as Miss Willmott's Ghost, in honour of the celebrated gardener Ellen Willmott, who would plant it and give it to friends.

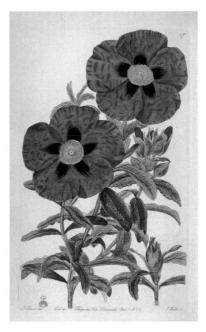

Cistus × purpureus & Helianthemum canescens

Rock roses were already popular garden plants in Gerard's time; in his 1597 *Herball* he described thirty-eight sorts of cistus and helianthemum (by which he meant any dwarfer variety). Such a large range was not described again until the nineteenth century, when the introduction of many Mediterranean and Near Eastern species revived enthusiasm for them. In the 1820s Robert Sweet published an illustrated account of over 100 species then being grown in London nurseries. Depicted in it were *Cistus × purpureus* (above), which flowered in James Colvill's nursery in 1826, while the helianthemum opposite was introduced by Reginald Whitley's nursery in Fulham.

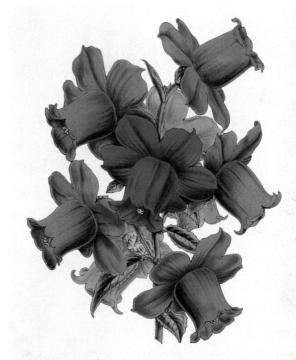

mith.FLS.delat.Bith. CAMPANULA MEDIUM CALYCANTHEMA. VBeodenDay&South

Campanula medium 'Calcyanthema'

Several species of *Campanula* have been popular in European gardens. *Campanula medium* (Canterbury or Coventry bells) was grown by Gerard in the seventeenth century. In the nineteenth century, one form of it, with a flattened corolla around the base of the bell, enjoyed great popularity under the name 'Calycanthema' (above); this was available in England until very recently.

GENTIANA flo: CERVLEO

Gentran oder blauwe Berbfflilien

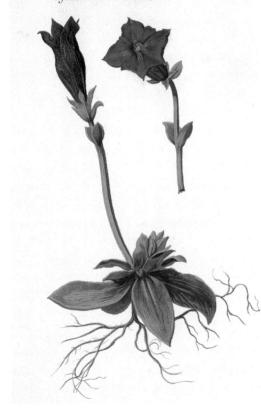

Gentiana acaulis

Gentians were much employed as mainly medicinal plants in the Renaissance, but by Gerard's time alpine gentians were already extensively planted at some country houses, and beginning to naturalise in Britain. Parkinson described only two gentians because he found them difficult to grow. Gentiana acaulis is now considered a debatable term, with some authorities regarding it as a group of species rather than a single species. Commonly called the gentianella, it was adopted as the symbol of the Alpine Garden Society in the 1930s.

$\mathfrak{L}^{\mathrm{ilium}}$ bulbiferum

Lilium bulbiferum, is native to southern France and central Europe, was once one of the most frequently illustrated of lilies in the sixteenth and seventeenth centuries. Variegated and doubleflowered forms continued to be grown in the eighteenth century, but since then its use as a garden flower has steadily declined. It is nonetheless the only European lily to have been extensively used in breeding modern hybrids: in the 1920s it was crossed with Lilium × maculatum to produce the Lilium × hollandicum hybrids, whose descendants continue today as popular garden lilies.

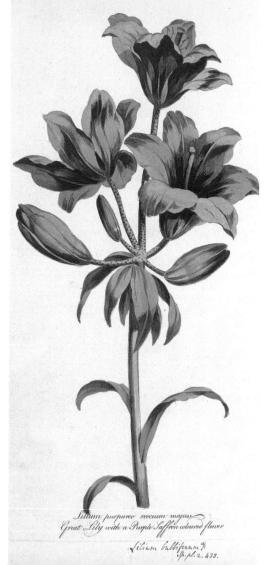

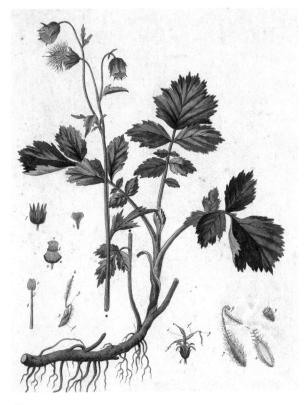

GEUM RIVALE

Geum rivale, the water avens, was a common garden plant in the sixteenth century, and is still grown today as a border plant, with half a dozen or more cultivars available. Geums became especially popular after the introduction of South American species in the nineteenth century, in particular *Geum chiloense*.

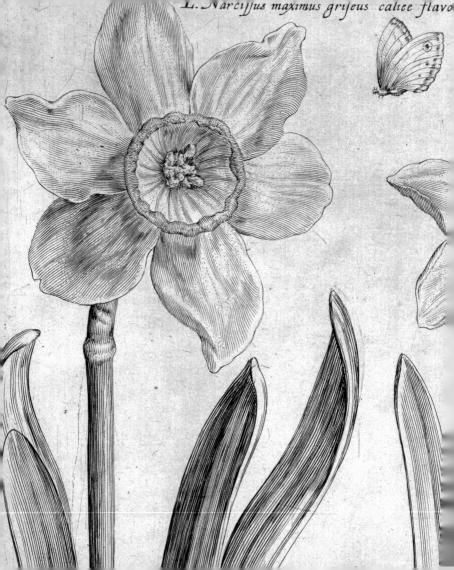

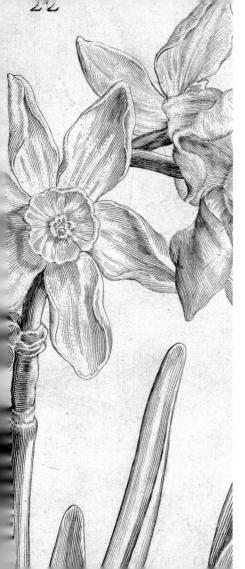

Chapter Jwo

NARCISSUS

Various species of narcissus, including *Narcissus odorus*, from the *Hortus Floridus* (1614) of Crispijn van de Passe.

\mathfrak{J} urkish empire

he first great wave of plant introductions to reach western Europe arrived in the sixteenth century from the Turkish empire, which at the time encompassed much of eastern Europe. The schism between the Roman and the Greek churches in the tenth century meant that a break between western and eastern Europe had been established even before the Turkish conquest of Constantinople in 1453. Thereafter, the Turks began progressively to move north and west through the Balkans and up the Danube; twice they reached as far west as to besiege Vienna, but both times were repulsed. All through the sixteenth and seventeenth centuries, western Europe remained aware of the expanding empire to the east.

One of the first western Europeans to realise the botanical wealth of the Turkish empire was Ghiselin de Busbecq, the Holy Roman Empire's ambassador to Constantinople from 1554 to 1562. He was struck by the varieties of flowers he saw growing in Turkish gardens, and sent bulbs of tulips, hyacinths, anemones, and crown imperials to his friend Clusius (Charles de l'Escluse) in Vienna. Clusius eventually moved to Leiden, bringing his new bulbs with him; he had already been circulating them to an extensive network of colleagues around Europe. Crocuses, colchicums, leucojums, erythroniums, ornithogalums, cyclamens, alliums, hyacinths, lilies, fritillaries, ranunculus, and above all tulips flowed into Europe from the 1560s onward. Ironically, some of these plants were native to eastern Europe, but this was not easy for early botanists to ascertain. It was not until the decline of the Ottoman empire in the nineteenth century that botanists from western Europe explored that area.

Many of these plants were highly variable and, while hybridisation was not yet understood, growers sought eagerly for new variations that appeared spontaneously and could be vegetatively propagated. John Gerard grouped tulips into fourteen categories in 1597, complaining that to try to describe all the varieties would be to 'number the sandes'. In 1629, John Parkinson outlined a classification of sixteen major forms, with forty-eight cultivars of *Tulipa praecox* and fifty-five of *Tulipa media*. By the 1660s, John Rea listed 184 varieties.

Gerard described ten foreign anemones, with Parkinson naming thirty-three cultivars. By midcentury, Thomas Hanmer grew forty-eight varieties, including plush flowers, in his Welsh garden (his record of which was published in 1933 as *The Garden Book of Sir Thomas Hanmer*). Parkinson grew ten forms of *Cyclamen persicum*, *Nigella damascena*, *Physalis alkekengi* (the socalled 'Chinese lantern'), *Syringa vulgaris*, *Hibiscus syriacus*, *Lychnis chalcedonica* and *L. floscuculi* were also introduced into Europe during the sixteenth century.

Of all the new plants from the Turkish empire, it was the tulip that achieved the greatest initial popularity – and notoriety. Thomas Johnson, revising Gerard's *Herball* in 1633, suggested that tulips might have been the 'lilies of the field' referred to in the Bible (Matthew 6. 28–29). Their colour range, and their capacity to produce variegated forms unpredictably, made them highly marketable.

The European interest in oddities and colour variations was already evident in the popularity of highly variable native plants like primulas and carnations. Tulips produced new colour patterns with great ease (as the result of viral infection), and the enthusiast would watch for a new variant that could be reproduced by vegetative propagation. Tulips were the first plants to be the subject of marketing and commercial exploitation on a large scale. During the early seventeenth century, the Dutch economy became tied to a dangerous extent to the market in tulip novelties, with disastrous results when the bottom fell out of the market in 1637.

Already by the 1620s the prices of the more spectacular varieties were rising fast, and fortunes were being made by canny growers, and lost by the unlucky. The most coveted variety was 'Semper Augustus', which was already selling for 1000 florins a bulb in the 1620s. Initially, tulip sales took place in the summer, after flowering was over, when bulbs could change hands before replanting. In the early 1630s, pure market speculation took over, and bulbs began to be sold in anticipation, even before they were lifted. In December 1636 and January 1637, competitive bidding pushed tulip prices to previously unheard-of levels; a bulb of 'Semper Augustus' fetched 10,000 guilders. Finally, in February 1637, the market was

The first anemones were sent to Europe from Constantinople in the mid-sixteenth century, and were to become one of the eight established florists' flowers. This illustration appeared in *Hortus Floridus* in 1614.

flooded, and crashed. Bulbs that had been sold for staggering prices one day could not find a buyer the next.

Other categories of florists' flowers of west Asian origin soared in popularity in the late seventeenth and eighteenth centuries. In 1629 Parkinson had red, yellow, white, and striped forms of ranunculus, including semi-doubles. In his *Universal Botanist* of 1777, Richard Weston named 1100 cultivars. Gerard knew of hyacinths, but had no cultivars himself; Parkinson had blue, white, and purple forms, including semi-doubles. By 1777 Richard Weston could enumerate 575 cultivars, including reds. (The first true double hyacinths emerged in the 1680s, through the nurseryman Pieter Voorhelm in Haarlem.) The price of hyacinths rose steadily during the early eighteenth century, with many desirable bulbs fetching hundreds of guilders in the Netherlands, peaking in the 1730s but without causing the sort of crisis that tulips had a century earlier.

For botanical travellers in the eastern Mediterranean, the incentive for seeking new flowers was as much a matter of scholarship as of uncovering some lucrative novelty for the garden. Debates over the identity of the plants named in ancient writings were a mainstay of academic botany for centuries. The identification of plants in Pliny's *Historia naturalis*, written in the first century AD, had already been opened to controversy by Niccolò Leoniceno in the fifteenth century. Many of the sixteenth-century herbals, or books on medicinal plants, were based on Dioscorides' first-century treatise; and Pierandrea Mattioli's commentary of 1554 was the first in a series of progressively rigorous attempts to determine exactly which plants Dioscorides had been referring to. It was to see these same plants that the Oxford botanist John Sibthorp made his expedition to Greece in the 1780s, resulting in the publication of the spectacular *Flora Graeca* after his death. This endeavour has carried on in the work of the botanist John Raven, who disputed traditional identifications in the 1970s.

And there was, of course, the Bible. The late seventeenth century saw the beginnings of systematic attempts to identify all the plants referred to in the Scriptures. Mountains of

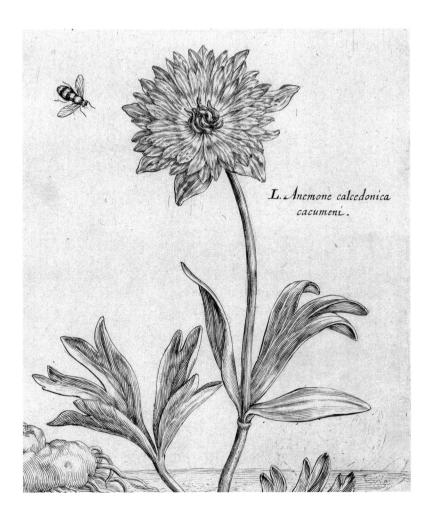

This formal seventeenth-century garden introduces Daniel Rabel's *Theatrum Florae* (1633). The bouquet in the centre of the scene includes recently arrived flowers from the Turkish empire including crown imperials and tulips.

scholarship were assembled, in the form of works like Ursini's *Arboretum Biblicum* (1699) and Celsius' *Hierobotanicon* (1745), on the basis of what proved to be inadequate knowledge of the region's flora. The desire to see at first hand the flora of Palestine inspired the journeys of the botanists Pierre Belon in the 1540s, Leonhard Rauwolf in the 1570s, and Joseph Pitton de Tournefort in 1700.

Through expeditions such as these, a significant flow of west Asian plants continued to reach Europe. Alyssum and gypsophila arrived during the eighteenth century, with *Scabiosa caucasica, Eryngium giganteum*, and *Aubrieta deltoidea* following in the first decades of the nineteenth. Meanwhile, the progressive Austro-Hungarian annexation of the European parts of the former Ottoman empire meant that Western botanists had increased opportunities to explore the Balkans and make inroads into Turkey itself. The major introductions of the later nineteenth century were Balkan snowdrops and chionodoxas, *Alchemilla mollis* from the Carpathians, and west Asian species of *Eremurus*, which began to be hybridised in the 1920s and 1930s by Sir Frederick Stern in his celebrated garden at Highdown in Sussex.

None of these flowers had quite the impact of *Rhododendron ponticum*, which was introduced to Europe in the 1760s. Although it was later to be found in the Iberian peninsula, it arrived from the Caucasus in 1763. At first it was grown in glasshouses, and then as an addition to the 'American garden', or peat garden. By 1836 the Hackney nursery of Loddiges was listing twenty-eight varieties. In 1841, its first year of publication, the weekly newspaper *Gardeners' Chronicle* published correspondence from gardeners reporting that ponticum could successfully seed itself in ordinary British soil. Before long, gardeners were filling their woodlands with it, both for the aesthetic floral effects and for its ideal qualities as underwood for game coverts. It remains, in Britain at least, one of the most enduring and prolific plant introductions from the region that was once known as the Turkish empire.

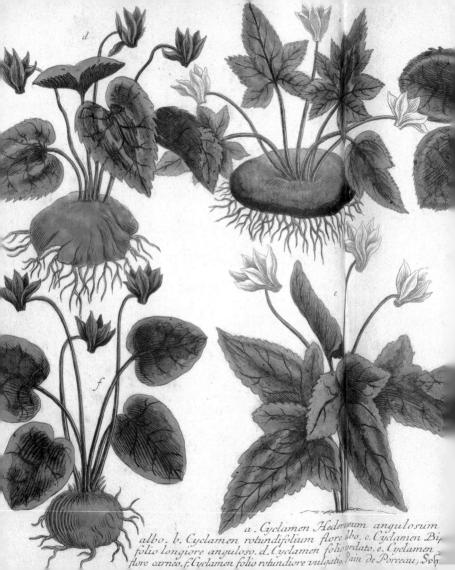

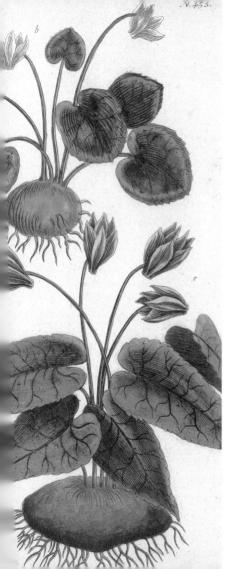

TURKISH EMPIRE

CYCLAMEN

Cyclamen persicum was introduced in the 1730s, the first important example of cyclamens grown primarily as green-house varieties. From the 1860s on, these became the subjects of intensive breeding, and white, red, pink, and purple cultivars appeared by the end of the century, to be followed in the twentieth by violet, dark red, and scarlet forms. In recent decades, the interest of breeders has shifted from flower colour to leaf patterning. This early illustration of cyclamens comes from *Phytanthoza* (1734–1747) by Johann Wilhelm Weinmann.

CYCLAMEN

The first cyclamens arrived in England in the second half of the sixteenth century. Gerard knew two species, one of them *Cyclamen europaeum*, and thirty years later John Parkinson had ten varieties, shown in this illustration from his *Paradisi in Sole Paradisus Terrestris* (1629). Thereafter, however, there was little development of new cultivars, and there were few introductions of other hardy cyclamen species until the nineteenth century.

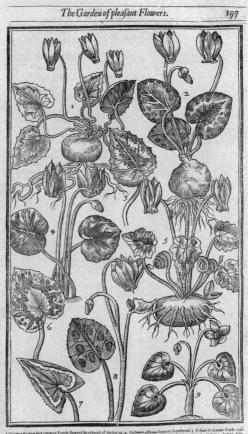

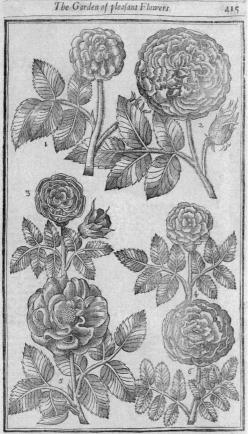

1 Refa Demuleras, The Danneles Role, Refa Persolutialis free Hollandics, The great Province Role, 3 Refa Penneaformoffs, This Frankford Role, a Refa more homein, The dwarfe red Role, 5 Refa Hangarias. The Hangarian Role, 6 Refa Isria mathplan. The great chole, wellow, Role.

$\mathcal{R}^{ ext{oses}}$

Parkinson listed twenty-four roses in his Paradisus Terrestris, some of them shown here; this was ten more than Gerard had known thirty years earlier. Parkinson's list included damask roses (Rosa × damascena), a longestablished hybrid resulting from the introduction of Near Eastern roses during the Crusades; the red rose (Rosa × gallica), familiar since Roman times and identified with the house of Lancaster; the white English rose (Rosa \times alba), identified with the house of York; and the striped York and Lancaster rose (R. damascena var. versicolor).

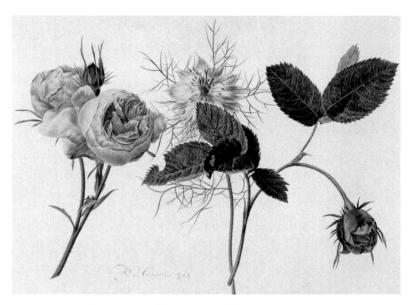

${ m R}$ oses and ${ m N}$ igella & ${ m R}$ osa sulphurea

The roses known in Europe up to the sixteenth century were red or white; the first yellow roses to be introduced were *Rosa foetida*, the 'yellow rose of Asia', in the 1580s, and *Rosa sulphurea* (opposite), now called *Rosa hemisphaerica*, which Clusius received from Turkey via Strasbourg in 1601. Both of these were known to Parkinson by 1629. Even so, yellow roses remained rare until the nineteenth century and the introduction of Chinese species.

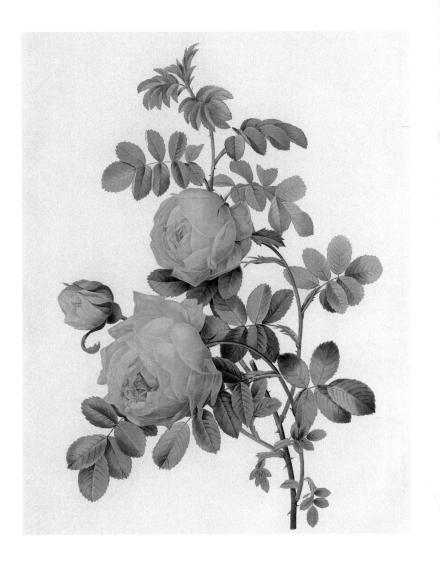

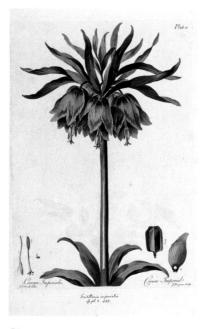

FRITILLARIA IMPERIALIS

Originally called the Turkish lily, *Fritillaria imperialis* was introduced from Turkey to Vienna in the 1570s, and derived its later name, the crown imperial, from association with the emperors of the Holy Roman Empire. It was the first plant featured in Parkinson's *Paradisus Terrestris* of 1629: 'The Crowne Imperiall for his stately beautifulness, deserueth the first place in this our Garden of delight.' He knew only the one form, although he had heard that a white-flowered variety had been raised.

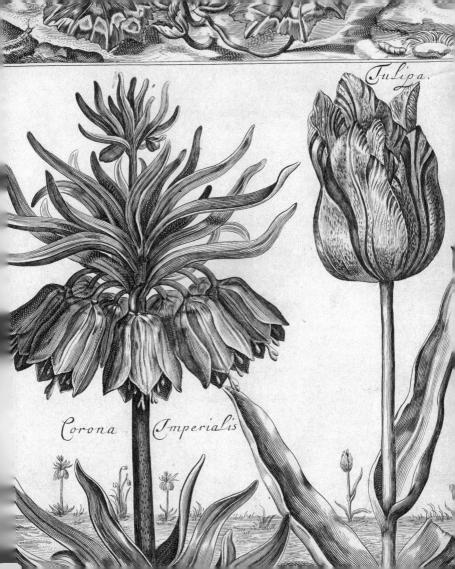

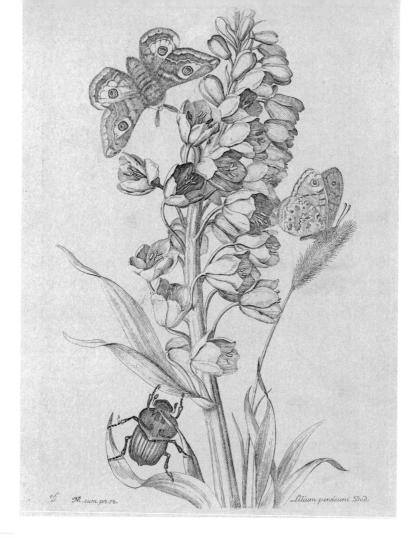

TURKISH EMPIRE

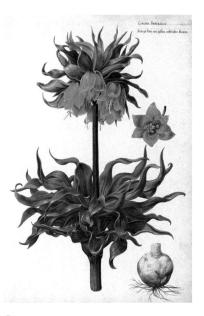

\mathfrak{F} ritillaria imperialis

The crown imperial was greatly popular in the seventeenth and eighteenth centuries, with over a dozen varieties eventually grown. Most of these, including ones with variegated leaves, have died out, but today there are again more than a dozen varieties available, with a colour range from yellow to red.

${\mathfrak F}$ ritillaria persica

Fritillaria persica, the second flower to be discussed by Parkinson, was another species to be introduced early via Constantinople. Parkinson knew only the smaller form, but a larger form was introduced from Russia in the eighteenth century by the German botanist Marschall von Bieberstein.

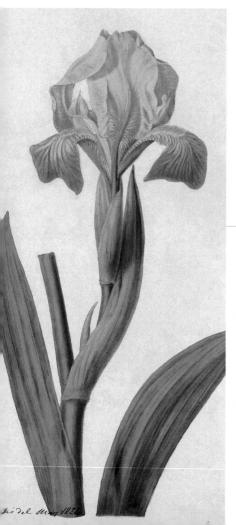

JRIS SPURIA

Rhizomatous irises, like the yellow flag *Iris* germanica, have been grown in gardens for centuries, and yielded the French royal symbol of the fleur-de-lys. But from the late sixteenth century new bulbous irises from Turkey and southern Europe began to command attention, and flag iris varieties dwindled. The colour range of *Iris spuria* made it popular in the sixteenth and seventeenth centuries.

JRIS PERSICA

This iris was known to Gerard, and was enthusiastically grown in the sixteenth and seventeenth centuries. To quote the great English iris expert W. R. Dykes: 'Imagine a pearly white flower washed over with turquoise-blue and seagreen laid on unevenly; give it a blotch of warm purple-brown on the blade of the falls and a central orange stripe, and you will have some faint idea of the beauties of *L persica*.'

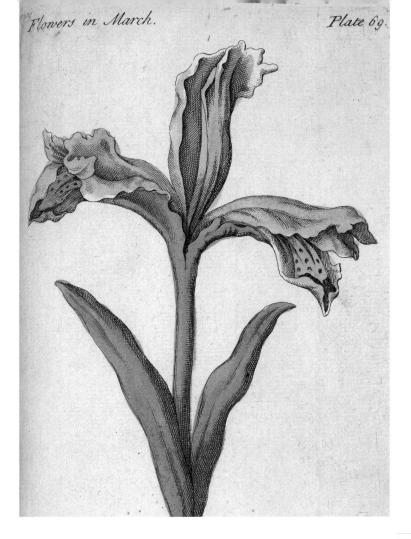

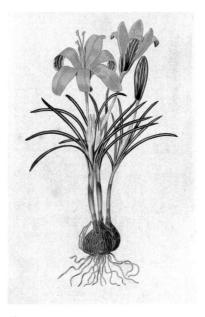

CROCUS SUSIANUS

Crocus susianus, now called *C. angustifolius*, is commonly called the Cloth of Gold crocus. Parkinson knew two varieties, one with stripes and the other with suffused purple at the edges. By 1700 the French botanist Tournefort could list forty-eight crocus varieties available in Europe; *Crocus vernus* was the most popular species because of its colour variation.

\mathcal{C} olchicum autumnale

Colchicums, sometimes misleadingly called autumn crocuses, are widespread throughout Europe and western Asia. While *Colchicum autumnale*, the European colchicum (as illustrated here by Redouté), has never lost its popularity, it was the introduction of species from Constantinople and the Mediterranean that stimulated colchicum collecting in the sixteenth and seventeenth centuries.

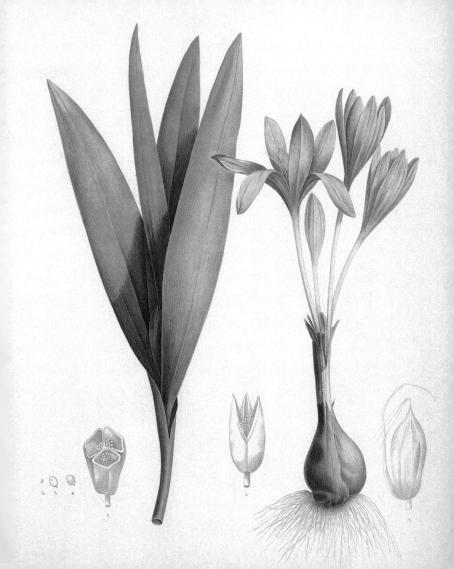

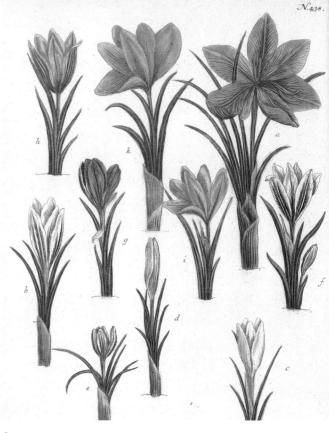

CROCUS CULTIVARS

The Dutch dominated the trade in crocuses until the nineteenth century. 'Our tulipgrowers have beaten the Dutch in the quality of their best novelties,' wrote Englishman George Glenny in 1851, 'and we see no reason why we should not beat them in crocuses'. A campaign for English crocus growing resulted in a significant bulb industry in Lincolnshire, which included tulips and daffodils by 1900.

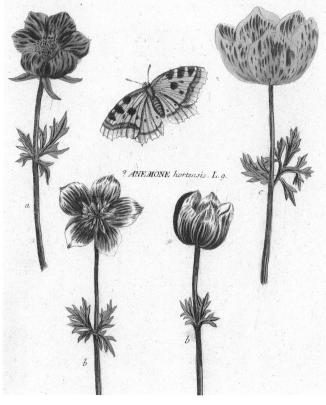

CNEMONE CULTIVARS

Anemone coronaria and A. pavonina are distributed throughout southern Europe in the wild, but were nevertheless introduced into European gardens from Turkey in the sixteenth century. Clusius described thirty-eight varieties in 1601; by 1682, Samuel Gilbert estimated there were nearly a hundred. The most important garden for early cultivars was Sermoneta, near Rome, said to have 28,000 specimens.

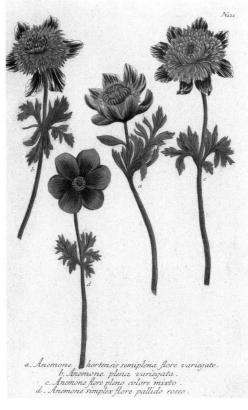

(PNEMONE CULTIVARS

The florists' anemone of the seventeenth century offered a colour range of red, yellow, and blue, sometimes striped or variegated. Doubles and semi-doubles were particularly prized, among them forms in which the carpels resembled a mass of soft threads – known as plush or velvet anemones. The star anemones, derived from *Anemone pavonina*, tended to have flatter-opening flowers.

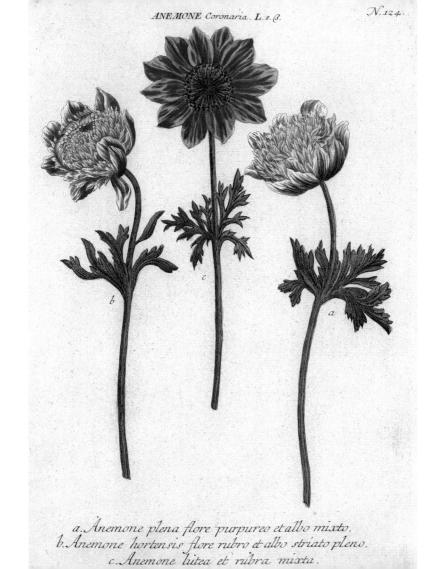

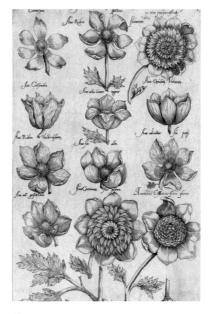

(INEMONE CULTIVARS

The seventeenth century was the heyday of the florists' anemone, but by the late 1700s the number of varieties grown was already declining. A new stimulus came from northern France, where the De Caen strain of *Anemone coronaria* was developed in the early nineteenth century, briefly enjoyed popularity as a florists' flower, and was then revived late in the century as a cut flower.

\mathfrak{J} ulip cultivars

Busbecq, the Holy Roman Empire's ambassador in Constantinople, first saw tulips in Turkish gardens in the 1550s, and sent specimens to Vienna. They were being grown in Europe by the 1560s, and were particularly admired for their tendency to display an unanticipated colour pattern in the petals – the result, as we now know, of virus infection.

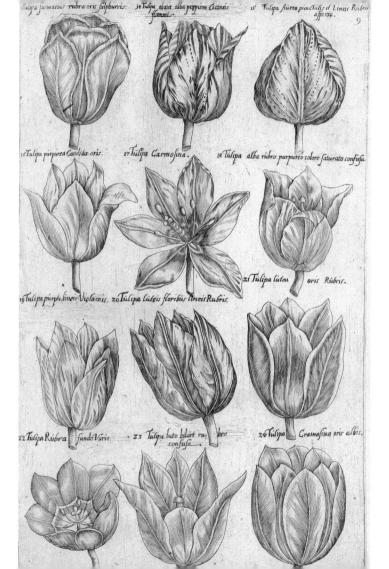

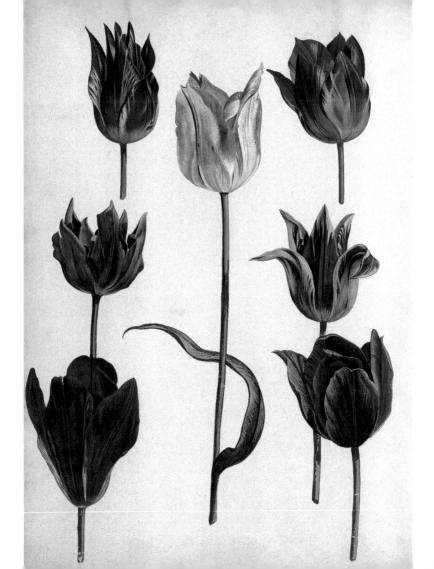

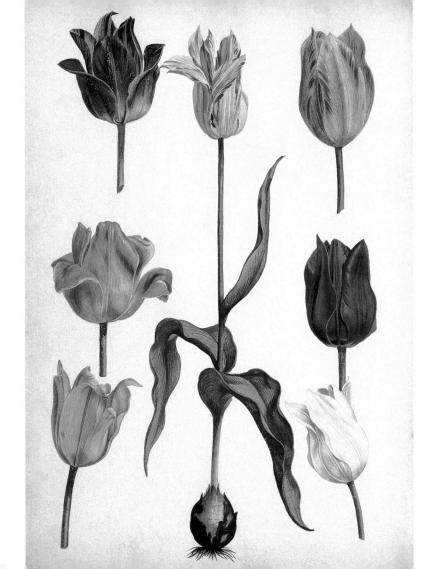

JULIPA 'ORANGE DUC THOL'

Before long, tulips were being traded for enormous prices, and dealers purchased bulbs in advance of flowering in the hope they would break with an exciting new pattern, which could be propagated vegetatively and sold widely. The resulting market correction in 1637 nearly bankrupted Holland, but did not end the search for new varieties. (The range of tulip cultivars shown on the previous pages, probably drawn in the 1630s, indicates something of the range available.) However, the rise of the hyacinth in the early eighteenth century relegated tulips to second place, and most of the early varieties disappeared. One survivor was 'Orange due Thol', a variant of which is illustrated here in a drawing attributed to August Wilhelm Sievert.

114

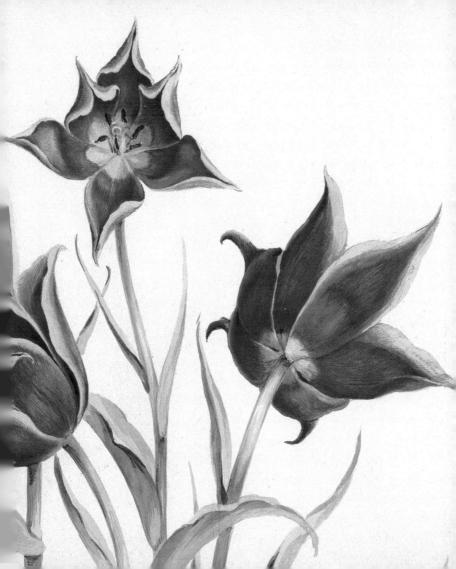

Julipa 'Lord Holland'

In the eighteenth century, the French succeeded the Dutch as the leading developers of new tulip strains, and in the early nineteenth century it was the turn of the English. The 1820s to 1840s saw an English tulip fever which never reached the extremes of the 1630s. The three preferred classes were the bybloemen (purple on white, such as 'Lord Holland'), the rose (red on white), and the bizarre (red on yellow, such as 'Peregrinus Apostolicus', opposite).

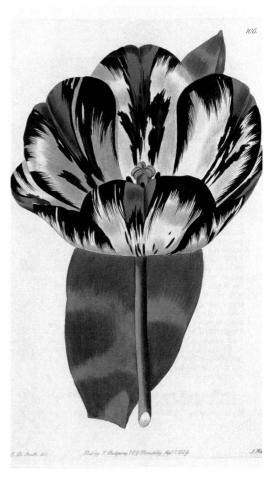

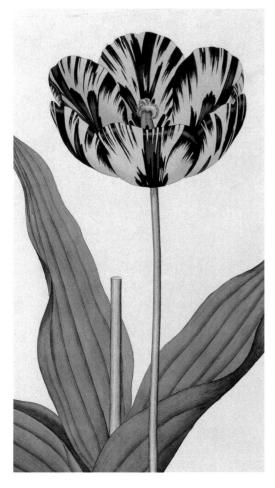

Julipa 'peregrinus'

In the late nineteenth century, the Dutch began once again to take the lead in tulip breeding, with the Haarlem nurseryman E. H. Krelage, introducing a new exhibition category, the Darwin tulip, in the 1880s; these were followed by Rembrandts, Triumphs, and Fleurde-Lys or lily-flowered tulips, with the nurseries of Krelage and Van Tubergen playing a major role in developing most of these. The flower bed, however, has now replaced the show bench as the main focus for tulip display.

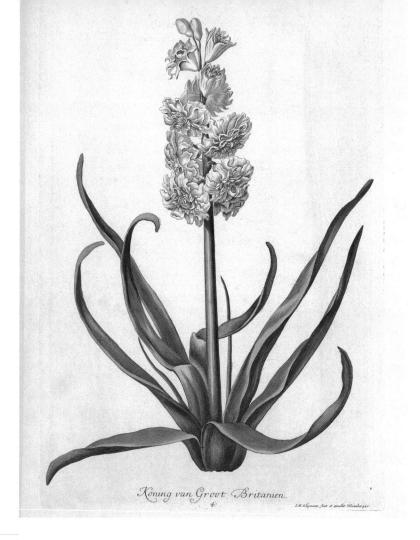

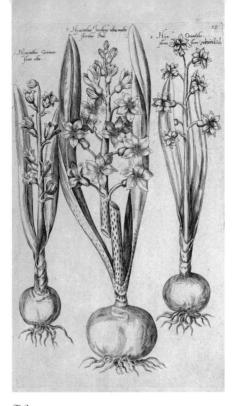

Hyacinth 'koning van groot britanien' & Hyacinth cultivars

The hyacinth, already extraordinarily popular in Turkey, reached Europe in the mid-sixteenth century. The earliest varieties were red or pink; semi-double forms were much favoured by collectors, until the first true doubles were grown by Pieter Voorhelm in the 1680s. Hyacinth 'Koning van Groot Britanien' (opposite) was one of the most famous doubles, because of the contrast between the white outer and the red inner petals.

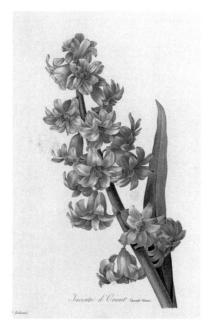

HYACINTH CULTIVARS

The pioneering double hyacinths reached prices of over a hundred pounds by today's standards; but memories of tulipomania ensured that dealers were cautious, and there was no comparable market collapse. By 1775, Richard Weston listed 575 sorts available in England, with a colour range of white, red and purple, and the first yellows. Throughout the second half of the eighteenth century, hyacinths outsold tulips, even in Holland. In 1829, William Cobbett claimed that there were 2000 varieties extant, but this was an undoubted exaggeration.

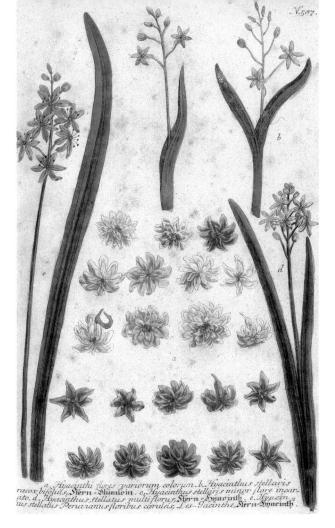

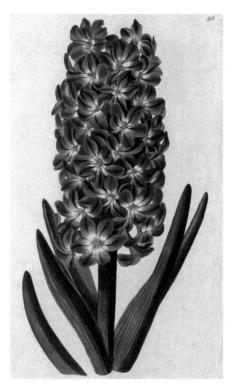

HYACINTH 'LYRA GRANDIS'

Hyacinths were not confined to the florists' show benches; much of the bulk in sales came from general domestic use. Unusually for a florists' flower, the pattern of the individual flower was considered less important than the overall shape of the inflorescence, and stripes or distinct patterns on the petals were discouraged.

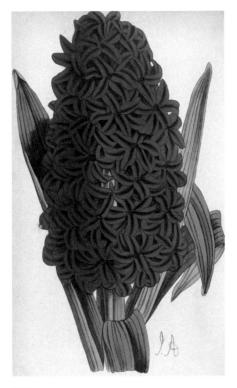

HYACINTH 'PRINCE ALBERT VICTOR'

The last phase of the hyacinth's history as a florists' flower saw the shift from the pyramidal shape formerly sought after, to the cylindrical column still popular today. A preference for darker colours was already noticeable in the late eighteenth century. 'Prince Albert Victor', bred by the English nurseryman William Paul, was greeted as a breakthrough in the production of deep reds and purples.

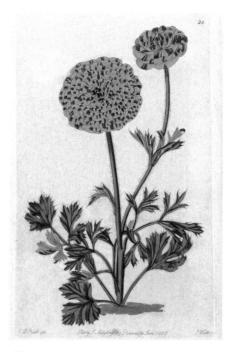

Ranunculus 'le mélange des beautés' & Ranunculus 'vereatre'

Like the anemone, the cultivated ranunculus was introduced from Turkey despite the presence of wild forms throughout southern Europe. By Parkinson's time, in the 1620s, it was available in yellow, white, and red, in striped and double-flowered forms, but it was not until the mideighteenth century that the number of varieties began to multiply. In the 1790s the nurseryman James Maddock claimed that there were more varieties of ranunculus than of any other plant.

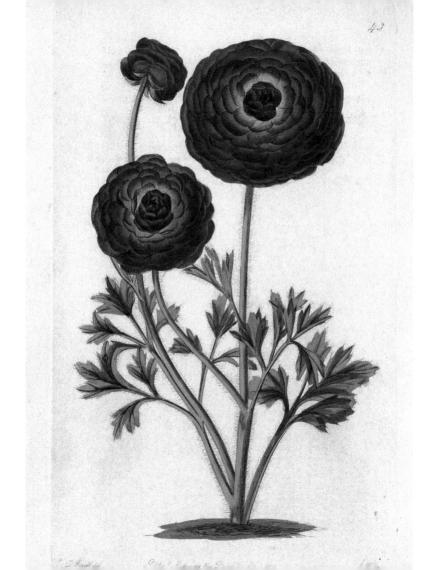

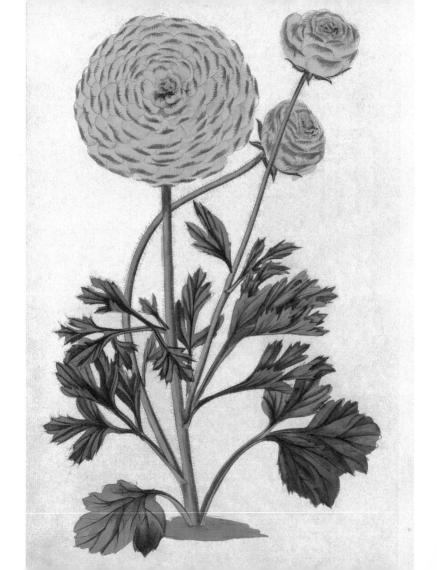

${{{\mathfrak R}}}$ anunculus gadwin douglas' & ${{{\mathfrak R}}}$ anunculus 'cupid'

The heyday of the ranunculus in England ran from the 1780s to the 1830s. Single-coloured forms were grown extensively for general garden use, as well as the highly patterned forms for competition. By the 1850s the fashion was fading, however, and by the 1880s the florists' ranunculus was effectively extinct. The varieties 'Gadwin Douglas' (opposite) and 'Cupid' (above) appeared in *The Florist's Guide* (1827–1832).

 \mathfrak{L} ychnis chalcedonica & \mathfrak{S} ilene coeli-rosa

These plants, once grouped together as *Lychnis*, are now divided into two different genera. *Lychnis chalcedonica* (above) and *L. coronaria* were introduced in the Middle Ages, and double forms and colour variants were collected by Parkinson and his contemporaries. *Lychnis* (now *Silene*) *coeli-rosa* (opposite) was less popular in England than in Germany, where it was commonly called Rose of Heaven.

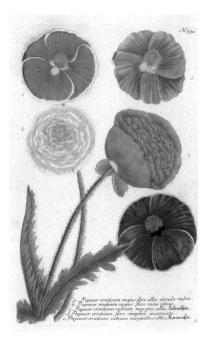

$\mathcal{P}^{\mathrm{oppy}\;\mathrm{cultivars}}$

Although *Papaver somniferum*, the opium poppy, is found throughout southern Europe, the stimulus to its ornamental use in gardens came after double-flowered forms were introduced from Constantinople in the sixteenth century. By the 1650s they were being grouped into violet, carnation, curled, fringed, and feathered poppies. The enthusiasm of continental growers then spread to *Papaver rhoeas*, varieties of which became known as Dutch poppies, even though the species is native to Britain. These illustrations are from Weinmann's *Phytanthoza* (1734–1747).

Dapaver erraticum mayus roseum margi = albo, sornisofen. b. Papaver erraticum majus pleno margine rubro striato. c. Papaver erraticum us flore rubro pleno, d. Papaver erraticum majus flore primo pleno, e. Papaver erraticum majus rose coloris albis notatum. f. Papaver erraticum majus flore pleno, marginibus rubris g. Papager erraticum majus simplez oris albis notatum.

d

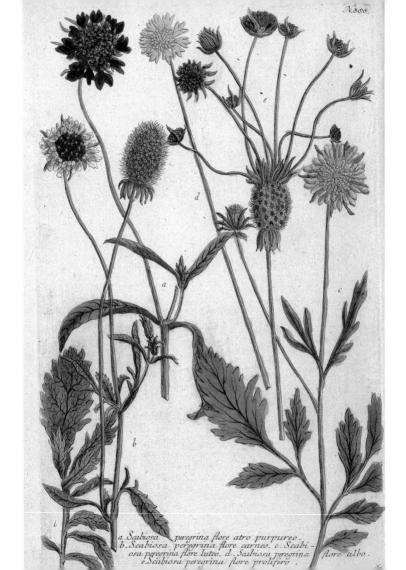

${\mathbb J}$ anacetum coccineum

The pyrethrums (now *Tanacetum*, shown here with a *Lychnis*, centre) were known in England from white- and yellow-flowered forms until the 1850s, when darker seedlings and double forms became available. From the 1860s they were enthusiastically bred, and until recently there were still some two dozen varieties in cultivation, but many have now become unavailable commercially.

SCABIOSA

The first scabious to become known in northern Europe was *Scabiosa atropurpurea*, introduced by Clusius from Italy in 1591. As the illustration here from *Phytanthoza* (1734–1747) shows, variant forms of scabious were eagerly grown in eighteenth-century Germany. *Scabiosa caucasica*, although introduced at the beginning of the nineteenth century, only became widely popular in the twentieth century.

CHAPTER JHREE

EXOTIC garden flowers from *De Koninglycke Hovenier*, an anonymous Dutch gardening treatise published in 1676.

(FRICA

The floral resources of sub-Saharan Africa were slower to register on the European consciousness than those of the Americas. Despite the enthusiasm of early travellers for both the equitable climate of the Cape of Good Hope and its potential as a colony, it was not until 1652 that the Dutch East India Company first set up a permanent settlement at the Cape, to serve as a stopping place for Dutch ships en route to Indonesia. A few South African plants – the first agapanthus, pelargoniums, and nerines – had already been taken to Europe. Yet it was only when Simon van der Stel became Governor of the Cape in the 1670s and started enthusiastically developing the Company's garden, that large numbers of previously unknown plants began arriving in Europe. The botanic gardens of Leiden and Amsterdam became the major centres for the introduction and supply of African plants for the next century.

More than any other category of plants, it was the succulents of South Africa that attracted the notice of the settlers. Partly this was because of their novelty – unlike virtually anything native to Europe – but also because of their potential medicinal value. The aloe, the most important Mediterranean succulent, was a major drug plant, and so the new South African specimens were keenly examined to see if medical benefits could be derived from them.

In the late seventeenth century, when only a small proportion of the American cacti were known, the Mesembryanthemaceae of the Cape constituted the majority of the succulents available in Europe. Even in England there was a greater variety of African succulents ('Hottentot figs') available than of American cacti ('Indian figs'). The first English book on succulents, Richard Bradley's *Historia Plantarum Succulentarum* (1732), described more African than American species. Succulents were a major theme in the glasshouses of early eighteenth-century connoisseurs, and the first British collectors to sample the Cape flora – Francis Masson in 1772, James Niven in 1798, and William John Burchell in 1810 – looked intently for new forms. Masson published a volume entirely on new stapelias, as did Nikolaus von Jacquin at the Vienna Botanic Garden.

Other flowering plants from the Cape were also treated initially as glasshouse exotics. The first kniphofias, or red-hot pokers, arrived in the first decade of the eighteenth century. Meanwhile, the number of pelargonium species gradually increased, and the first Cape lobelias arrived in the 1750s. (None of these plants were used significantly in the outdoor garden until the nineteenth century.)

Later on in the eighteenth century, South African bulbs began to arrive in Europe, and long before the century's end had ousted the succulents from all but the botanic gardens' collections. Zantedeschias (originally called calla lilies or arum lilies), amaryllis, sparaxis, arctotis, crinums, brunsvigias, and the first South African gladioli had all been introduced into England by the beginning of the nineteenth century. These remained plants for the greenhouse and conservatory, but were extensively grown and collected. The artist Priscilla Bury's huge work, *A Selection of Hexandrian Plants* (1831–1834), was effectively a monograph on African bulbs, especially *Amaryllis* and *Crinum*.

These bulbs were joined in European greenhouses in the late eighteenth century by South African species of *Erica* – the Cape heaths. The extraordinary popularity of these plants from the 1780s to the 1860s is difficult to imagine today, as they have largely disappeared from amateur cultivation. In their heyday, however, it was possible for the botanical illustrator Henry Andrews to publish four quarto and five octavo volumes depicting hundreds of species then being grown. Before the end of the eighteenth century, Cape heaths had become the subject of the first sustained programme of deliberate hybridisation, thanks to William Rollisson's nursery in Tooting, which set about crossing the various species they held. Proteas enjoyed something of the popularity of Cape heaths, but without ever reaching such heights of enthusiasm or being significantly bred in captivity.

By the 1840s, the efforts at hybridisation had shifted their focus. William Herbert, Dean of Manchester, a pioneer of the hybridisation of ornamental plants, devoted much of his attention to gladioli in the 1830s and 1840s. In the 1840s Belgian growers developed the

An African aloe from Munting's *Phytographia Curiosa* (1704). There is no agreement among commentators which species of aloe this is. Most African aloes introduced into Europe did not flower in captivity for years, and it is possible that the flowers were drawn from conjecture rather than from knowledge.

Gandavensis hybrids, and the development of new varieties has never ceased since. Gladioli were grown both in greenhouses and in the outdoor flower garden, and during the second quarter of the nineteenth century various other South African plants that were shown to be hardy or half-hardy also moved outside the greenhouse. Sir Joseph Paxton pioneered the bedding of lobelias at the Crystal Palace in the 1860s; kniphofias had to wait until nearly the end of the century before they were drawn into the hybridist's orbit, and nerines until the Edwardian period.

None of these ever attained quite the universality that awaited the pelargonium. The first specimens arrived in Europe in the seventeenth century, and others followed during the eighteenth. By the later years of that century pelargoniums had become popular glasshouse plants, and new species were eagerly collected by connoisseurs. By the 1820s they were being used for summer bedding in the outdoor garden. But most of these pelargoniums were woody-stemmed plants, with a comparatively small amount of flower in proportion to leaf and stem; and nurserymen and amateurs began attempting to cross the more ornamentally flowered with the dwarfer species.

Pelargoniums never suffered the eclipse that wiped out the other bedding plants. They endured the rivalry of tuberous begonias during the last decades of the nineteenth century, and continued to be indispensable plants for the parterre, and for the municipal park, throughout the twentieth century. During the Edwardian period they finally fell from fashion among the horticultural elite. Many nineteenth-century pelargoniums are still commercially available today, and the last third of the twentieth century even saw a revival of zonals, the variegated-leaved forms of *Pelargonium zonale*, which had been the favourites of the 1860s and 1870s. Indeed, as late twentieth-century breeders introduced ever brighter flower colours in begonias and impatiens (the other leading categories of bedding plants in recent years), there was a reaction in favour of pelargoniums, which were seen as less garish.

Other South African plants which arrived during the nineteenth century, but which were

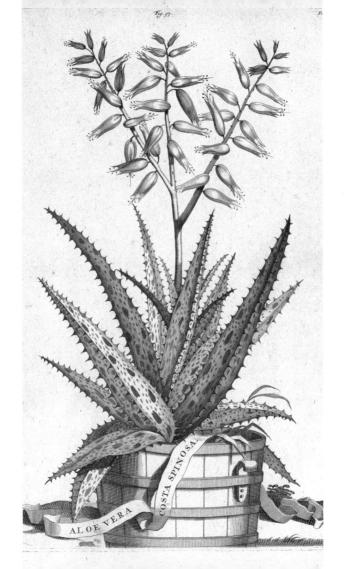

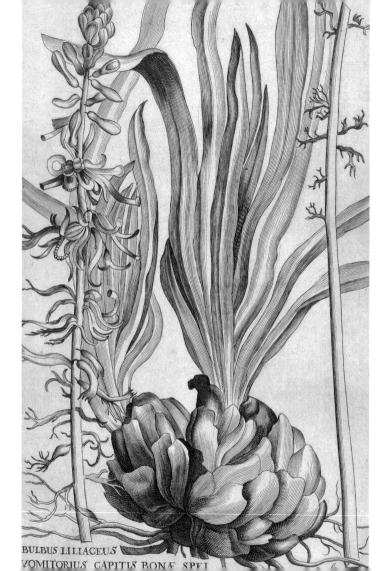

An engraving from Jacob Breyne's *Exoticarum* of 1678, depicting a bulb he received from the Cape of Good Hope in 1678 and succeeded in growing in his garden. It has not been conclusively identified but may belong to the Iridaceae.

never the objects of such cult-like enthusiasm as either Cape heaths or pelargoniums, included *Freesia*, *Schizostylis*, *Crocosmia*, *Gerbera*, *Nemesia*, and *Gazania*. Another addition to this list in more recent times has been *Rhodohypoxis*, which was introduced as long ago as the 1870s, but only began to be valued when rock gardens became popular in the early twentieth century. In the 1860s the plant collector Friedrich Welwitsch added significantly to the stock of desert flora in the 1860s by introducing *Welwitschia mirabilis*, but this curious plant has never been cultivated outside botanic gardens, at least in the United Kingdom.

Tropical Africa has never added greatly to the European garden flora, for obvious climatic reasons; but two genera have become important as greenhouse and indoor plants. *Streptocarpus rexii* was introduced from East Africa in the 1820s, but it was not until a century later that hybrids began to appear, mainly in America. By the late twentieth century it was becoming one of the most popular houseplants. The other genus came to light as a result of German colonisation. In 1892, Baron Walter von St Paul-Illaire sent specimens of a newly discovered plant to Hermann Wendland at the Berlin Botanic Garden. Wendland named it *Saintpaulia* in the discoverer's honour, and, as the last important botanical discovery of the nineteenth century, it made an initial splash in the press. Once again, however, it was not until the 1920s, and again in America, that it attracted the attention of hybridists, and under the vernacular name of African violet achieved popularity as a houseplant.

Finally, the last third of the twentieth century saw a sudden boom in the use of East African species of *Impatiens* as a bedding plant. *Impatiens walleriana*, the busy lizzie, was first grown in England in the 1880s, but was generally ignored in favour of species from the Indian subcontinent until the 1960s, when it began to attract the serious attention of breeders, and several series of cultivars were launched on the market, with a colour range extending from scarlet to white. In the 1990s the African forms of *Impatiens* faced competition from cultivars of New Guinea species, but at the start of the twenty-first century they are still one of the most popular and widely used bedding plants, both in England and America.

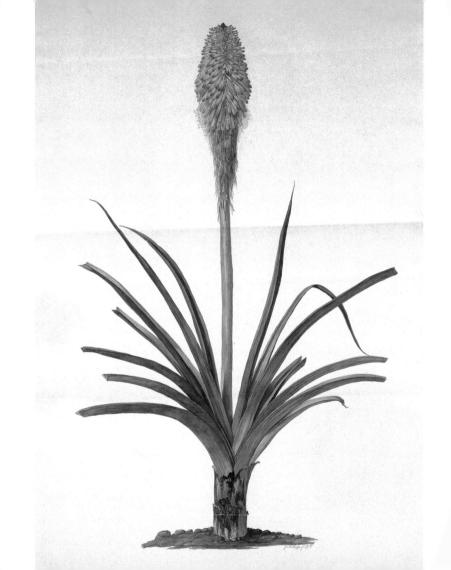

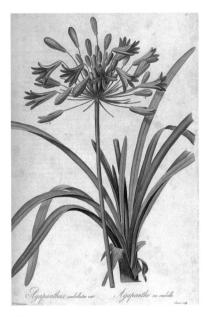

(GAPANTHUS AFRICANUS

Agapanthus umbellatus, now A. africanus, as illustrated here by Redouté, was known to Parkinson in 1629, and once it was distinguished from the crinums, was believed to be the only species. As a result, there were no attempts at hybridisation until the end of the nineteenth century, and it was only in the midtwentieth century that the full range of species became known.

${ m K}$ Niphofia uvaria

The popular name for this flower has shifted from the elegant torch lily to the modern red-hot poker, and the cultivar names have become similarly acerbic: compare 'Star of Baden-Baden', a survivor of the main period of kniphofia breeding associated with Max Leichtlin of Baden, with a modern name like 'Toffee Nosed'. *Kniphofia uvaria* was the first variety to reach Europe, in 1707.

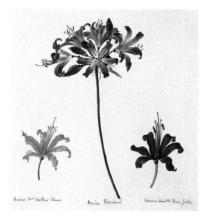

Merine cultivars

The introduction of the nerine has been the subject of much fable and guesswork. It was long thought to be a native of Japan, partly because Engelbert Kaempfer thought he saw it there (what he saw was probably *Lycoris*). By the 1660s it was already being called the Guernsey lily; in fact it arrived from South Africa. Although a cherished greenhouse exotic throughout the eighteenth and nineteenth centuries, little effort was made to breed new varieties until H. J. Elwes embarked on a programme of breeding about the turn of the nineteenth century. The drawings here were made for him by the young Lilian Snelling, who later become the most important British botanical artist of the twentieth century.

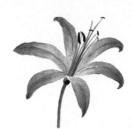

mes Holmes.

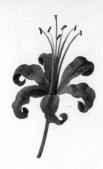

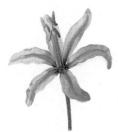

Miss Shelley

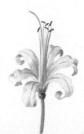

Lady White

Hon. Mrs Bridgeman.

${\mathbb Z}$ antedeschia aethiopica

Zantedeschia was first observed in the late seventeenth century, and introduced into England in 1731. Variously known as the arum lily or calla lily, it became a popular greenhouse and garden plant. Other species have been subsequently introduced, the most important being Z. elliottiana in the 1890s, but it has never been found in the wild and may have been a hybrid. It has certainly been used for hybridising, and today Zantedeschia cultivars with yellow and pink flowers are available, as well as forms with variegated foliage.

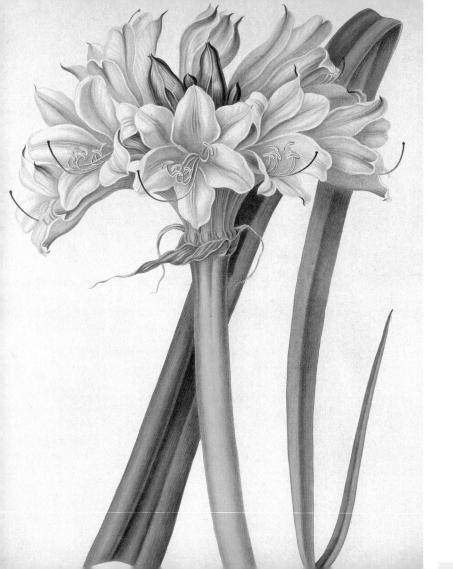

\mathfrak{S} paraxis grandiflora

Various species of *Sparaxis* were introduced into Europe in the eighteenth and nineteenth centuries, when African bulbs were at their height of popularity for greenhouse cultivation. The major early introductions were *Sparaxis fragrans* in 1793 and *Sparaxis grandiflora* in 1803 (illustrated here by Redouté and now considered a subspecies of *Sparaxis fragrans*), but by the 1840s Mrs Loudon could list eleven species grown in England.

CRINUM BULBISPERMUM

Crinum bulbispermum was introduced into England in the 1750s, and grown by Philip Miller at the Chelsea Physic Garden under the name Amaryllis longifolia. Francis Masson collected it in the 1770s and brought it to Kew; by the early nineteenth century it was being offered by several London nurserymen. Various pink-and-white-flowered cultivars can still be obtained today.

AFRICA

CRINUM AUGUSTUM

One of the most popular plant groups for the early nineteenth-century greenhouse was the genus *Crinum*. Species from South Africa, Mauritius, the Indian Ocean islands, and Australasia yielded large white flowers that were eagerly sought after, and filled the pages of Priscilla Susan Bury's *Selection of Hexandrian Plants* in the 1830s. One of the most popular, *Crinum augustum*, first flowered at the Liverpool Botanic Garden in 1829; Mrs Bury's illustration was made from a specimen grown by Richard Harrison of Aigburgh.

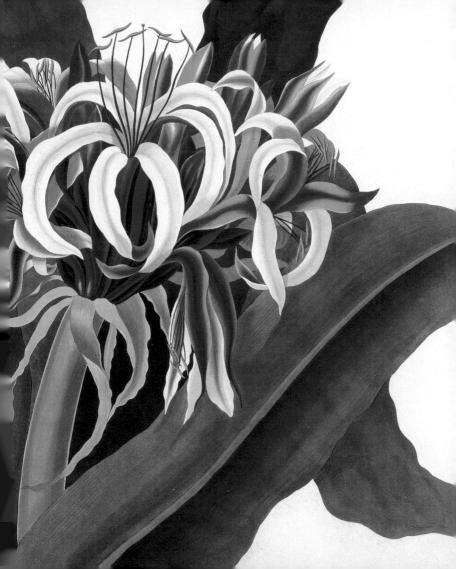

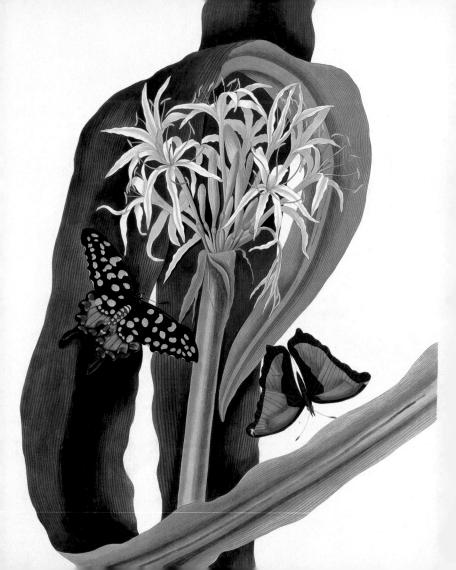

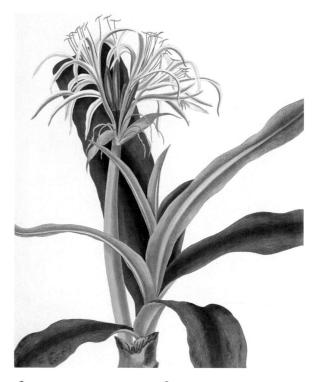

CRINUM PEDUNCULATUM & CRINUM HYBRID

These crinums were illustrated by Priscilla Bury in her *Selection of Hexandrian Plants.* During the 1820s, efforts were made to produce *Crinum* hybrids – the one pictured above was raised by Richard Harrison, but the principal breeders were William Herbert, Dean of Manchester, and the nurseryman Robert Sweet. During the 1830s the popularity of the large-flowered Cape bulbs began to decline, though *Crinum* fared better than its rivals, with more species still extant in the 1850s than of *Amaryllis ot Brunseigia*.

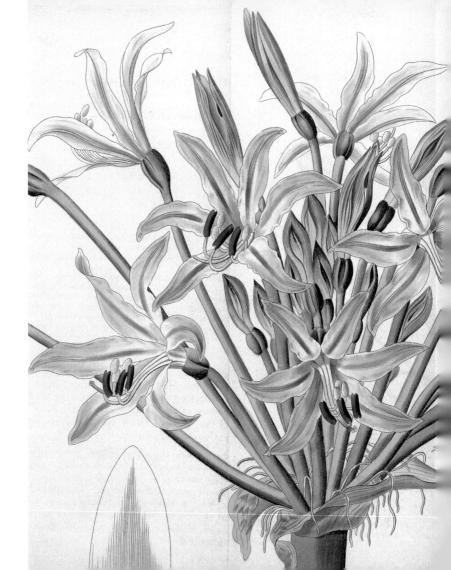

\mathfrak{B} runsvigia grandiflora

Various species of *Brunsvigia* (named in honour of the House of Brunswick) arrived in Europe from the 1750s to the 1820s. They were as popular as those other African introductions *Amaryllis* and *Crinum*, but the large number of cultivated species that had once flourished had greatly diminished by the 1850s. *Brunsvigia* has been crossed with *Amaryllis* to create plants marketed variously as × *Brunsdonna* and × *Amarygia*; and crossed with *Crinum* to produce × *Brunscinum*.

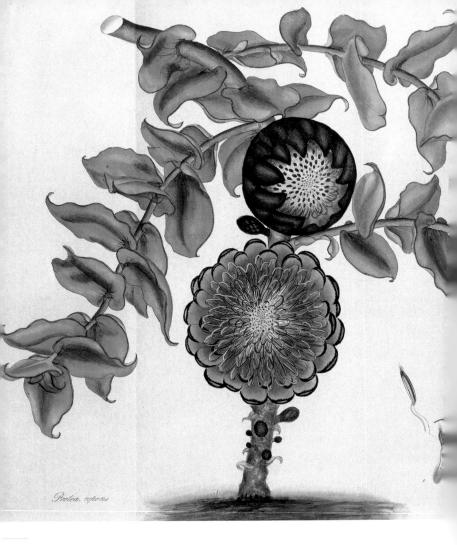

PROTEA REPENS

In Clusius' *Exoticorum* of 1605 there is a report of an 'elegant thistle' collected by a Dutch trader in South Africa a few years earlier. This has since been identified as *Protea nerifolia* – the first South African plant to be described in Europe. Specimens began to arrive in the Netherlands in the seventeenth century, but few in comparison with the flood that swept into Europe in the late eighteenth century through the English collectors Francis Masson and James Niven. Henry Andrews' *Botanist's Repository*, begun in 1797, depicted over 42 species of proteas (some now reclassified into other genera) already known as greenhouse plants, including *Protea reps* illustrated here.

${\mathcal P}$ rotea compacta & ${\mathcal P}$ rotea cordata

The first, and for 150 years, the only book on the cultivation of proteas was published by the Chelsea nurseryman Joseph Knight in 1809. For several decades, proteas flourished in European greenhouses, but by mid-century greenhouse management was changing. Early greenhouses had been heated by hot air, creating a dry environment suitable for proteas, but once steam and hot-water heating came in, greenhouses often became too moist for them, and proteas faded from the English scene. These illustrations of *Protea compacta* (formerly *formosa*) and *Protea cordata* (right) are from a 1797 issue of the *Botanist's Repository*.

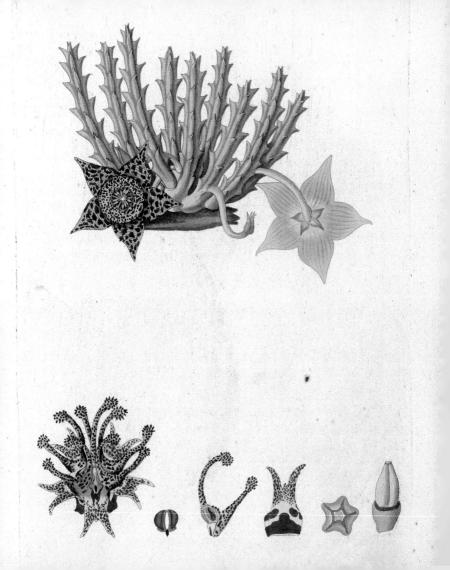

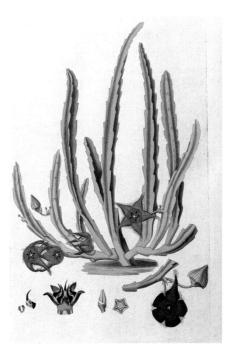

\mathfrak{S} tapelia clypeata & \mathfrak{S} tapelia deflexa

Stapelias were first described in the 1640s as fritillarias – an assigned category that did not last long. Mrs Loudon described them in 1844 as 'curious stove-plants, with showy flowers proceeding from the root, which smell so much like carrion, that flesh-flies have been known to lay their eggs upon them'. Despite this drawback, or even because of it, stapeliads were regarded as exciting curiosities. *Stapelia clypeata* (left) and *Stapelia deflexa* (above) were illustrated for *Stapeliarum in Hortis Vindobonensibus Cultarum Descriptiones* (1806–1820).

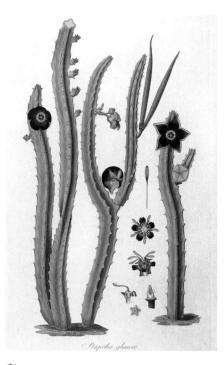

S TAPELIA GLAUCA & S TAPELIA PEDUNCULATA

The only book published by Francis Masson (*Stapeliae Novae*) was devoted to stapeliads – he had collected several species in the 1790s. In 1806 Nicolaus Joseph Freiherr von Jacquin, published a larger monograph, *Stapeliarum in Hortis Vindobonensibus Cultarum Descriptiones*, including these illustrations (*Stapelia glauca*, above; *Stapelia pedunculata*, right).

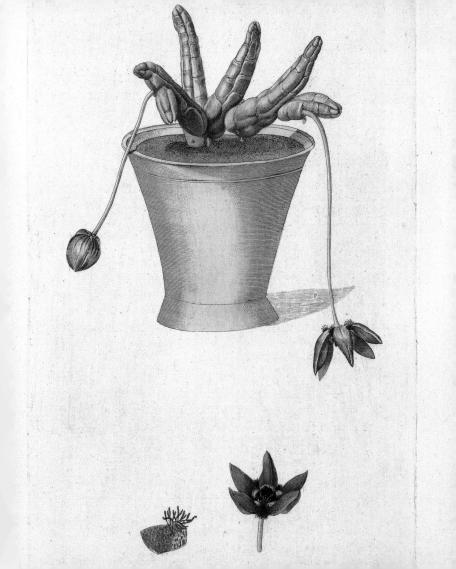

AFRICA

\mathfrak{S} tapelia campanulata

Stapelia campanulata is one of the species of stapeliads collected in South Africa by Francis Masson, and depicted in his book *Stapeliae Novae* (1796–1797).

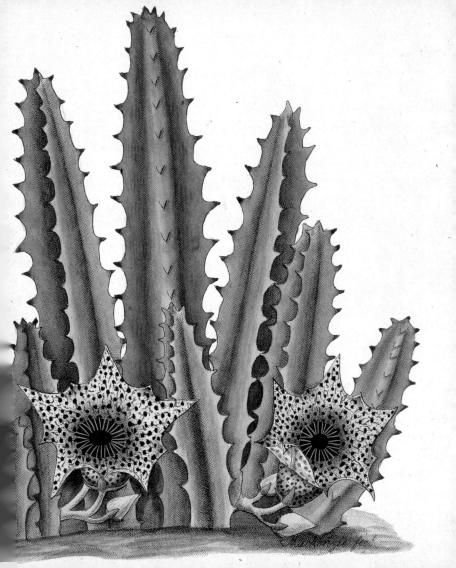

AFRICA

O THONNA BULBOSA

South African Compositae were popular in the seventeenth and eighteenth centuries, albeit not as much as succulents. Species of Arctotis and Othonna were introduced and grown in European glasshouses (this early illustration of *Othonna bulbosa* appeared in *Exoticarum* by Jacob Breyne in 1678). But in the late nineteenth century they languished. There was a short-lived attempt to promote South African annuals as bedding plants in the 1920s and 1930s, and since the 1940s *Arctotis* and *Dimorphotheea* have produced a large range of cultivars. *Othonna* species are still available, but have so far eluded the hybridist.

AFRICA

Lobelia speciosa

African lobelias began to be introduced in the eighteenth century. Lobelia erinus arrived in the 1750s, but was not used as a bedding plant until the 1860s, by which time compact varieties were being produced and marketed under the name Lobelia speciosa. Further cultivars continued to appear throughout the twentieth century; at mid-century, there was an international vogue for using dwarf lobelias as edging plants. Today cultivars can be found in various shades of blue, red, and white.

167

Erica obbata & Erica cerinthoides

Erica cerinthoides (right) was introduced into Europe in 1774, the first of the South African, or Cape, heaths to arrive. The collector Francis Masson was the principal eighteenth-century source, introducing eighty-six species in all; a further fifteen species were introduced between 1796 and 1800 by a young nurseryman named William Rollisson. Cape heaths were to prove one of the most important groups of greenhouse plants throughout the following century.

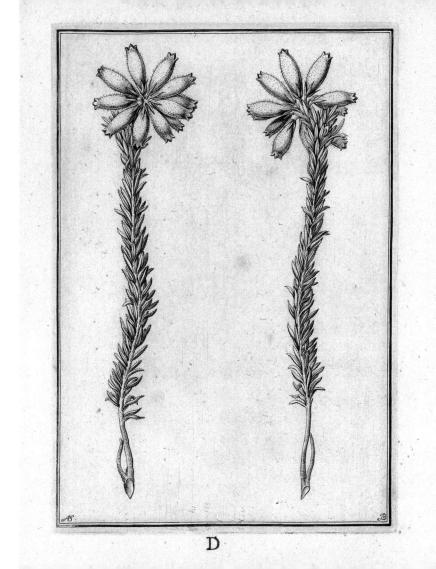

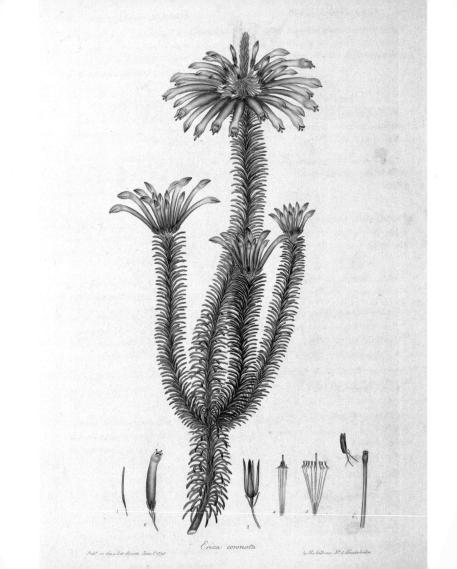

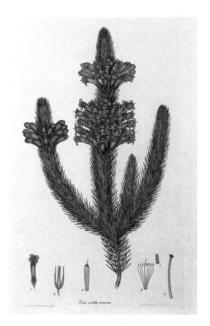

\mathfrak{E} rica coronata & \mathfrak{E} rica vestita

William Rollisson's nursery was established in Tooting, then south of London, in the 1790s, and there Rollisson undertook the first systematic programme of hybridisation of Cape heaths. In 1826 the *Gardener's Magazine* published the record of his breeding programme: 285 varieties, together providing continuous flowering throughout the year. The popularity of Cape heaths began to diminish after the mid-1800s; by 1876 a similar list revealed only 143 varieties, but it was not until World War I that their long occupation of the English greenhouse finally ended. These early illustrations of Cape heaths are from *Coloured Engravings of Heaths* (1794–1830) by Henry Charles Andrews.

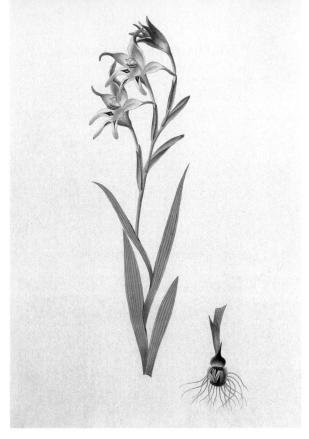

${f G}$ ladiolus carneus

Although European species of gladiolus were being grown in Gerard's time, they were eclipsed by the South African species which began to arrive once the Dutch Cape Colony was established. A red 'Ethiopian' gladiolus was already known in the mid-seventeenth century, but the main flood of species began in the 1740s, and continued unabated into the late 1800s.

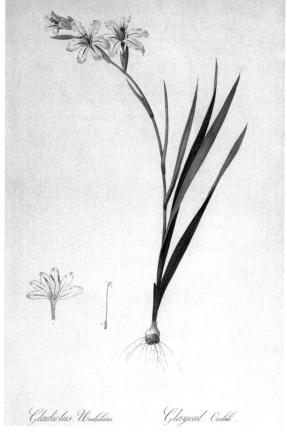

G ladiolus undulatus

William Herbert, the Dean of Manchester, was a pioneer hybridist of ornamental plants. In addition to working on daffodils, crocuses, and amaryllis, he began breeding gladiolus hybrids in the 1820s. Gladiolus cultivars have spread through European and American gardens for nearly two centuries now.

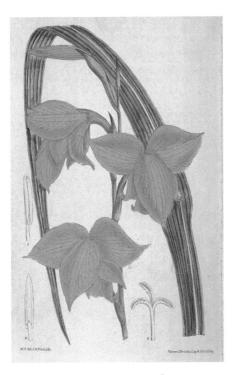

${f G}$ ladiolus primulinus & ${f G}$ and avensis hybrid

The first great successes of gladiolus breeding were the Ghent gladioli, or Gandavensis hybrids, first launched in 1842 by the nurseryman Louis Van Houtte. These were rivalled by the English Brenchleyensis hybrids from 1848, the French Lemoinii hybrids in the 1880s and the Childsii hybrids, originally bred by Max Leichtlin of Baden, but taken to America and continued there by John Lewis Childs. *Gladiolus primulinus* (above) was re-introduced in 1904 (having arrived in 1887 but been lost), and the subsequent Primulinus hybrids became the early twentieth century's major line of development.

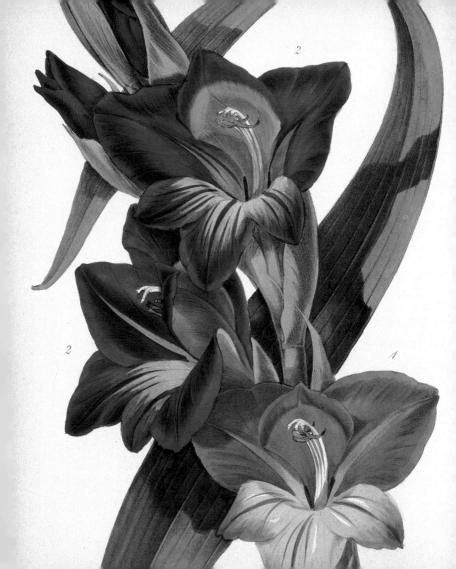

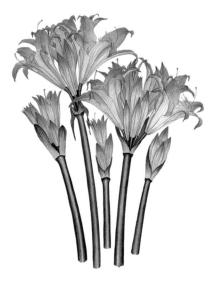

(MARYLLIS BELLADONNA

There is much confusion over the name *Amaryllis*; most of the plants marketed under that name today are South American, and officially assigned to the genus *Hippeastrum*, leaving *Amaryllis* for the South African species. They were very popular in the early nineteenth century, and hybridised by William Herbert and others; Robert Sweet listed 175 hybrids in the 1830s.

${\it g}$ ladiolus primulinus hybrids

The nursery firm of James Kelway, of Langport, Somerset, began using *Gladiolus primulinus* in hybridisation, creating a group of Langprim cultivars, but these were overshadowed by the Primulinus hybrids created by the nurseryman Frank Unwin, which in the 1920s were accepted as the standard for the group in Britain. Primulinus hybrids proved less popular in America, where small-flowered plants called Miniatures became the leading trend up to the 1940s.

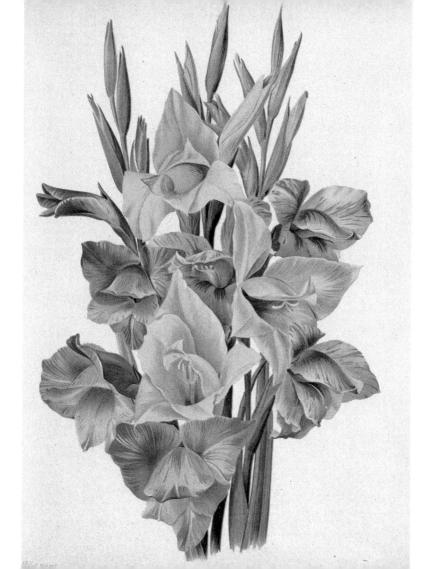

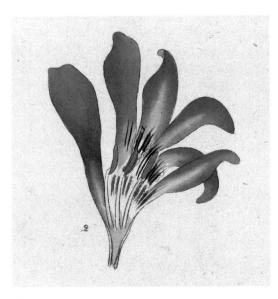

${\mathfrak B}$ abiana nana

Originally described by Henry C. Andrews as *Gladiolus nanus*, this plant was transferred in the 1820s into the genus *Babiana*, which had been created in a reform of the classification of African irises. *Babiana* shared in the period enthusiasm for *Gladiolus* and *Ixia*, with which they were often confused.

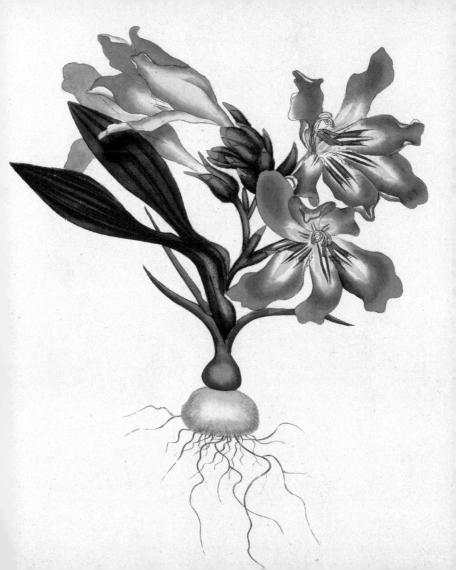

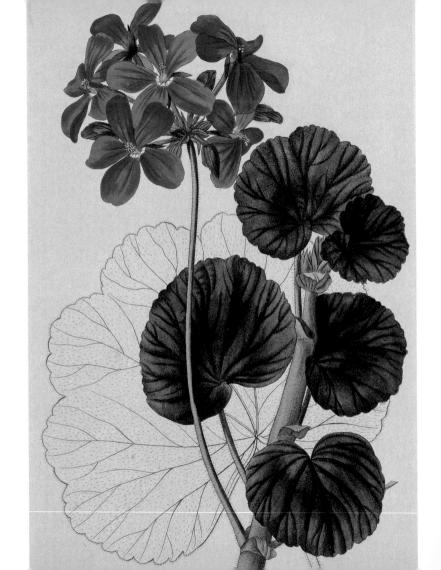

$\mathcal{P}_{ ext{elargonium triste \&}}$ $\mathcal{P}_{ ext{elargonium inquinans}}$

Pelargonium triste (above) was illustrated in the 1630s, and had become a greenhouse plant by the end of the century; *P. peltatum* was introduced in 1701, and *P. sonale* in 1710. The name *Pelargonium* was coined by the French botanist Tournefort, but Linnaeus collapsed it into the genus *Geranium*, from which it re-emerged in the 1790s. By that time the English had learned to call them geraniums, and have never abandoned the habit.

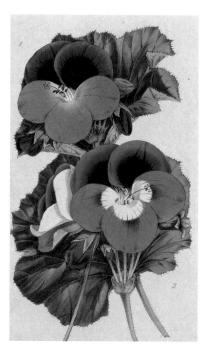

${\mathcal P}$ elargonium cultivars

The early pelargoniums used in British gardens were tall plants with woody stems and a small proportion of flowers. By the 1830s the race was on to breed varieties that were dwarfer, suitable for summer bedding, with a higher proportion of flower to foliage. 'Tom Thumb', the first true bedding pelargonium, was marketed in 1844, and by the 1860s pelargoniums had become the most important of bedding plants. They never suffered an eclipse as great as did petunias and verbenas, and some Victorian cultivars are still extant.

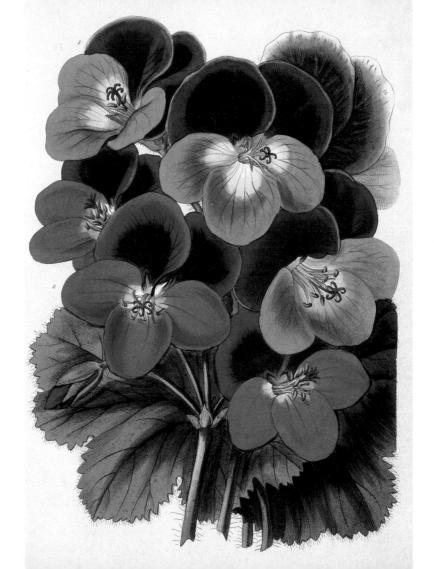

GAZANIA SPLENDENS

Gazania rigens was introduced in 1755, and in the mid-nineteenth century various cultivars, marketed as Gazania splendens (depicted here with Callicarpa dichotoma), were used for bedding. Their use declined in the early twentieth century; in fact, as recently as the 1950s, no cultivars were listed in English books on annuals. Today, an ever-increasing number of gazania cultivars for bedding hits the market every year, mainly in yellow, pink, and white, though greens and pale purple have recently been added to the range.

Gerbera jamesonii

Gerbera jamesonii was introduced into Europe in 1887. In the 1920s, French nurseries began to breed double forms, but since the 1940s American and Australian firms have been the leaders in developing new cultivars and extending the colour range. Most gerbera production until recently was directed at the cut-flower trade, but in the 1980s new short-stemmed cultivars were produced in Japan, and a new market has opened up for gerberas as plants for containers.

AFRICA

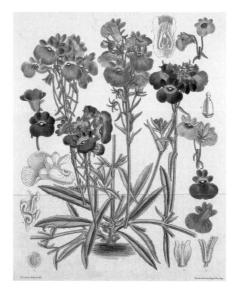

Memesia strumosa

The first *nemesia* to be exhibited at the Royal Horticultural Society, in 1892, won an Award of Merit, but the production of garden forms was slow. During the 1930s, South African annuals, most notably *Nemesia* and *Dimorphotheea*, were promoted for municipal bedding schemes in Britain. Since then, *nemesias* have been extensively hybridised. They were originally orange, but red, yellow, white, and purple *nemesias* have been developed, as have bi-coloured flowers.

Crocosmia aurea

Crocosmia took longer to arrive in Europe than the other South African bulbs, because it does not grow at the Cape of Good Hope, but further inland. *Crocosmia aurea* was introduced in 1846, as *Tritona aurea*, and assigned to the new genus in 1851. The first hybrids made by Victor Lemoine, at Nancy in the 1880s, were marketed as *Monthretia crocosmiaeflora*, and hybrid forms are still widely known as monthretias.

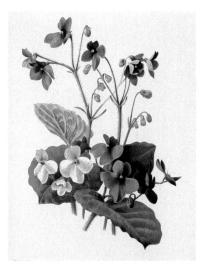

\mathfrak{S} aintpaulia cultivars

In 1893, the German magazine *Gartenflora* published the first account of a plant discovered in Tanganyika the previous year, and christened *Saintpaulia ionantha*. It was not until after World War I that the Californian nursery of Armacost and Royston began breeding hybrids, marketed as African violets. Other nurseries produced the first double flowers in 1939, and the first pink flowers in 1940. Several hundred cultivars emerged in the second half of the twentieth century.

FREESIA CULTIVARS

Freesia refracta was introduced in 1816, and further species followed. Max Leichtlin, the Baden nurseryman, was a pioneer in hybridising freesias in the 1860s, but they did not achieve wide success until the firm of Van Tubergen began breeding in 1901. By the mid-twentieth century there were nearly fifty varieties on the market, with a colour range of white, yellow, red, and purple.

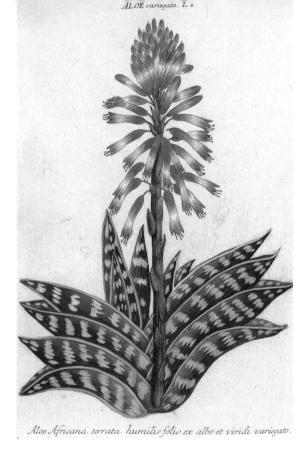

CLOE VARIEGATA

Alor variegata was one of the first African aloes to be grown in Europe, with seeds sent to the Netherlands about 1700. While much of the early interest was medicinal -Alor vera had long been used for medical purposes in Europe - it also suited the fashion for succulents. By the beginning of the nineteenth century, Adrian Hardy Haworth was able to list over twenty species and varieties in his collection.

ALOE SAPONARIA

Aloe saponaria, formerly called Aloe disticha, or the 'Great Soap Aloe' as it was known in the early nineteenth century, is one of the most variable of the spotted aloes, and has produced various natural hybrids in addition to those bred in cultivation. It was being grown in Holland and Germany at the beginning of the eighteenth century.

CHAPTER FOUR

THE SUNFLOWER (*Helianthus annuus*), as shown in *Hortus Floridus* in 1614, by which time it was already a familiar garden plant.

THE AMERICAS

hen the first Spaniards arrived in Mexico, they discovered that the Aztec capital contained vast gardens 'laid out in regular squares, and the paths intersecting them were bordered with trellises, supporting creepers and aromatic shrubs ... The gardens were stocked with fruit-trees, imported from distant places, and with the gaudy family of flowers which belong to the Mexican Flora, scientifically arranged ... Such are the accounts transmitted of these celebrated gardens, at a period when similar horticultural establishments were unknown in Europe.' So wrote W. H. Prescott in his *History of the Conquest of Mexico* (1843). The suspicion has lingered ever since that the first European botanical gardens, established in the 1540s, were inspired by the Aztec achievement.

American succulents were the first plants from the New World to attract widespread attention (soon followed by tobacco). Columbus recorded having seen what he thought were aloes in the Caribbean, and Camerarius recorded an American aloe (*Agave americana*) flowering in the botanic garden at Pisa in 1583. The conquest of Mexico in the 1520s resulted in specimens of aloe, dubbed 'Indian figs' (because their swollen stems were likened to the shape of figs), being sent to Europe.

The Spanish territories in Mexico were also the source of various herbaceous plants, among them *Tagetes*, the 'French' and 'African' marigolds; *Lobelia cardinalis*, the cardinal flower; and the first evening primroses. But the most important, in terms of garden popularity, were the tuberose and the sunflower. *Polianthes tuberosa* arrived as early as the 1620s, and by the end of the century had become one of the most widely used garden flowers in France, the subject of many parterres in the age of Louis XIV. *Helianthus annuus*, the giant sunflower, was introduced in the sixteenth century, and attracted attention not only for its size but for its diurnal motion.

By 1597, John Gerard in England knew the marvel of Peru (*Mirabilis jalapa*) and tomatoes, or love apples, which he treated as an ornamental plant. By 1629, John Parkinson was reporting on English gardeners growing *Tropaeolum minus*, 'French' or 'African' marigolds, daturas,

Canna indica, opuntia or prickly pear, and passionflowers. The first time a passionflower flowered in Europe was at the Farnese gardens in Rome in 1619–1620. By 1629, Parkinson had seen passionflowers in England; by the late eighteenth century, several species were available in European glasshouses. The main point of introduction into Europe for Latin American plants in the late eighteenth century was the nursery of Lee and Kennedy in Hammersmith. It was responsible for distributing the first dahlias, fuchsias, and zinnias in the 1780s and 1790s. The other single most important garden introduction from South America in the eighteenth century was *Heliotropium perucianum*, discovered by the French botanist Joseph de Jussieu in the 1730s.

The first decade of the nineteenth century saw one of the most important scientific expeditions of all time: Alexander von Humboldt and Aimé Bonpland travelled through Mexico, Central America, and Colombia, bringing back with them new concepts of geography, and a host of plants. These included *Lobelia splendens*, *Lobelia fulgens*, and several dahlias. The empress Joséphine had been one of their sponsors, and it was through her that dahlias finally burst on the European world. By the 1830s, dahlia frenzy was approaching the tulipomania of two centuries earlier.

Spanish control over South America was broken by the rebellions of the early nineteenth century. The way was now clear for collectors to explore the Andes, the Amazon, and Argentina. John Miers, Alexander Cruckshank, Hugh Cuming, Robert Schomburgk, James Tweedie, and William Lobb were among the plant hunters who made reputations by introducing South American plants to Europe. The most celebrated discovery was the giant Amazonian waterlily, *Victoria regia* (now *Victoria amazonica*), which Schomburgk found in the 1830s. Gardeners from the Royal Botanic Gardens at Kew and the Duke of Devonshire's estate at Chatsworth raced to cultivate the first flowering specimen. Joseph Paxton, the Duke's celebrated gardener, won, and built a special glasshouse for the plant (the prototype of the Crystal Palace).

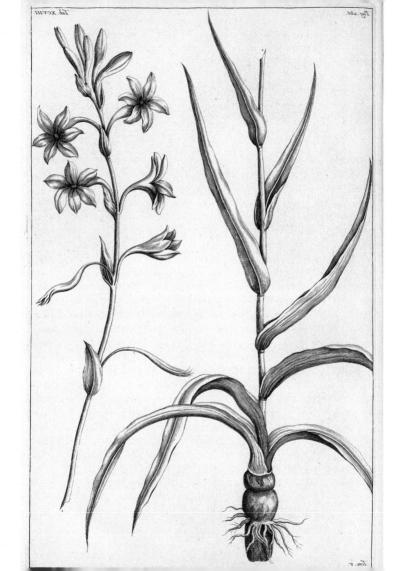

Canna indica, as depicted in the *Herbarium Amboinense* of Rumphius (Georg Eberhard Rumpf), an early flora of part of Indonesia. Cannas had been introduced into the Far East from America by the Spaniards in the sixteenth century, and were taken to be part of the local flora by visiting Europeans.

Three of the four most successful garden flowers of the nineteenth century were from South America (the fourth, the pelargonium, was South African). The first calceolarias had been introduced from Peru in the 1770s, but it was not until the 1820s that a range of species arrived and attracted attention. In the same decade, *Petunia nyctaginiflora* and *integrifolia*; *Salvia splendens, fulgens*, and *patens*; and *Verbena peruviana* and *incisa* were also introduced. The 1850s saw petunias, verbenas, and calceolarias, together with pelargoniums, effectively take over the *parterre* – that portion of the flower garden that could be seen from the windows of the house. Hundreds, if not thousands, of varieties were launched on the market, and all have now disappeared from cultivation. The last wave of South American plants to make an impact in the garden were grown for their foliage, and carpet bedding, the use of low-growing foliage plants to create patterned beds, was the horticultural fashion of the 1870s.

The North American flora did not have the same initial impact in Europe as Central and South American flora had in the Renaissance. In part this was because of the slower pace of exploration and colonisation in the north. Exploration in the sixteenth century was sporadic, and the first permanent colony was established in Canada in 1608. The English had already set up the Virginia Company (named in honour of Elizabeth, the Virgin Queen) to explore and settle any portions of the continent not already claimed. But it was not until the 1620s that British settlement of the eastern seaboard began in earnest. Among the first floral products of the Virginia Company were *Rudbeckia* and *Tradescantia*, which reached England via the celebrated gardener John Tradescant the elder. His son travelled to America and brought back *Yucca filamentosa* in the 1630s. Even so, throughout the first half of the seventeenth century North American plant exports were vastly outnumbered by South American ones. This began to change in the 1670s, with the decline of the Spanish economy and the boom in North American trade. American trees and shrubs began to arrive in Europe.

Paris, the major point of introduction in the first half of the seventeenth century, began to yield to London, where collectors like Bishop Compton at Fulham Palace, and distributors

THE AMERICAS

Shown opposite is the sort of passionflower illustration that circulated before the plants were actually grown in Europe: an idealised view which exaggerated the characteristics that were believed to symbolise the passion of Christ.

like the wealthy woollen-draper Peter Collinson at Mill Hill, welcomed the new introductions. But, while American dogwoods, arbutus, stewartias, amelanchiers, and eventually buddlejas, were the collectors' key concern, other plants arrived too. The early eighteenth century saw the introduction of *Dodecatheon meadia*, *Aster novae-angliae*, oenotheras and more *rudbeckias*. *Erigeron philadelphicus* and *macranthus*, *Allium cernuum* and the first American phloxes followed later in the century. The minister John Banister, the naturalist Mark Catesby, and the botanist John Bartram sent large numbers of new species from the British colonies. Bartram alone contributed *Phlox divaricata*, *Phlox maculata*, *Monarda didyma*, and *Lilium superbum* in the mideighteenth century.

By the end of the century the term 'American plants' had taken on a specific meaning: the flowering shrubs associated with eastern American peaty swamps – rhododendrons, azaleas, kalmias or mountain laurels, andromedas, magnolias, and the like. Meanwhile, the expansion of the new United States led to the botanical exploration of the lands west of the Mississippi. Lewis and Clark's expedition of 1804 resulted in the discovery of *Gaillardia aristata, Mimulus luteus, Calochortus* and *Clarkia elegans*, and *Erythronium grandiflorum*, and in the 1810s botanic gardens began to flourish in America. In the 1820s the Horticultural Society of London sent David Douglas as a plant collector on three journeys to America. He introduced over 200 plants into England and, in addition to the conifers for which he is famous (the Douglas fir being named in his honour), he brought back *Mimulus moschatus, Lupinus polyphyllus, Clarkia elegans*, and *Eschscholzia californica*.

American annuals flooded into England between the 1820s and 1840s, providing much of the plant selection in the early, experimental days of the bedding system. But by the 1850s the rate of introductions from America was declining. The remainder of the century saw additions to the ranks, but no new discoveries of new genera for the flower garden. The exception was succulents, which in the twentieth, and on into the twenty-first, have returned to popularity, more than five centuries after they first caught the imagination of european gardeners.

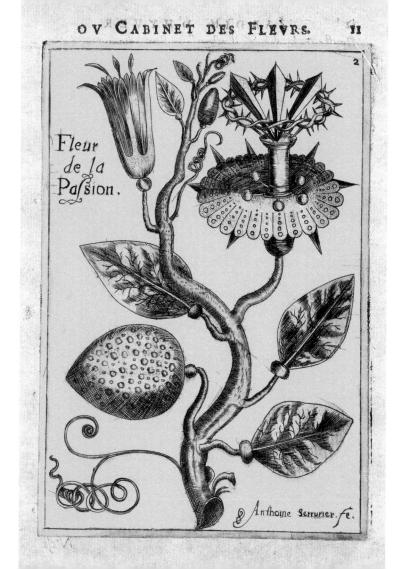

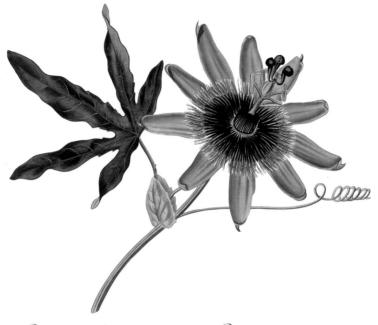

${\mathcal P}^{ m assiflora}$ caeruleo-racemosa & ${\mathcal P}^{ m assiflora}$ × caerulea

In 1577, Nicolas Monardes' account of the economic products of the American colonies was translated into English under the title *Joyfull Newso out of the Newe Founde Worlde*. It included an account of the 'maracot' plant in which the structure of the flowers was compared to the passion of Christ. The style was likened to a whipping post; the stigma, three nails; the corona flaments, a crown of thorns; ten petals and sepals, ten disciples present at the crucifixion; 'all as true as the Sea burnes', as Parkinson said. Interest was provoked by exaggerated representations of the plant, and it was not until 1620 that a living plant flowered in Europe, in the Farnese gardens in Rome. Within a decade it was being grown in England, and other species followed throughout the eighteenth century. The first hybrid, *Passiflora × caeruleo-racemosa* (above), was grown in 1820 by the Fulham nurseryman Thomas Milne.

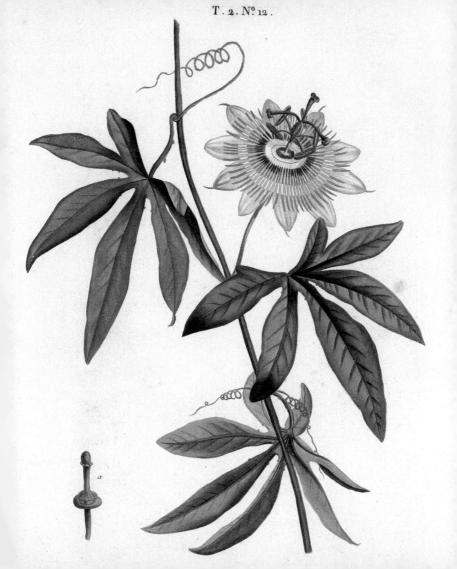

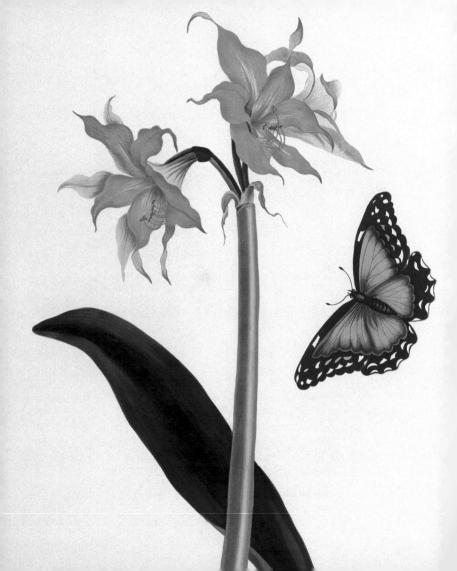

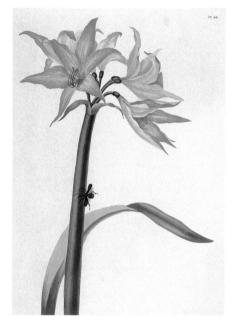

H IPPEASTRUM STRIATUM

A seemingly endless nomenclatural controversy hangs over the name Amaryllis. Various South American plants originally included in this genus were separated and classed as Hippeastrum by William Herbert in 1821. But generations had become accustomed to thinking of them as Amaryllis, and throughout the twentieth century the American Amaryllis Society continued to condemn Hippeastrum as an invalid name. It has been argued that Linnaeus actually had the American plants in mind when he coined the name Amaryllis. These illustrations of Hippeastrum striatum are from A Selection of Hexandrian Plants (1831–1834) by Priscilla Bury.

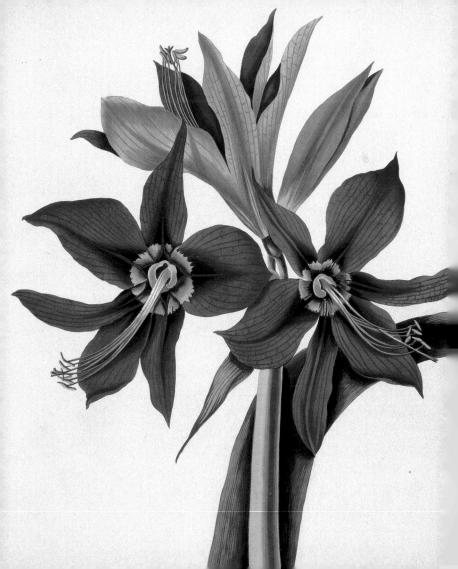

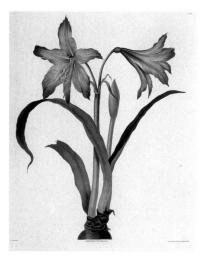

Hippeastrum aulicum & Hippeastrum psittacinum

Hippeastrum species flowed into England in the late eighteenth and early nineteenth centuries, and Liverpool became a showcase for the new introductions – H. psittacinum (above), first flowered there in 1813. The first hybrid hippeastrum had been produced in 1799 by a watchmaker named Arthur Johnson: a cross between H. vittatum and H. reginae. By 1839, the third edition of Robert Sweet's Hortus Britannicus recorded sixty-three species and seventy-nine cultivars being grown in British gardens – or greenhouses.

${{{\mathbb F}}}$ uchsia magellanica

The fuchsia was named by Charles Plumier in 1693, in honour of the pioneering sixteenth-century botanist Leonhard Fuchs. It was not until about 1790 that *Fuchsia magellanica* was introduced into cultivation. Several more species arrived between 1820 and 1850, notably *F. fulgens*, introduced from Mexico by the Horticultural Society's collector Theodor Hartweg; this became the ancestor of the modern hybrid fuchsia, initially through the English breeder James Lye, from the 1860s to the 1890s, and then Victor Lemoine of Nancy at the turn of the century.

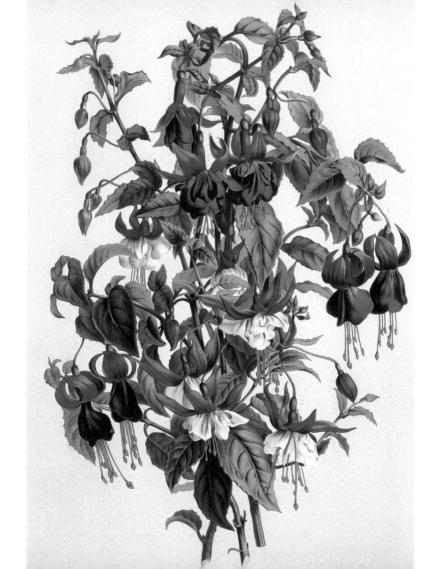

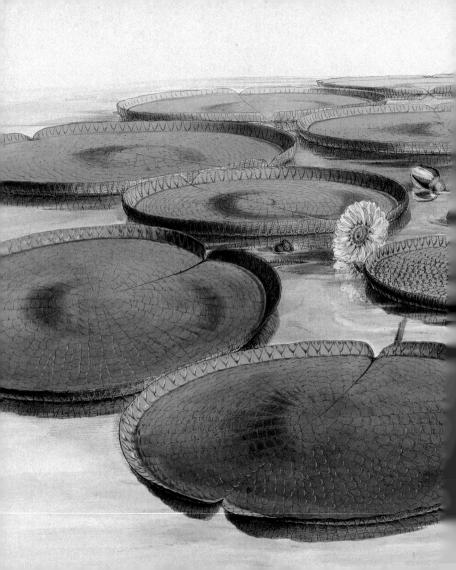

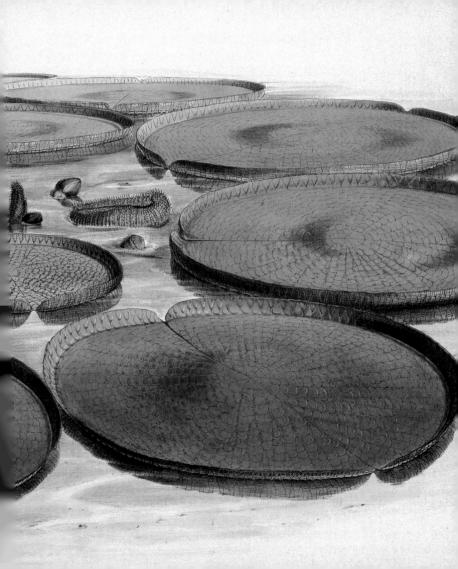

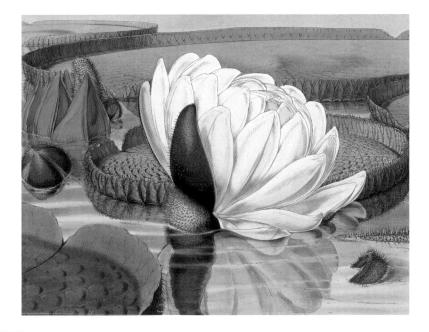

🕐 ICTORIA AMAZONICA

In 1838, the collector Robert Schomburgk introduced the largest water-lily ever seen, and John Lindley named it *Victoria regia* in honour of the Queen (but it had already been described, and *V. amazonica* is now the correct name). In 1849, Kew and Chatsworth competed to see who could flower it first; Chatsworth won, and the head gardener, Joseph Paxton, built a pioneering glasshouse to accommodate it. *The Illustrated London News* for 17 November that year carried an illustration of Paxton's daughter Annie standing on a floating leaf to demonstrate its sturdiness, and most later growers of victorias felt compelled to duplicate the feat. Walter Hood Fitch illustrated *V. amazonica* (previous page, opposite, and below) in Sir William Jackson Hooker's volume entitled *Victoria Regia* (1851).

${\mathfrak B}$ uddleja globosa

The buddleja was named after the early eighteenth-century English botanist Adam Buddle. *Buddleja globosa* was introduced in 1774 by the Kennedy and Lee Nursery in Hammersmith, at first as a greenhouse plant. Because of doubts as to its hardiness, *B. globosa* was never grown as extensively as the later purple-flowered introductions, but its unique orange flowers were always admired.

Calceolarias

The first calceolarias reached England in the 1770s, but the more ornamental Peruvian and Chilean species had to wait until the 1820s: *C. corymbosa* and *C. integrifolia* in 1822, *C. biflora* in 1826, *C. bicolor* in 1829. George Penny of the Milford Nursery produced the first hybrids, and from the mid-1830s calceolarias became an undeclared florists' flower, with colour variations in stripes, dots, and patches cagerly sought.

CALCEOLARIAS

Calceolarias were leading a double life by the 1850s. On the one hand, new hybrids were developed that increased the size of the bubble and the complexity of the colour patterns, to make decorative plants for the greenhouse and show bench. On the other, flowers with solid colour began being used for bedding in the 1840s. The opening of London's Crystal Palace Park in 1854 saw calceolarias join pelargoniums, petunias, and verbenas as the major bedding plants of the period. In the twentieth century they underwent a catastrophic decline, and none of the nineteenth-century cultivars now survive, though new equivalents of the florists' calceolaria have begun to appear again as F1 Hybrid Bubbles.

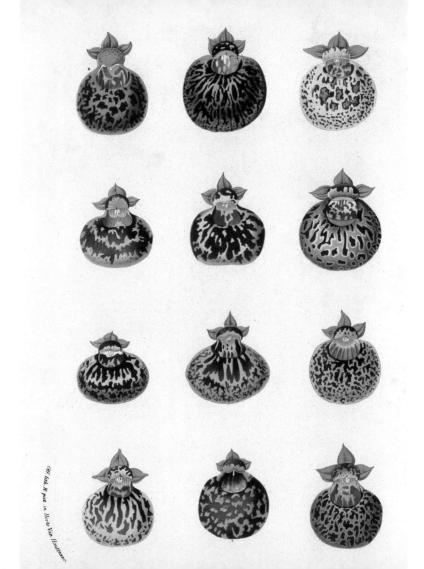

${\mathscr P}$ etunia cultivars

The first petunia to be discovered was *Petunia nyctaginiflora*, in 1823, and as early as 1830 Robert Mangles was experimentally using it as a bedding plant. *Petunia violacea* followed in 1831, and the first hybrids had been raised by 1837. From then until the 1870s, petunias were one of the four main categories of bedding plants in Britain, but in the later years of the century their use declined, as they proved unreliable in the British climate. None of the Victorian bedding petunias survives today. These two cultivars, shown with the smaller Achimenes, were illustrated by Charlotte Caroline Sowerby.

() ERBENA CULTIVARS

The first South American verbena to be introduced was *Verbena bonariensis*, in 1726, but it was a group of species arriving in the 1820s and 1830s that attracted the attention of gardeners: *Verbena incisa* in 1826; *V. peruciana* in 1827; and in 1834. By 1837 verbenas were successfully being used for hybridisation, and joined petunias as bedding plants of primary importance. They were phased out of bedding late in the nineteenth century, but, after Henry Eckford developed a strain with a white 'eye' in the centre, verbenas enjoyed a second lease of life as plants for the border.

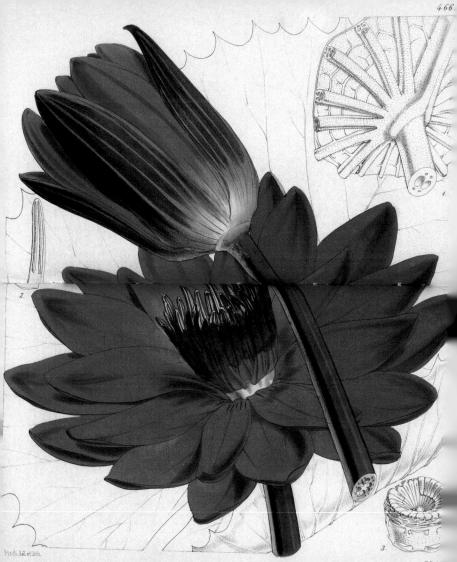

CANNA INDICA

Cannas reached Europe about 1570, but were also extensively grown in the East Indies. The first attempts to produce hybrid cannas took place in France in the 1840s, and focused on foliage. As a result, cannas were long treated as foliage plants in England. Production of flowering hybrids began in the late 1850s, again the work of French nurserymen like Crozy and Sisley at Lyon, Lemoine at Nancy and Vilmorin in Paris.

${ m Jhe}$ duke of devonshire's hybrid nymphaea

The first hybrids of tropical water-lilies, like this one bred at Chatsworth in the 1850s, were confined to glasshouses. Then, in 1891, the *Revue Horticole* announced that Joseph Latour-Marliac, a nurseryman at Temple-sur-Lot, had succeeded in growing hybrids that were hardy outdoors, using the American species *Nymphaca flava* and *N. tuberosa*.

${\mathbb G}$ unnera scabra

The last of the big foliage discoveries, and the one that lasted longest as a feature in the outdoor garden, was the gunnera. *Gunnera manicata* was discovered in 1867 by the Belgian nurseryman Jean Linden, and quickly superseded the smaller species that had previously been known (such as *G. scabra*, now *G. chilensis*, introduced about 1850). Long after the demise of subtropical gardening, gunnera continued to hold a place in the wild and water gardens of Britain and Europe.

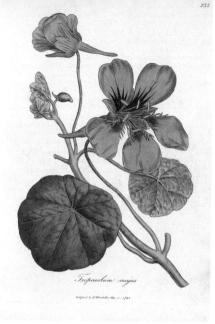

\mathfrak{J} ropaeolum majus

The principal species of garden nasturtium arrived in England in the sixteenth and seventeenth centuries. The yellowflowered *Tropaeolum minus* was known to Gerard; *Tropaeolum majus* was available by 1690; and the first double-flowered forms appeared in Italy in the 1760s. *T. lobbianum* (now *T. peltophorum*) was introduced in 1843, becoming popular later in the century.

$\mathcal P$ olianthes tuberosa

The tuberose was introduced into Europe in 1629, and by the second half of the century had become one of the most esteemed garden flowers, for its scent as much as for its beauty. Louis XIV placed orders for thousands of tuberoses at a time for the gardens at the Trianon, where they filled the flowerbeds.

THE AMERICAS

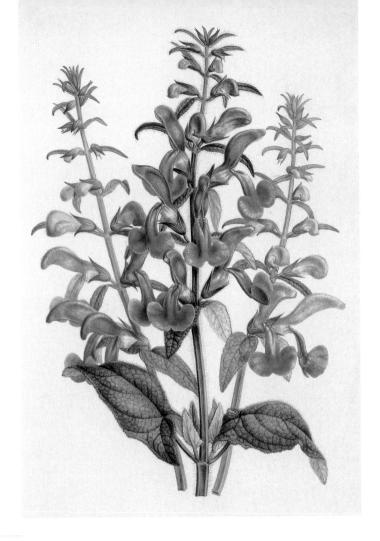

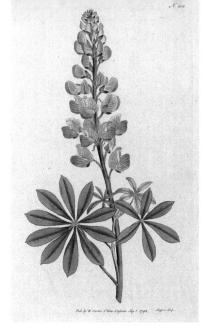

$\mathfrak{L}^{\mathrm{upinus\ perennis}}$

Lupinus perennis was the first American lupin to be introduced into Europe, possibly by John Tradescant, who certainly listed it in the 1650s. Lupinus arboreus emerged from Captain Vancouver's expedition in 1792, and David Douglas introduced Lupinus polyphyllus in 1826.

SALVIA PATENS

Although Salvia coccinea had been sent to Europe as early as 1774 by John Bartram, it was the more ornamental Salvia fulgens from Mexico, and Salvia splendens (1822), that attracted notice and became used as bedding plants. Salvia patens was introduced in 1838 as a greenhouse plant. The famous blue bedding forms, most notably 'Cambridge Blue', only emerged in the twentieth century.

\mathfrak{J} radescantia virginiana

Whether or not John Tradescant introduced the plant named after him, it had entered English gardens by 1629. A very variable species, it came to boast named varieties with white, red, blue, purple, and pink with touches of yellow. E. B. Anderson proposed in the 1930s that the range of variation was a consequence of natural hybridisation, and in his honour the cultivars were grouped together as *Tradescantia × andersoniana*; but later botanists found no evidence that tradescantias hybridise readily in the wild, and that group name has been discontinued in favour of the more neutral Virginiana hybrids.

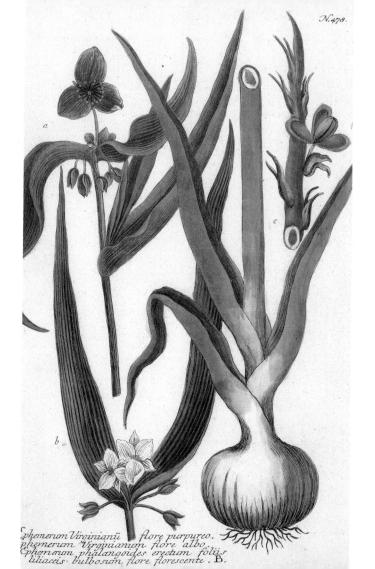

Helianthus annuus. Tährige Sonnenblume. Ok.749.

Jab.551.

THE AMERICAS

\mathcal{H} elianthus annuus

Nicolas Monardes, who had been the first to describe the passionflower, also first described the sunflower. It quickly reached England, and John Gerard claimed in 1597 that he had grown a specimen to the height of 14 feet. By the 1730s, Philip Miller, at the Chelsea Physic Garden, claimed to know seven varieties of the giant sunflower, some so common that many people took them for native plants.

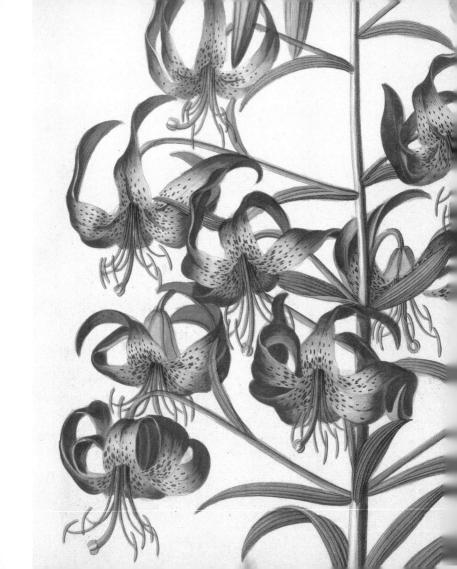

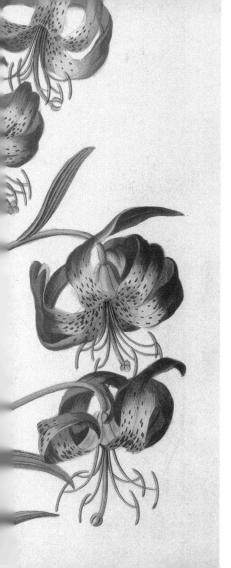

Silium superbum

The first American lily of importance, *Lilium* superhum was collected by Mark Catesby in 1738 and distributed in England through Peter Collinson. It may have become known earlier; Thomas Hanmer's reference in the 1650s to a 'Red Virginia spotted with brown spots' may indicate a previous introduction that was subsequently lost. Despite the spectacular introductions from China and Japan in the nineteenth century, it never lost its popularity as a garden plant. This illustration by Georg Dionysius Ehret is from *Plantae Selectae* (1750–1765).

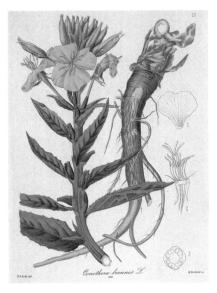

\mathfrak{O} enothera biennis

The evening primrose reached Europe in the 1610s, first becoming known as the 'tree-primrose'. Because it could endure the smoke of London, it became a popular plant for urban gardens, and eventually something of a weed. Various additional species were introduced in the eighteenth and nineteenth centuries, giving a range of purple, white, and yellow flowers.

(STER NOVAE-ANGLIAE

The name 'Michaelmas daisy' was attached to American asters from an early period. The younger Tradescant introduced *Aster tradescantii* in 1637, but the major species were *Aster novi-belgii* (1680s), from what was then New Holland but is now New York, and *Aster novae-angliae* (1710s), after the former Dutch colony had been swallowed up in New England. It is shown here in an illustration from *La Flore et la Pomone Française* (1828–1833) by Jean-Henri Jaume Saint-Hilaire.

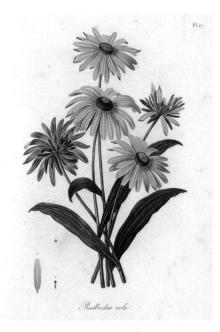

${ m R}$ udbeckia pinnata & ${ m R}$ udbeckia hirta

Rudbeckia laciniata was introduced from French Canada in the 1630s, but it was Rudbeckia hirta (above), the black-eyed Susan, introduced in 1714, that gave the genus a lasting place in English gardens. This illustration appeared in *LArt de Peindre les Fleurs à l'Aquarelle* (1834) by Augustine Dufour. Various additional species arrived in the nineteenth century, and were used for hybridising. *Rudbeckia pinnata* (opposite), here from the 1822 volume of the *Botanical Magazine*, was introduced in 1803 but has since moved into the genus *Ratibida*.

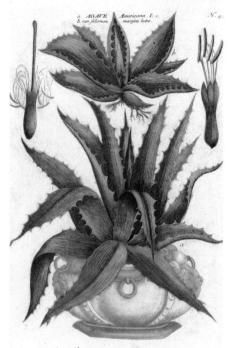

a. Mõe Mucronato folio Americana major. b. Mõe Muricata major foliis Pietis seu ex Luteo variegatis.

(Cave Americana & Cereus eriophorus

Agave americana (above), the 'American aloe', first flowered in Pisa in 1583. Enthusiasm for American succulents later subsided as a wider range of Dutch succulents arrived from South Africa, but returned in the late eighteenth and nineteenth centuries with the introduction of American desert cacti, such as *Cereus eriophorus* (opposite).

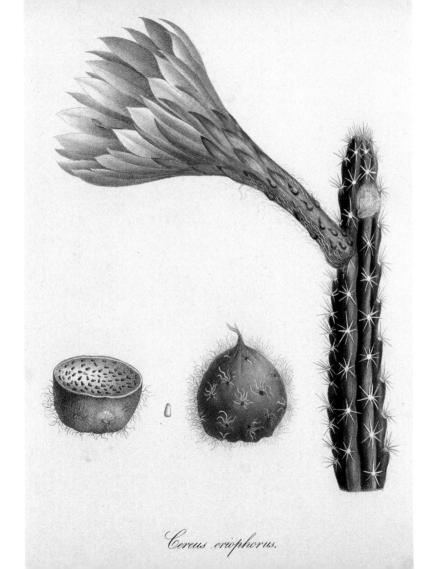

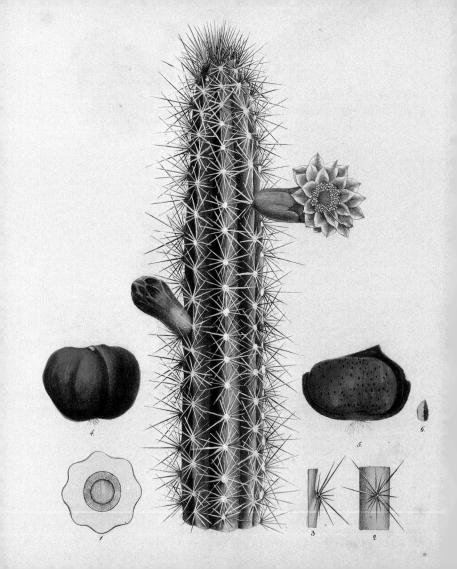

THE AMERICAS

Cereus curtisi & E chinocactus pfeifferi

The cylindrical-stemmed cacti were assigned a separate genus *Cereus*, which has then been further fragmented into *Selenicereus*, *Trichocereus*, etc., but until a thorough revision of the species is made, many of the current names must be considered provisional only. These and other cacti were eagerly collected during the early nineteenth century, and for a while cacti and orchids competed to see which would furnish the greater craze; but after mid-century orchids won out, and collections of greenhouse cacti were more a part of continental, than English, gardens.

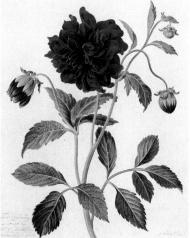

\mathfrak{D} ahlia 'the sovereign' & \mathfrak{D} ouble dahlia

Dahlias were described in the sixteenth century by the botanist Francisco Hernandez, but none reached Europe until the late 1780s, when Antonio José Cavanilles was making great efforts to reinvigorate the Botanical Garden in Madrid. Alexander von Humboldt sent seeds to Berlin in 1804, where two years later fiftyfive cultivars flowered. The empress Joséphine collected dahlias at her garden at Malmaison, and they finally reached England after the Napoleonic war ended. Over 100 varieties were available by 1820, and over 2000 by 1840. Dahlia 'The Sovereign' (above) is from a drawing by James Sillett (1764–1840). The double dahlia (right) is from *Choix des Plus Belles Fleurs* (1827) by Redouté.

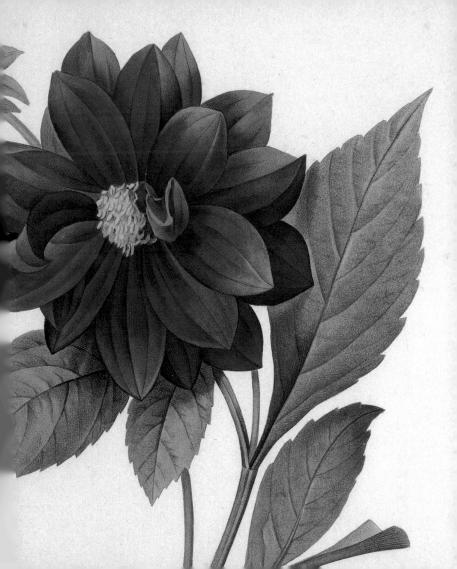

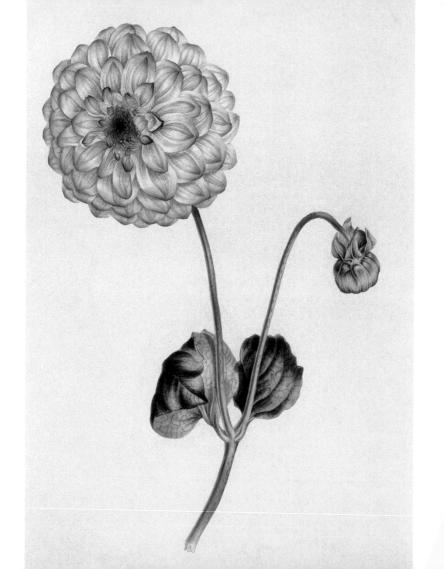

\mathfrak{D} ahlia 'the queen' & \mathfrak{O} ahlia 'picta formisissima'

During the 1820s and 1830s, while dahlias were at their highest prices, efforts were made to establish them as a new category of florists' flower. Thereafter, various exhibition categories developed, paralleling those of chrysanthemums, notably, from the 1830s to the 1880s, the show or fance dahlias, now called ball types, in which a sphere of geometrically arranged petals was the ideal. Cactus dahlias appeared in the 1870s, decoratives and collerettes in the 1900s, and water-lily dahlias in the 1940s. Dahlia 'The Queen' (opposite) and 'Picta Formisissima' (above) are decoratives.

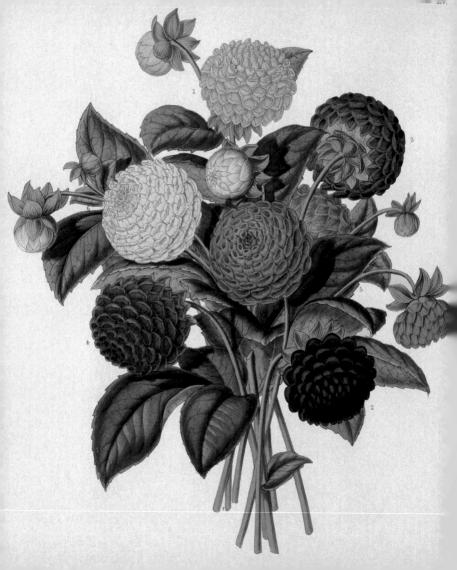

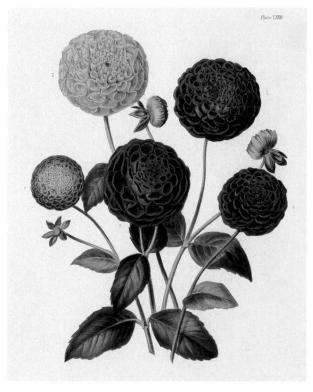

${\mathcal{G}}^{\mathrm{ompon}}$ & ${\mathfrak{L}}^{\mathrm{illiput}}$ dahlias

The first dwarf dahlias appeared in 1828; the first anemone-flowered types in 1830; pompons (including the originally distinct lilliputs) in the 1840s. (Pompon-type flowers were observed as early as 1808 but were not accepted as a category until the entire plant was bred as dwarf.) Dahlias have gone in and out of fashion as garden flowers, but have always been popular as exhibition flowers.

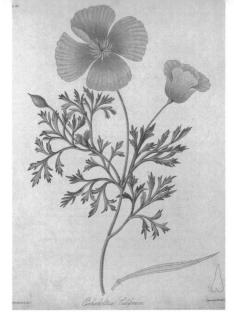

\mathfrak{E} schecholzia californica

The Californian poppy was named in 1815 by the German botanist Adalbert von Chamisso, after his friend Eschscholz, the ship's doctor on his expedition. Introduced into Europe by David Douglas, it quickly roused the enthusiasm of gardeners. The original colour range was yellow to white, but reds appeared in the late nineteenth century, culminating in Luther Burbank's New Crimson California Poppy early in the twentieth century.

${f G}$ aillardia picta

Gaillardia pulchella was introduced as early as 1787 but never became an important garden flower. Other species arrived from the 1810s on, most notably Gaillardia aristata and Gaillardia pieta, the latter found in Louisiana in 1833 and illustrated here from *The British Flower Garden* (1823–1837) by Robert Sweet. These were the ancestors of the later garden hybrids, such as G. × grandiflora, which is still available today.

Memophila insignis

By the 1840s English gardeners had come to recognise a category of plants called Californian annuals – 'mostly sent home by Douglas', as Mrs Loudon said in her *Ladies' Companion to the Flower Garden.* 'They all bear cold much better than they do heat; and they will live through the British winters in the open air without any protection.' *Nemophila insignis* was one of these, sent to Britain by David Douglas in the 1830s; the colour range was extended in the 1840s with the addition of white-and-black-flowered species.

Coreopsis grandiflora

Some species of *Coreopsis* were introduced in the late seventeenth and eighteenth centuries, but it was a series of species discovered in the 1820s and 1830s, most notably *C. grandfilora* (1826), as illustrated here by Margaret Roscoe in 1829, and *C. coronata* (1835), that established the genus in British gardens. Although *Coreopsis* is a perennial, it soon came to be treated for convenience as an annual, and joined the list of 'Californian annuals'.

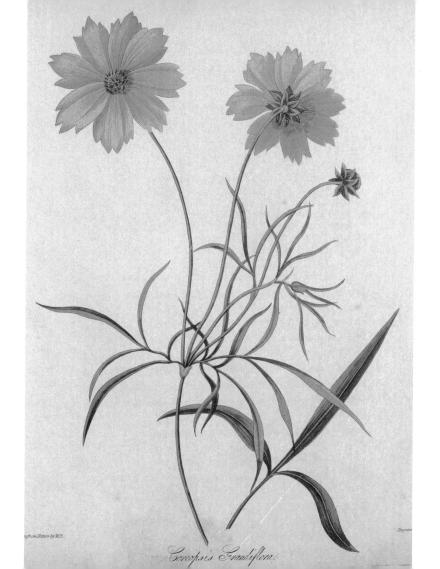

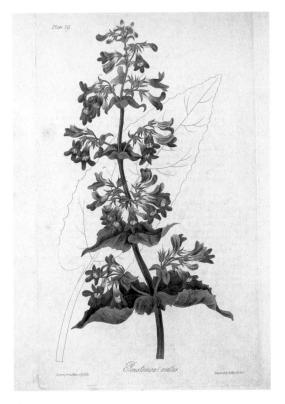

\mathcal{G} enstemon ovatus

Another plant owed to Douglas; though some species had been discovered in the eighteenth century. Douglas introduced fifteen species in the late 1820s and 1830s, and the popularity of the plant dates from that sudden influx. By 1850 there were white, pink, blue, and purple varieties available in England. But the modern cultivars, descended from crosses made between *P. hartwegii* and *P. cobaea*, have been bred primarily in the United States, although there have recently been increased efforts to popularise penstemons in Britain.

THE AMERICAS

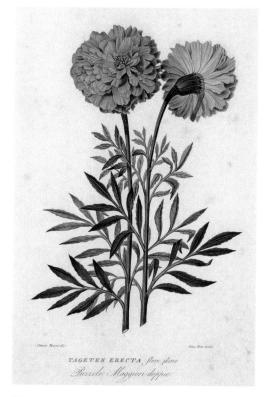

$\mathcal{J}_{\text{AGETES ERECTUS}}$

The so-called African and French marigolds (*Tagetes erectus* and *patula* respectively) are both South American in origin, and derive their names from the routes by which they entered Europe. Both had reached England before the end of the sixteenth century. From the 1860s, bedding varieties were bred in America, but played only a minor role in Britain until the twentieth century, when the garden authority Gertrude Jekyll used them extensively, both in her infrequent bedding schemes and in borders.

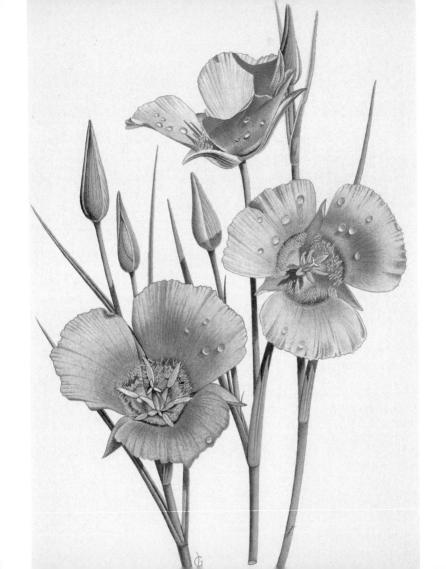

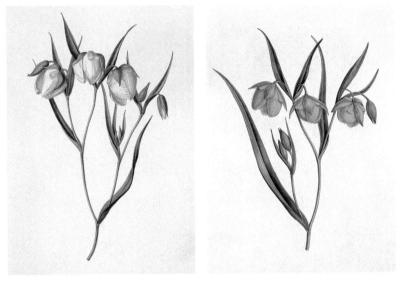

Calochortus macrocarpus, Calochortus albus & Calochortus pulchellus

Calochortus is a genus of bulbs from the west coast of North America, first discovered by the Lewis and Clark expedition and named in 1814. David Douglas introduced five species in the 1820s and 1830s, among them *C. albus* (above left) and *C. pulchellus* (above right), as illustrated here from drawings made in 1833 by Sarah Ann Drake. *Calochortus* attained its greatest popularity in England in the late nineteenth century, with the advocacy of William Robinson. *C. macrocarpus* is illustrated opposite.

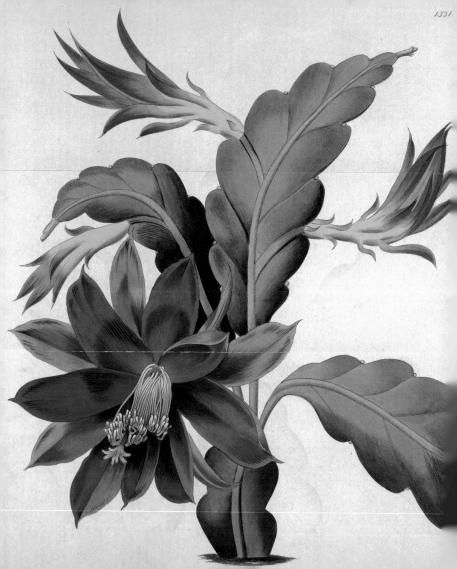

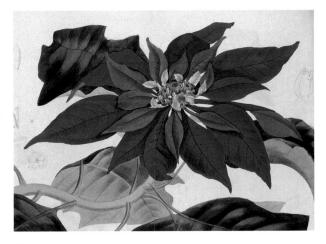

\mathfrak{E} uphorbia pulcherrima

The poinsettia was so named after one of its discoverers, Dr Poinsett. It had already been described as *Euphorbia pulcherrima*, but Americans used the name *Poinsettia* for so long that it became an accepted vernacular name. It was introduced into Europe in the 1830s, and had a long but minor career as a glasshouse plant, before it began being hybridised in America in the 1920s and 1930s and popularised as a Christmas decoration.

\mathfrak{N} opalxochia ackermannii

Adrian Hardy Haworth split the Christmas cacti away from the rest of *Cactus*, and gave them their own genus *Epiphyllum*. *Epiphyllum ackermannii* was introduced by the Chelsea nurseryman James Tate in 1829, but was eclipsed mid-century by other species that began to yield exciting hybrids, of which there are now more than 1000. By the time *E. ackermannii* was reintroduced from the wild in the mid-twentieth century, nomenclatural changes meant that it had become *Nopalxochia ackermannii*, while the Christmas cactus hybrids now fall under *Schlumbergera*. This illustration comes from the *Botanical Register* for 1830.

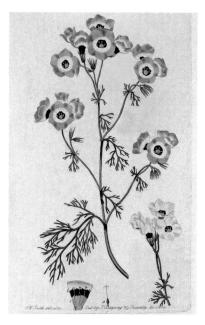

${ m g}$ ilia tricolor

In 1833, David Douglas introduced several species of *Gilia* from western North America into England, where they were distributed through the Horticultural Society. Perhaps the most immediately popular was *Gilia tricolor*, with its distinctive blue and white petals.

${\mathcal Z}$ innia elegans

Zinnias were grown extensively by the Aztecs before the Spanish conquest of Mexico, and only reached Europe in the eighteenth century. *Zinnia elegans* arrived in the 1790s, but was not as popular as the dahlia. The first double zinnias were raised in France in the 1850s and enjoyed a flurry of interest in the 1860s. The modern large-flowered cultivars began to appear after World War I.

${\mathfrak A}$ lternanthera versicolor & ${\mathfrak J}$ resine herbstii

Carpet bedding – the use of low-growing foliage plants to create patterned beds – was christened in 1868 and was the major horticultural fashion of the 1870s, spreading around the world. The plants used consisted of sedums, dwarf succulents like sempervivums and echeverias, and a group of recently introduced South American foliage plants. Three species of *Alternanthera*, including *Alternanthera versicolor* (above), arrived in the early 1860s. *Iresine herbstii* (opposite) was introduced in 1864 by the Richmond nurseryman Hermann Herbst, formerly the director of the Rio de Janeiro Botanic Garden.

\mathfrak{B} egonia × sedeni & \mathfrak{B} egonia rex

Tuberous begonias became the major new bedding plants of the late nineteenth century. Their ancestors were collected in South America by Richard Pearce, a collector for the Veitch nurseries in England in the 1860s, and the first hybrid, *Begonia* × *sedeni* (above), was bred by Veitch's hybridist, John Seden, in 1868. The nurseries of Lemoine in Nancy and Van Houtte in Ghent immediately followed Veitch's example, rivalled from 1875 by John Laing of Forest Hill, who became the major English breeder.

$\mathfrak{C}^{\mathrm{hapter}}\,\mathfrak{F}^{\mathrm{ive}}$

NERIUM ODORUM (now a variety of *Nerium oleander*) is a strongly scented oleander introduced from the Far East in the 1860s.

(ISIA & AUSTRALASIA

rade between eastern Asia and Europe had been sustained throughout the Middle Ages along the great silk routes. Plants, however, did not make the long journey across Asia, though desirable plant products like spices did. When the first European naval expeditions to reach southern and eastern Asia were launched, between 1495 and the 1520s, it was the Portuguese who dominated the India and China trade. They did not concern themselves much with plant importation – spices were the initial staple of the India trade, and silk and porcelain of the Chinese. Nonetheless, *Impatiens balsamina* and *Hemerocallis fulca* were both introduced into Europe before the end of the sixteenth century.

In India, the English, Dutch, and French began to make inroads on the Portuguese trade domination in the early seventeenth century. A century and a half of trading, fort-building, and combat eventually resulted in the East India Company controlling Indian foreign trade from 1769. In 1787 the Company established the Calcutta Botanic Garden; the first two superintendents, William Roxburgh and his successor Nathaniel Wallich, sent plants to Kew and to private gardeners in England. They made Calcutta a clearing house for plants from all over southern Asia. One strain of Chinese roses became known as Bengal roses because they had been distributed via Calcutta. The first Indian rhododendrons, cotoneasters, berberis, roses, and herbaceous plants such as *Tulipa stellata* and *Primula denticulata* had all reached Britain by the 1840s, sent from Calcutta and from the Saharanpur Botanic Garden in the Punjab.

In 1685, Chinese ports were officially opened to ships of all nationalities. Even then, customs regulations were so strict that foreign trade was effectively limited to Macao and Canton. Chinese chrysanthemums appeared briefly in the Netherlands in the 1680s, but soon disappeared from cultivation, while an Oriental hibiscus flowered at the Chelsea Physic Garden in the first decade of the eighteenth century. The hibiscus was introduced by the East India Company doctor James Cunningham. Although Chinese plants had limited impact in Europe at the time, the accounts of Chinese gardens by Jesuit missionaries led to a fashion for Chinese-style effects in European landscapes.

The early nineteenth century saw sporadic but enthusiastic attempts to introduce Chinese garden plants, importing to Europe the results of China's centuries-old traditions of plant breeding. Chrysanthemums, China asters, camellias, peonies (especially tree peonies or moutans), and roses, all excited attention in Britain and Europe. Most were introduced by horticulturally minded sea captains. Sir Joseph Banks, the Director of the Royal Gardens at Kew, planted the first tree peony there in 1790. Sir Abraham Hume of Wormleybury in Hertfordshire was active in distributing peonies and chrysanthemums. Two founders of the Horticultural Society, the amateur gardener and collector Charles Francis Greville and William Townsend Aiton, the superintendent of Kew, helped distribute plants, the latter from specimens received at Kew. Among the results, in the first decade of the nineteenth century, were hydrangeas and tiger lilies. In 1818, John Reeves, a tea inspector at Canton, began to send plants to the Horticultural Society, among them some of the first wisterias. In the 1820s the Society sent two collectors to China: the first, John Potts, returned with seed of *Primula sinensis*; the second, John Damper Parks, was sent with specific instructions to look for the yellow form of *Rosa banksiae*.

By then, horticultural attention was focusing on lands to the south and east of China, Australia in particular. By the time the first English settlers began to arrive in Australia in 1788, the Hammersmith nursery of Kennedy and Lee in London was already offering five Australian plants, three of them *Banksia* species. The nursery remained the principal channel of introduction for the slow trickle of new plants that followed the establishment of the colony at Sydney. In 1829 the first 'free' colony was established, at Swan River on the west coast. The brothers James and Robert Mangles, both of whom were important and innovative gardeners in Surrey, collected plants from the new colony and sent seeds to England. Between 1827 and 1828, the interest in Australian plants had grown sufficiently for the nurseryman Robert Sweet to issue a volume entitled *Flora Australasica*, illustrating and describing fifty-six plants being grown in England: banksias, dryandras, acacias, grevilleas, leschenaultias, hakeas, and

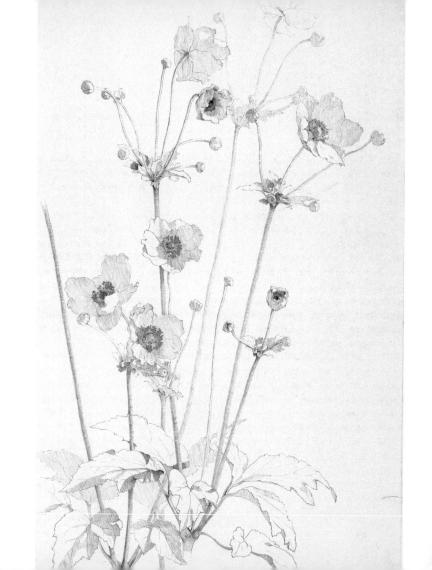

Anemone 'Honorine Jobert', one of the most popular and enduring of Japanese anemone hybrids, bred by a Verdun nurseryman in the late 1850s, and first offered in England by the nursery of F. and A. Smith of Dulwich in 1863.

boronias. There was some interest in New Zealand plants but they never became particularly fashionable. The exception was *Hebe speciosa*, which crept into England in the 1840s, followed gradually by other species. However, it was not until the twentieth century that hebes were extensively hybridised.

The focus on exotic plants swung back to East Asia after Britain's opium war with China secured commercial inroads under the Treaty of Nanking (1842). The first plant collector to take advantage of the new freedom was Robert Fortune, sent out by the Horticultural Society. Most of his collecting was from nurseries and gardens rather than from the wild. Among the plants he brought back were *Anemone japonica* (now *A. hupehensis*), *Jasminum nudiflorum*, and *Dicentra spectabilis*, as well as azaleas, forsythias, and other shrubs. Fortune made further expeditions for the East India Company, but by the 1850s attention had shifted to the Himalayas as the source of the most exciting introductions. Joseph Dalton Hooker, later the superintendent of Kew, explored the Himalayas and brought back twenty-five new species of rhododendrons. He also brought back bergenias and primulas.

The final frontier in the European trade advance was Japan. The Dutch and Portuguese had established trade contacts in the sixteenth century, but the Japanese government closed Japan to Western contact in the 1630s, and allowed trade only with the Dutch, who were allowed to dock at an island in Nagasaki harbour. Only three botanists succeeded in travelling on the Japanese mainland over the next two centuries: Engelbert Kaempfer in the 1690s, Carl Thunberg in the 1770s, and Philipp Franz von Siebold in the 1820s and 1830s. Of these, only Siebold succeeded in introducing a significant number of plants into Europe, through a nursery he established in Leiden. Japan had a tradition of plant breeding almost as old as China's, and many of Siebold's introductions came directly from Japanese gardens of the time: irises, lilies, hydrangeas, hostas and flowering cherries.

In 1853, the American Commodore Perry compelled Japan to open its ports to international shipping. The first important plant collectors to arrive, apart from the returning

An illustration of *Banksia coccinea* by Ferdinand Bauer, who acted as botanical artist on Matthew Flinders' expedition to Australia in 1802–1805. Bauer subsequently published his drawings as *Illustrationes Florae Nocae Hollandiae*.

Siebold, were Robert Fortune and John Gould Veitch, who between them brought back to Europe *Lilium auratum*, *Primula japonica*, Japanese clematis and chrysanthemums, and the form of Virginia creeper formerly known as *Ampelopsis veitchii*.

European interest in Japanese plants was followed some decades later by a vogue for Japanese gardens. The eighteenth-century fascination for Chinese garden style was falling from fashion by the 1850s, and it was not until the 1890s, when Josiah Conder published *The Flowers of Japan* (1891) and *Landscape Gardening in Japan* (1893), that Japanese gardens came to be seen as distinct and interesting. Attempts at making gardens in a Japanese style began in England in the 1890s; the heyday of the style was the Edwardian period, when Japanese designers were sometimes imported to do the job authentically, and the trend spread throughout Europe. The Japanese garden was then understood as a special category of rock and water garden, and plants such as hostas and daylilies, *Iris sieboldii* and *kaempferi* varieties enjoyed a burst of popularity as suitable plantings for the style. The fashion for Japanese-style gardens faded in England after World War I, but the fashion for Japanese plants continued through the twentieth century.

The last great wave of Asian plant introductions came once again from China, as plant collectors penetrated the country's interior. The Veitch nursery in Chelsea was responsible for sending Ernest Henry Wilson to China in 1899 on the first of two expeditions that sparked a torrent of collecting in western China, Tibet and the eastern Himalayas. Rhododendrons, above all, became the focus of collecting in the early twentieth century. Several important lilies entered cultivation in Europe through Wilson; *Gentiana sino-ornata* and various primulas through Forrest; a wide variety of alpines through Farrer and Purdom; and *Meconopsis betonicifolia* var. *baileyi*, the celebrated blue poppy, through Kingdon-Ward. This spate of expeditions, and the introductions which resulted, was finally ended by World War II and the Communist takeover in China. Only in the last two decades of the twentieth century did Western plant collectors once again visit the areas which Forrest and Wilson traversed.

Ford B

Hibiscus Rosa-Sinensis

The name *rosa-sinensis* means 'rose of China', and reflects the fact that the early hibiscus introduced to Europe were garden varieties representing a long history of cultivation in China. The first to become known were double-flowered forms, which reached the Chelsea Physic Garden by the 1730s; singles were not known until species from the Indian Ocean were introduced around the mid-nineteenth century.

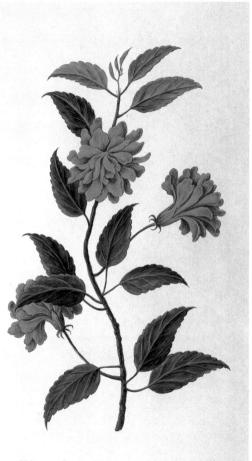

Hebiscus chinensisis in fina a Anexton in Mybe isaas men Sardin. Hibitcus rohi chinensis Flore, ruho pleno.

Hibiscus Rosa-sinensis

The first European hybrids of hibiscus were produced by the Veitch nurseries in Chelsea in the 1880s. But it was the USA and Hawaii that saw the greatest interest in breeding varieties; in Hawaii there were reportedly 3000 named varieties already in circulation in the 1920s and 1930s, and the first Hibiscus Society was founded in Hawaii in 1911.

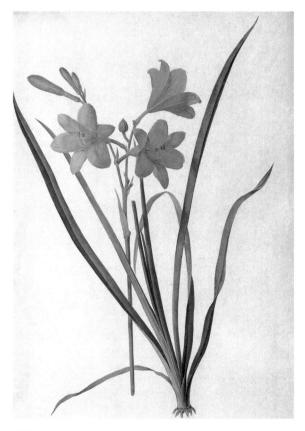

Hemerocallis flava

Two species of daylilies, *Hemerocallis flava* and *H. fulva*, were introduced from China into Europe in the sixteenth century under the name Lilio-asphodelus, possibly in the form of garden varieties rather than wild species. The modern cultivars began to emerge in North America just before World War II, and North American growers have continued to dominate the genus.

$\mathcal J$ mpatiens balsamina

The balsam, the eastern Asian relative of the African busy lizzie, reached Europe in the early sixteenth century. Gerard grew it outdoors in a bed of hot dung; once greenhouses became widespread, it moved indoors. Despite the problems of growing it in the English climate, gardeners persevered in order to get doubleflowered and variegated forms with red or purple mixed with white.

$\mathfrak{L}^{\mathrm{ilium}\ \mathrm{lancifolium}}$

The tiger lily *Lilium lancifolium* (also called *Lilium tigrinum*) arrived in the British Isles in 1804, having been collected in Canton by the Kew collector William Kerr. It very quickly became a favourite garden flower, and by 1830, Tennyson could list it along with the hollyhock in his poem 'A spirit haunts the year's last hours...', which helped to establish the lily as a suitable resident for 'old-fashioned gardens' later in the century.

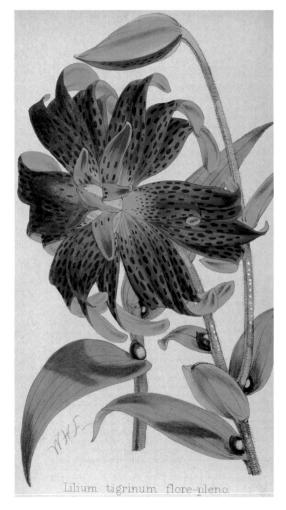

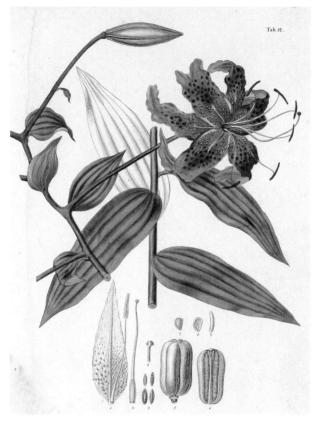

\mathfrak{L} ilium speciosum

In the wake of Chinese came Japanese lilies. *Lilium japonicum* was collected by Thunberg in the 1770s; Siebold sent *Lilium speciosum* to Germany in 1830, and it reached England two years later, quickly becoming known as 'Queen of the Lilies'. Its rival for this title, *L. auratum*, was introduced by John Gould Veitch in the 1860s.

$\mathcal G$ ris sanguinea

The Siberian irises include *Iris sibirica*, which despite its name grows in Europe and western Asia, and genuinely east Asian species introduced in the nineteenth century, like *Iris sanguinea* and *I. clarkei*. These became the ancestors of the modern bearded irises.

JCYDRANGEA MACROPHYLLA 'OTAKSA'

The first hydrangeas to reach Europe in the eighteenth century were American species, but they were quickly eclipsed by Chinese and Japanese varieties, including *Hydrangea* 'Otaksa', illustrated here by Sebastian Minsinger. Their classification was at first uncertain, and they were labelled as viburnums, elders, and hortensias before their affinity with the American species was realised.

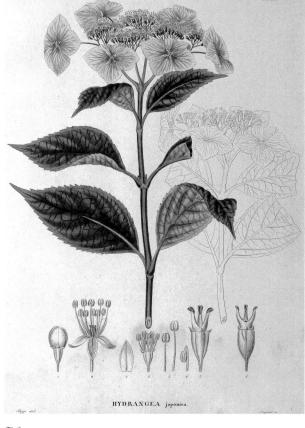

Hydrangea japonica & Hydrangea macrophylla 'belzonii'

The first Asiatic hydrangea to reach England arrived at Kew in 1789, becoming famous because its flowers could change colour from pink to blue. From the 1830s, Philipp Franz von Siebold introduced Japanese garden varieties, which masqueraded in his works as different species.

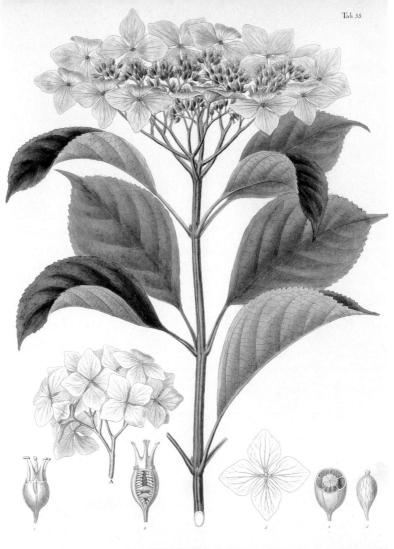

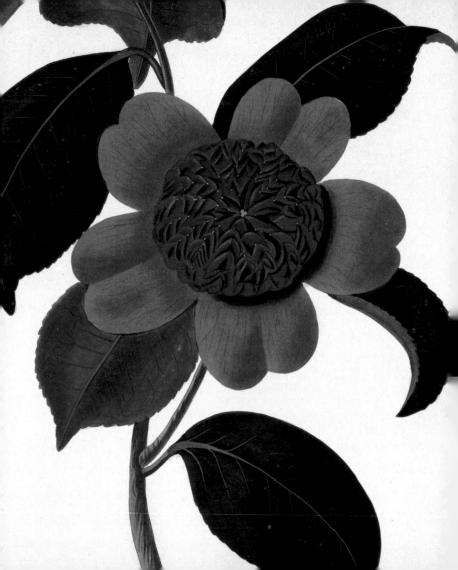

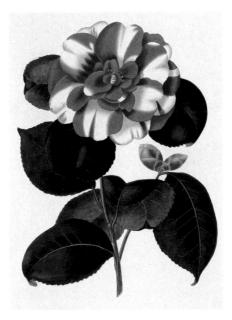

Camellia japonica 'variegata' & Camellia japonica 'anemoniflora'

The camellia first impinged on the European consciousness as the source of tea, but for a long time *Thea* was considered a separate genus from the ornamental varieties rumoured to flourish in Oriental gardens. In 1739, at Thorndon Hall, Essex, Lord Petre succeeded in flowering the first camellias in Europe; it was widely believed that they died soon after from being kept in his hottest glasshouses. In 1792, John Slater of the East India Company imported two double camellias, white and striped, and the race was on. By 1819, when the first book on the subject appeared (Samuel Curtis's *Monograph on the Genus Camellia*), there were 29 varieties being grown in England.

Camellia japonica cultivars

About 1830 the nurseryman Alfred Chandler began raising new varieties from seed, among them 'Chandleri Elegans', still grown today. There followed a few decades of enthusiastic camellia breeding, peaking in the 1840s. Their flowers showed the characteristics of the period's florists' flowers: tight, geometrical flowers, preferably with stripes or distinct edges.

${\mathfrak B}$ anksia serrata

Banksias were the first Australian plants to attract attention in England. *B. integrifolia* was already available in 1788, and further species were introduced in the 1790s. For a while they were highly popular as greenhouse subjects, but fell rapidly from favour in the 1850s and 1860s. 'It is difficult to understand why they have been allowed to pass so suddenly out of cultivation,' complained the nurseryman B. S. Williams in 1870.

Dryandra Longifolia

This was one of a number of *Dryandra* species introduced in England from 1803–1805. some twentysix species were grown in England during the early nineteenth century. They shared the fate of banksias later in the century, despite the attempts of people like B. S. Williams to promote them as part of the current fashion for foliage plants.

Patersonia

From the 1810-1840s, the British magazines depicted and described many Australian plants that disappeared from cultivation within a few years, as even more ornamental sorts were introduced. Already by the 1870s much of the 'New Holland' flora that had been grown in English greenhouses had been lost from cultivation. Patersonia lanata was introduced by the renowned nurseryman John Mackay in 1826, illustrated the following year (as shown here) in Flora Australasica (1827-1828) by Robert Sweet.

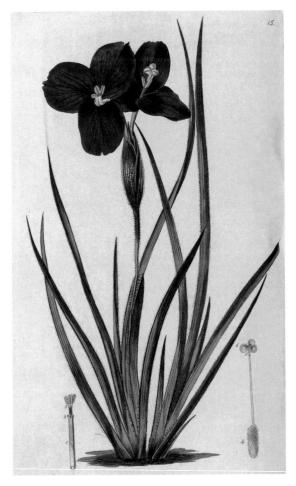

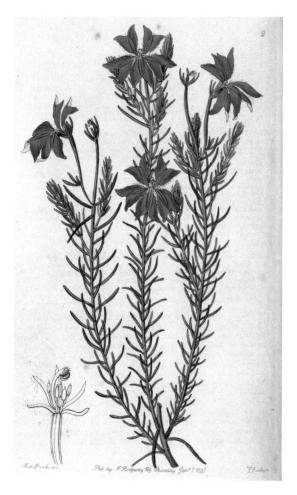

Leschenaultia Biloba

The very first species of Leschenaultia arrived in England in the 1820s, and L. biloba followed in 1840 from the Swan River colony. It remained popular in English greenhouses long after the initial wave of enthusiasm for these plants had passed, and in 1894 Thomas Baines could still say that L. biloba 'Major' was 'justly esteemed as one of the finest plants in cultivation... It is one of the things the cultivation of which no young plant grower should rest satisfied until he has mastered.'

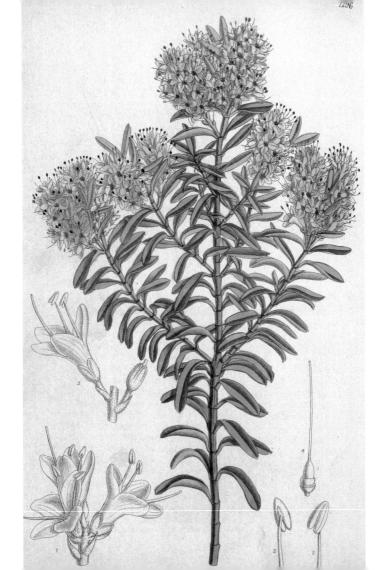

${\mathbb G}$ revillea Rosmariniflora

The grevillea was named after Charles Francis Greville, one of the founders of the Horticultural Society. This species was discovered by Allan Cunningham in 1822, and was being grown in England when Robert Sweet published this image in *Flora Australasica* (1827–1828). Grevilleas, in particular *G. rosmariniflora*, were one of the few Australian plants to succeed outside the greenhouse.

Hebe colensoi

The most popular garden plants of New Zealand origin have been hebes, which until 1926 were assimilated into the European genus *Veronica. Hebe speciosa* crept into England in the 1840s, followed gradually by other species, with extensive hybridisation taking place in the twentieth century.

ASIA & AUSTRALASIA

$\mathcal{C}_{\mathrm{HRYSANTHEMUM}}$ indicum

The garden chrysanthemum had a long history in China and Japan before it came to the attention of Europe in the 1790s. The first specimens arrived in France at the start of the French Revolution, reaching Kew a few years later. In 1796 James Colvill's nursery in Fulham put on the first big display of the flower. Between 1820 and 1830 nearly seventy varieties arrived, and in 1832 chrysanthemums were finally raised from seed in England. The first specialist chrysanthemum show was held in Norwich in 1843, and three years later the Stoke Newington Chrysanthemum Society, later the National Chrysanthemum Society, was founded.

Chrysanthemum 'gloria mundi' & Chrysanthemum 'alfred salter'

In 1846 Robert Fortune introduced two small-flowered chrysanthemums from China, which became the ancestors of a new exhibition category: the pompons. The earlier quill-petalled and ragged blooms were already yielding place to more compact, ball-shaped flowers, and in the 1850s the nurseryman John Salter grew the first perfectly symmetrical, incurved chrysanthemum, 'Alfred Salter' (right). Further classes of chrysanthemums were added in the late nineteenth and early twentieth centuries.

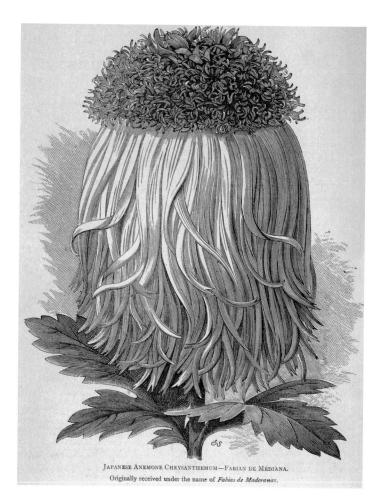

HOSTA LANCIFOLIA

Hostas were known as Funkias until the early twentieth century. *Hosta lancifolia* was introduced in 1829, followed by *H. plantaginea* in 1830, and then *H. fortunei* in 1876. The vogue for Japanese-style gardens about the turn of the century increased their popularity, but it was not until the midtwentieth century that hosta breeding took off in America, in tandem with the breeding of hemerocallis.

\mathcal{C} HRYSANTHEMUM CULTIVAR

The fascination for things Japanese, and the interest in new categories of chrysanthemum, combined to create a brief vogue in the late nineteenth century for elaborate Japanese cultivars. During the early 1900s, however, these cultivars played only a minor role, and further Japanese types such as cascades and charms had to wait until mid-century for popularity in the West.

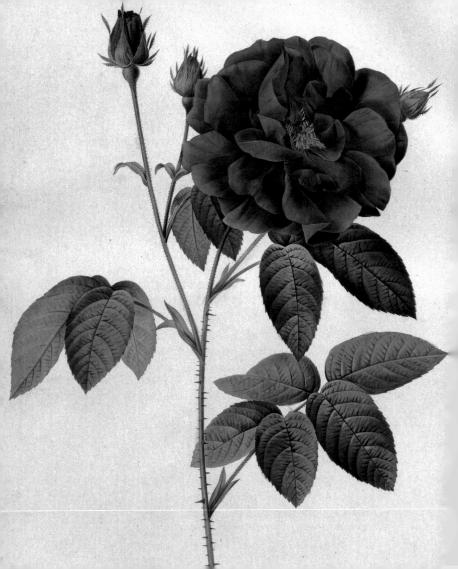

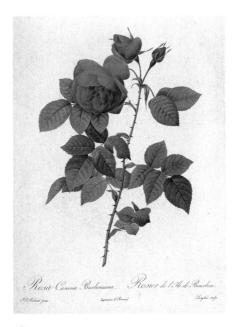

\Re osa × Borbonica

Chinese roses began to appear in Europe in the late eighteenth century. 'Slater's Crimson China' and 'Parsons' Pink China' both arrived in 1789, and the latter became the ancestor of some of the nineteenth century's first new categories of rose.

${ m R}$ osa gallica var. officinalis

Rosa gallica grows naturally in France, southern and central Europe, and was the first rose species to yield an extensive range of cultivars. The variety *officinalis* dates from at least the thirteenth century, when it was grown in France for perfumery.

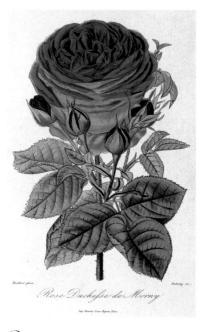

${\mathcal R}$ ose 'duchesse de morny' & ${\mathcal R}$ osa × lheritieriana

In 1808 Sir Abraham Hume received from China the first tea-scented rose, called 'Hume's Blush'. Crossing it with Noisettes and Bourbons produced a new category, called Tea Roses. In 1837 the first Hybrid Perpetual, 'Princesse Hélène', was raised in France, to be followed by some 4000 other cultivars, such as 'Duchesse de Morny' (above), before this category declined in the twentieth century.

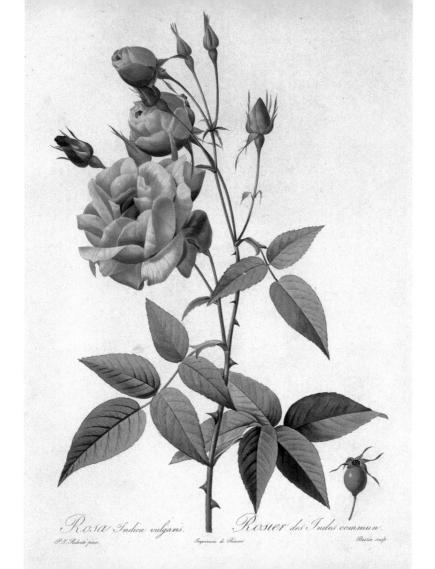

${ m R}$ osa banksiae

Rose banksiae, in a double white form, was introduced by William Kerr in 1807. In 1823 the Horticultural Society sent John Damper Parks to China to collect a rumoured double yellow form, and in 1824 he returned with both it and the first yellow tea rose. This is one of the earliest illustrations of *R. banksiae* seen in Europe; it was made from a drawing by an anonymous Chinese artist, commissioned in Canton by John Reeves in the 1810s or 1820s.

300

${ m R}$ osa 'maréchal niel'

Using yellow tea roses from China for hybridisation, the number of yellow roses in Europe increased steadily throughout the nineteenth century, including the famous yellow Noisette 'Maréchal Niel', bred by Henri Pradel in 1864. This plate of the celebrated yellow rose appeared in *Roses et Rosiers*, 1872.

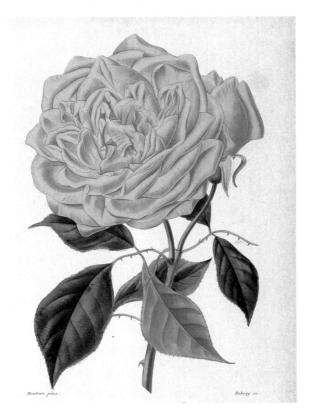

\mathcal{P} aeonia suffruticosa cultivar & \mathcal{P} aeonia officinalis

Peonies have a long history in European gardens, with *P. officinalis* (right, as illustrated by Pierre-Joseph Redouté) and *P. mascula* being grown in both single- and double-flowered forms in the sixteenth century. But the development of a wide range of varieties came only in the nineteenth century, with the introduction of the Chinese moutan or mudan (*Paeonia suffruticosa*, above), the tree peony, in the 1780s, followed by *P. lactiflora* from Siberia in 1805. The Somerset nurseryman James Kelway began hybridising peonies in the 1860s, and by the turn of the century could offer 300 singles and doubles.

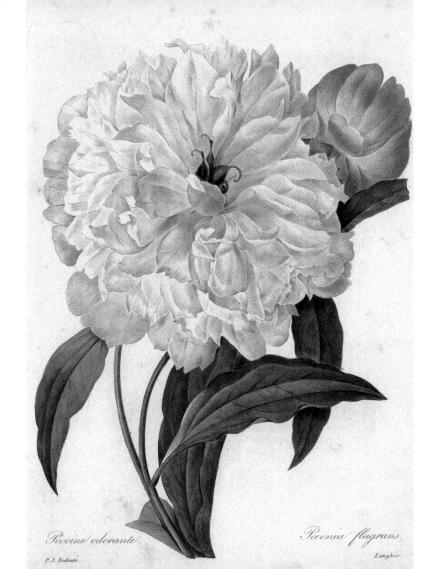

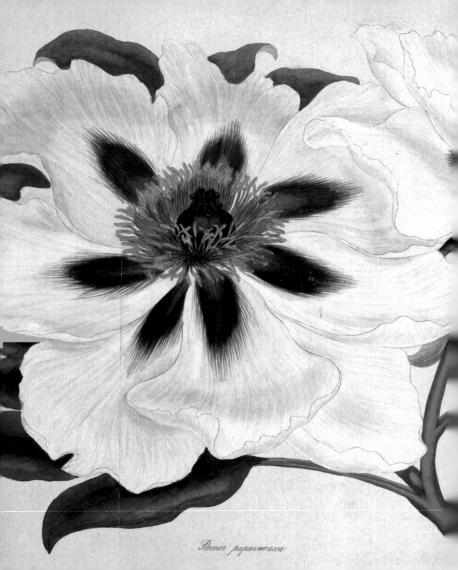

${oldsymbol{\mathcal{P}}}$ aeonia suffruticosa cultivar

Sir Abraham Hume, who was responsible for introducing tea roses from China, also took a hand in introducing Chinese peonies. The peony shown here, as illustrated for the *Botanist's Repository* (1797–1815), was first described as *Paeonia papaveracea* but was in fact a cultivar of the moutan (*Paeonia suffruticosa*). It first flowered in Hume's garden at Wormleybury, Hertfordshire, in 1808.

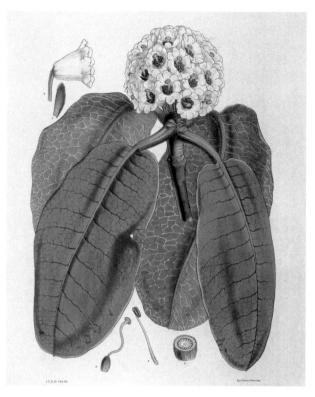

${ m R}$ hododendron falconeri

The first rhododendrons in European gardens were American bog-loving species, grown in special 'American gardens' where they could be provided with peaty soil. These were followed by the west Asian *Rhododendron ponticum*, which in 1841 was revealed could grow in ordinary English soil. During the first wave of enthusiasm for planting rhododendrons in the ordinary garden, the young Joseph Hooker brought back twenty-six Himalayan species that were distributed from Kew in the late 1840s, including this one, *Rhododendron falconeri*.

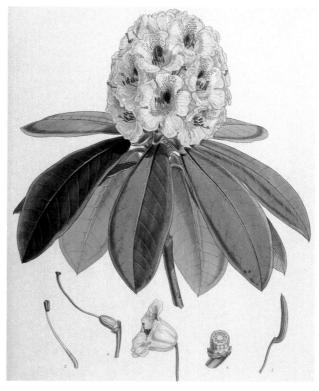

${ m R}$ hododendron wightii

The process of creating hardy hybrids of Himalayan rhododendrons began quickly, for gardeners already had twenty years of practice hybridising the American and west Asian species. While the aim of the early hybridists had been to create masses of colour to be seen from a distance, the new hybrids were often valued for the appearance of the individual trusses of flowers, for purposes of competition as well as garden effect. This species was illustrated by Walter Hood Fitch for *Rhododendrons of Sikkim-Himalaya* (1849–1851).

$\mathcal{C}_{\mathsf{LEMATIS}}$ florida

John Fothergill received the first Asiatic clematis in his garden at Upton (then in Essex, since swallowed up by London) in 1776: it was a double form of *Clematis florida*. Other garden forms of this species arrived during the nineteenth century; Siebold sent the 'Bicolor' form from Japan in 1837; the wild form was not found until the 1880s. *Clematis montana* and *C. patens* were introduced in the 1830s, and the stage was set for a major programme of hybridisation.

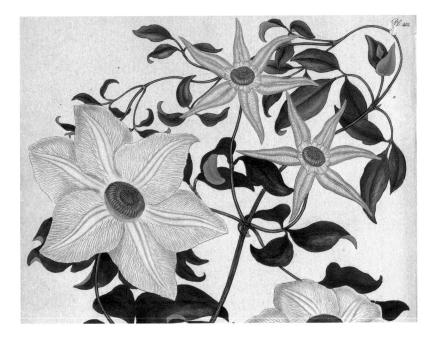

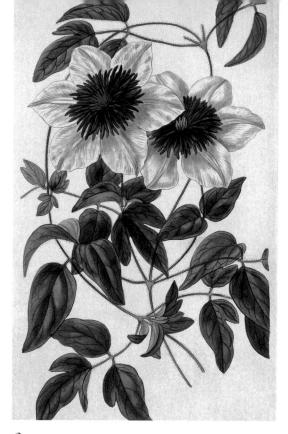

 $\mathcal{C}_{\text{LEMATIS FLORIDA 'BICOLOR'}}$

E. G. Henderson of the Pineapple Nursery in Maida Vale produced the first large-flowered clematis hybrids in the 1830s, but it was George Jackman who came to dominate the scene with *Clematis × jackmanii*, raised in 1862. By 1872, when he published his book *The Clematis as a Garden Flower*, he could list no fewer than 178 species and hybrids of clematis.

${\mathcal G}$ ris laevigata & ${\mathcal G}$ ris japonica

The first Japanese iris to reach Europe was introduced from China as *Iris chinensis*; only later was it realised that Thunberg had already described it as *Iris japonica* (opposite), pictured here in an eighteenth-century drawing attributed to August Wilhelm Sievert. *Iris japonica* flowered in a number of London nurseries in 1796. The next big introduction was *Iris kaempferi*, in 1857, in the form of garden varieties which allowed for much confusion over nomenclature. *Iris laevigata* (above) was eventually placed in a separate species, and many authorities now refer *I. kaempferi* itself to the species *Iris ensata*.

JRIS KAEMPFERI CULTIVARS

The vogue for Japanese-style gardens at the end of the nineteenth century led to a rush of imported Japanese garden varieties suitable for planting near lakes and ponds. The Yokohama Nursery Company, which had offices in London for some years, distributed a catalogue of fifty Kaempferi cultivars in the early 1900s (which included these woodblock prints), and many no doubt found their way into English gardens before hybrids began being produced in England.

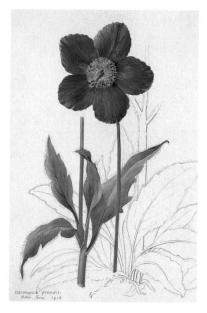

Meconopsis grandis

The blue poppy, *Meconopsis betonicifolia*, was discovered in Yunnan in 1886 by the missionary Père Delavay, and its introduction into Europe thereafter became an explorers' dream until Frank Kingdon-Ward succeeded in 1924. By that time other species of meconopsis had been introduced to good effect: *M. grandis* arrived in the 1890s, and has been used as the parent of many hybrid forms.

CLLIUM CAERULEUM

Allium caeruleum was introduced before 1840, and slid gradually into cultivation over the following decades. It was not until the twentieth century that ornamental alliums achieved wide popularity.

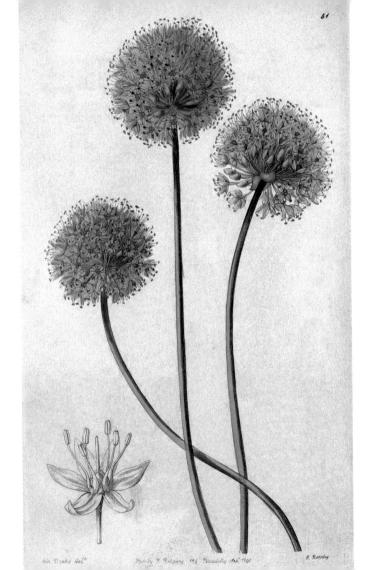

ASPIDISTRAS

Aspidistra elatior (above) – sometimes sold as A. lurida (opposite), which is a distinct species – was introduced from China in 1824 by the Horticultural Society's collector John Damper Parks. From the 1860s, as the cult of foliage plants grew, it was employed as a house and greenhouse plant. It only really came into its own as other foliage plants such as caladiums and rex begonias fell from fashion. The vogue of the aspidistra was mainly a product of the Edwardian period, and continued through the first half of the twentieth century.

CESCHYNANTHUS GRANDIFLORUS & CESCHYNANTHUS SPECIOSUS

The improvement of greenhouses in the early nineteenth century coincided with improved plant collecting techniques, and the result was an influx of tropical flowering plants for the hothouse. Among the novelties was *Aeschynanthus grandiflorus* (above), now *parasiticus*, introduced from India in 1838. Crossed with the Javanese *A. speciosus* (left), introduced in 1845, it produced *A. splendidus*, still popular at the beginning of the twentieth century.

Renealmia racemosa & Alpinia speciosa

Alpinia speciosa (opposite) was introduced from China in 1792 as Alpinia nutans. In the 1820s and 1830s, Alpinia species, including the tropical American species, which were even then being assigned to the separate genus Renealmia (above), were popular as hothouse plants, but were seldom grown in Britain.

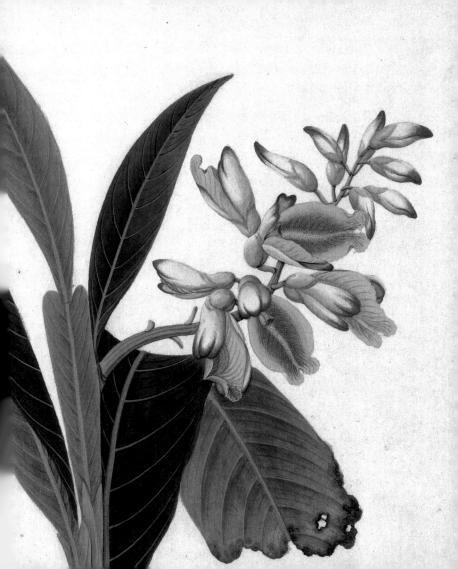

ON PLANT NAMES...

Unit the early eighteenth century, Latin was the language of international communication throughout Europe. All the major works on plants had been published in Latin, and learned professionals had been accustomed to Latin names for centuries. However, there was no central authority for plant names and, as these tended to be descriptive, it was up to the individual author how to frame the names: which elements of the plant's description to emphasise. Thus, the same plant was variously described as *Ranunculus vernus rotundifolius minor* (the small spring-flowering ranunculus with rounded leaves – Tournefort), *Ranunculus praecox rotundifolius, granulata radice* (the early round-leaved ranunculus with knobby roots – Morison), and *Ranunculus foliis cordatis angulatis petiolatis* (the ranunculus with heart-shaped leaves and angled petioles – Linnaeus in his early days).

In the 1730s, the Swedish botanist Carl Linnaeus began pushing for a reform of plant nomenclature. He proposed abandoning the long descriptive names hitherto used, and suggested giving each plant species a simple two-name code: the name of the genus, followed by a single epithet. Thus, he renamed the ranunculus referred to above *Ranunculus ficaria*. This may not give much information about the plant, but Linnaeus argued that that was not the function of a name. If anyone wanted the plant's description, they could look up the plant in a book. (For this reason it quickly became necessary to affix an initial or abbreviation to indicate which botanist coined the name, to let people know what books to look in. Thus L. at the end of a plant name indicates Linnaeus, Lindl. indicates John Lindley, DC indicates De Candolle, and so on.) In 1753, Linnaeus published *Species Plantarum*, in which he listed all the plants known to him, and gave them all new names in his proposed binomial form. It took less than two decades before virtually all opposition to this idea had fallen away, and Linnaeus's rules have been used consistently ever since (unlike his system of classification).

In 1866 the first International Botanical Congress was held, and it was agreed to draw up a list of rules for botanical nomenclature, as problems and conflicts had arisen frequently. The first Code was drawn up by the Swiss botanist Alphonse de Candolle, and adopted at the

ON PLANT NAMES ...

second Botanical Congress, in 1867 in Paris. Amendments to the Code have been considered at each international botanical congress since then – roughly every five years.

One major problem that had been occurring was the multiple discovery of plants by different botanists, who might describe plants as new without realising that someone else had already done so. From 1867 the first published name officially became the correct one. (Correctness of name has tended to matter more to botanists than to gardeners, who have tended to prefer stability of name. So one strategy for retaining familiar Latin names has been to retain them in use as vernacular names, so that poinsettia continues to be the common name for *Euphorbia pulcherrima*, and *wellingtonia* for *Sequoiadendron giganteum*.) Some people, like the German botanist Otto Kuntze, argued that names in use before Linnaeus should therefore be allowed to take precedence over Linnaeus's own. A new rule was thus introduced in the so-called Vienna Code of 1905, making the date of Linnaeus's *Species Plantarum* (1753) the official beginning of botanical nomenclature; no names used previously were valid, unless Linnaeus had adopted them in that work. A list of over 400 plant names was drawn up which were to be conserved.

Further problems arose when some botanists claimed that their names had chronological priority, when all that they could show was a name in a list, without any accompanying description to show which plant they had in mind. So *nomina nuda* ('naked names', i.e. without descriptions) were declared unacceptable. To be validly published, a name had to include a description that met the criteria for identification. The rule was made binding from 1860, the decade of the first formulation of the rules; some earlier *nomina nuda* were allowed to stand, in order to avoid wholesale renaming. Nonetheless, as every gardener will recognise, there have been many changes of name among garden flowers, and not only because of the discovery of prior publications that invalidate the familiar name. The other principal factor determining name changes is reclassification: the amalgamation of different genera into a single larger genus, or the break-up of a single large genus into a number of smaller ones.

This mezzotint engraving shows Sir Joseph Hooker receiving rhododendrons on his expedition to the Himalayas in 1850. Until this point the rhododendron species grown in Europe had been introduced from America or the Caucasus.

A separate code of names, the International Code of Nomenclature for Cultivated Plants, has also been drawn up for cultivated varieties. W. T. Stearn, representing the Royal Horticultural Society at the International Horticultural Congress in Stockholm in 1952, drew up the first version of this code, which was published in 1953 and has been revised several times since. It made official the concept of a cultivar, a word which for a long time had separate definitions in Europe and America. In the United States, the great botanist Alfred Rehder had coined the term for a variety raised in cultivation, but Stearn had independently coined it to mean a variety which was either raised or maintained in cultivation. The International Code adopted Stearn's definition, which is gradually ousting Rehder's definition even in its homeland.

Under the Code, a cultivar must be given a name, not in Latin but in a vernacular language (though older cultivars are allowed to retain long-established Latinate names), and this name is distinguished by being printed in Roman rather than italic letters, with single quotation marks; for example, *Iris germanica* 'Nepalensis', *Iris germanica* 'The King', *Ranunculus ficaria* 'Bowles' Double', *Ranunculus ficaria* 'Dusky Maiden'.

Another concept introduced in the Code war is that of the grex, another of W. T. Stearn's coinages. A grex is the name for a group of hybrids of common ancestry, yet it is not the name of any individual hybrid. When the Reverend William Wilks bred a group of white-flowered poppies in the 1880s, he called them Shirley poppies, after Shirley in Surrey where he was vicar; there is no variety of poppy called 'Shirley', but a group of poppies which resulted from the same breeding programme. The same is true for Headbourne Hybrid agapanthus, Polar Bear rhododendrons, Barnhaven polyanthus, and many others. A grex should not be confused with an exhibition category, like Parrot tulips, Alpine auriculas, or Split-corona daffodils, where the category may be defined by visual appearance and does not imply common ancestry. The term 'grex' is now gradually being replaced by 'horticultural group'.

SELECTED BIOGRAPHIES

ANDREWS, HENRY CHARLES (FL. 1790s–1830s)

Andrews was an artist and engraver, and the son-in-law of the Hammersmith nurseryman James Kennedy (see Lee and Kennedy). Beginning in the 1790s, he published a series of works on newly introduced plants, for which he both wrote the text and drew and engraved the plants. They were published a subscription basis, and for many years five different works ran concurrently: *The Botanis's Repository* (1797–1811), *Coloured Engravings of Heaths* (1794–1830), *The Heathery* (1804–1812), *Geraniums* (1805–1825), and Roses (1805–1828). He disappears from view in the 1830s; it is not known when he died.

BARR, PETER (1826-1909)

Born in Scotland, Barr moved to Worcester and then to London, where in 1861 he started a seed and bulb establishment in Covent Garden under the name of Barr and Sugden. Barr became particularly enthusiastic about daffodils, and attempted to find surviving examples of the old varieties listed by Parkinson in the 1620s; as part of this effort, he persuaded the Royal Horticultural Society to publish a checklist of the names of available daffodils – the beginning of modern plant registration. His firm continued as Barr and Sons, until in the 1950s it merged with its old rival, R. Wallace and Co. of Colchester, to become Wallace and Barr.

BURY, MRS EDWARD (FL. 1820S-1860S)

Priscilla Susan Falkner was borr in Liverpool in the 1790s; the exact year is not known. She married Edward Bury, a prominent railway engineer, and became a friend of William Roscoe, a wealthy Liverpool patron of the arst. Roscoe, an amateur botanist, published a large work on Monandrian Plants in the 1820s; Mrs Bury followed his example and published A Scherinon of Hexandrian Plants in the years 1831–1834, making the drawings for the illustrations herself. She also made illustrations for The Botanist, publication dieda around 1870.

CLUSIUS, CAROLUS

(CHARLES DE L'ESCLUSE, 1526-1609)

L'Escluse was Flemish by birth; he studied at Montpellier, but his family was persecuted and reduced to poverty for Protestantism, and L'Escluse spent years wandering throughout Europe, translating botanical works, collecting plants, and making contacts. Finally, in 1573, the Emperor Maximilian II invited him to Vienna to assist with the imperial gardens; while there he helped introduce plants such as tulips from Constantinople. In 1587 he was made a Professor in Leiden, where he helped to build up the tulip trade. His major publications were *Rariorum Aliquot Stirpium* (1576); *Rariorum Plantarum Historia* (1601); and *Exatiorum* (1605).

COLVILL, JAMES (1777–1832) SEE SWEET.

DOUGLAS, DAVID (1799-1834)

Douglas was working at the Glasgow Botanic Garden when the Horticultural Society of London hired him as a plant collector in 1823. Its first journey was to eastern North America, where he was asked to bring back fruit varieties. He then made two expeditions to the West Coast of North America, in 1825–1827 and 1830–1834. He introduced over 200 species, most notably the tree which was named after him, the Douglas fir. His last expedition took him to Hawaii, where he died by falling into a pit in which a wild bull was trapped.

EHRET, GEORG DIONYSIUS (1708–1770) SEE WEINMANN.

FORTUNE, ROBERT (1812-1880)

Fortune was the first prize student of the Horticultural Society's examinations for gardeners. In 1843 the Society sent him to China, where he collected garden varieties of ornamental plants. On his return he became Curator of the Chelsea Physic Garden (1846–1848), and then returned to China on behalf of the East India Company, for which he collected tea plants in order to start up a tea industry in India. He made several other journeys to China and Japan, privately as well as for institutional clients, and wrote four books about his travels – most famously *Three Years' Wanderings in China* (1847).

GERARD, JOHN (1545-1612)

Gerard was a barber-surgeon, who went on to become curator of the College of Physicians' garden of medicinal plants. He had a garden of his own in Holborn, of which he published a catalogue, which has been credited with being the first complete catalogue of a garden ever published. He was also responsible for Lord Burgley's gardens in the Strand and at Theobalds in Hertfordshire. The Queen's Printer, John Norton, hired Gerard to write a book on medicinal plants to accompany illustrations he had rented from Germany; the result was Gerard's *Herball* (1597), the most famous English book on the subject. After Gerard's death it was revised by Thomas Johnston (1633 and 1636 editions).

GILBERT, SAMUEL (FL. 1690S) SEE REA, JOHN.

HANMER, SIR THOMAS (1612-1678)

Sir Thomas Hanmer fought on the royalist side in the English Civil War, and spent the rest of his life in retirement at his house at Bertisfield in Wales. In 1659 he wrote a book about his garden, which he never published; the manuscript was finally edited by Ivy Elstob, and published as *The Garden Book of Sir Thomas Hanmer* in 1933. Today it is regarded as the most important gardening document from the Commonwealth period.

HERBERT, WILLIAM (1778-1847)

Herbert was a clergyman, who spent most of his career (1814–1840) as Rector of Spofforth in Yorkshire, before being made Dean of Manchester, a post he held until his death. From the 1820s on, he experimented with hybridising many different kinds of plants, most notably gladioli and Cape bulbs. His principal publication was *Amaryllidaceae* (1837), but he also wrote important articles, for one of which, on crocuses, he made a series of drawings that survive today in the Lindley Library.

HOOKER, SIR JOSEPH DALTON (1817-1911)

The son of Sir William Jackson Hooker, the first director of the Royal Botanic Gardens, Kew, Joseph was the botanist on the expedition of the *Errbuy* (1839–1843); From 1848 to 1851 he collected plants in the Himalayas, introducing twenty-six species of rhododendrons of *Sikkim-Himalaya* (1849–1851), *Illustrations of Himalayan Plants* (1855), and *Himalayan Journals* (1854). He later collaborated with George Bentham on *Genera Plantarum* (1862–1883), and compiled the massive *Flora of British India* (1872–1897). An early supporter of Darwin, he succeeded his father as Director of Kew (1865–1887).

KELWAY

A family of nurserymen based in Langport, Somerset, James Kelway (1815–1899) established the nursery in 1851, and began breeding delphiniums and gladioli. He was succeeded by his son William (born 1839), who took a similar interest in peonies. By the 1880s, Kelways was one of England's foremost nurseries for hardy perennial plants, a reputation they carried for most of the twentieth century.

KOUWENHOORN, PIETER VAN

(FL. 1620s-1630s)

Pieter van Kouwenhoorn (also written Couwenhoorn) was a glass painter, working in the 1620s and 1630s in Haarlem and Leiden; he was best known for his windows in the Annahofje in Leiden. The Lindley Library of the Royal Horticultural Society possesses an album of forty-six coloured drawings which he made, with the manuscript title 'lerzameling can bloemen naar de natuur geteekend door (Collection of howers drawn from nature by) *Pieter van Konzenhoorx*. It was obviously intended for publication, but never printed at the time.

LEE AND KENNEDY,

A celebrated nursery in Hammersmith, then to the west of London. James Lee (1715–1795) founded the Vineyard Nursery there in 1745; he was the author of An Introduction in Botary (1760 and later editions). In the later eighteenth century the firm introduced many exotic plants, including the first fuchsias and the first Australian plants. Lee's partner Lewis Kennedy (c1721–1782) was also a garden designer, with several gardens in Northumberland to his credit; his son John Kennedy (1759–1842) advised the empress Joséphine on her garden at Malmaison, and was issued with a special passport so that the Napoleonic Wars did not interrupt the supply of plants sent from his nursery.

LINDLEY, JOHN (1799-1865)

John Lindley was the son of a Norfolk nurseryman, whose debts he rashly undertook to pay off as a young man, and never succeeded in doing, despite holding down three simultaneous full-time jobs for much of his career: as Professor of Botany at University College, London, as editor of the gardening newspaper *The Gardeners' Chronick*, and as Assistant Secretary of the Horticultural Society, in which capacity he identified plants brought back by the Society's collectors, ran flower shows, edited the Society's publications, and much else. His personal library, bought by the Society after his death, formed the nucleus of the present-day Lindley Library.

LOUDON, JOHN CLAUDIUS (1783–1843) AND JANE WELLS (1807–1858)

Born in Scotland, John Claudius Loudon came to England at the beginning of the nineteenth century as an agricultural reformer and

landscape gardener. He founded England's first gardening and architectural magazines; published a massive *Encyclopaedia of Gardening* (1822 and later editions), the standard work of its period; and invented a wrought-iron glazing bar that made it possible to build gasshouses with iron frames. Becoming enthusiastic about as sciencefiction novel called *The Mummy* (1827), he arranged to meet the author. She turned out to be a young woman named Jane Wells Webb, whom Loudon married. Wells was also the author of several note gardening books, such as *Gardening for Ladies* (1840), *The Ladies' Companion to the Flower Garden* (1841), and *The Ladies Flower Garden* (four volumes, on annuals, perennials, and greenhouse plants, 1840–1848).

MASSON, FRANCIS (1741-1805)

Masson was a gardener at the Royal Gardens at Kew, and became the first collector sent from Kew to discover new plants abroad. His first expedition, in 1772-1773, was to the Cape of Good Hope, where he again collected plants between 1786 and 1795, having also travelled in the Canary Islands, West Indies, and Spain. On his return to England, he was accused of illicitly providing plants for the nursery of Lee and Kennedy (q.v.), but exonerated. He was given a year's leave to write his book *Stapeliae Novae* (1796–1797), and then sent to collect plants in Canada, where he died.

PARKINSON, JOHN (1567-1650)

Parkinson served as Apothecary and Herbarist to King James I. His plans for publishing a herbal to replace the older work of John Gerard (qx) were frustrated when a new edition of Gerard's book was produced in 1633. Parkinson's eventual herbal, *Theatrum Botanicum*, was published in 1640, but it was never reprinted. He enjoyed much greater success with a book on ornamental garden plants which he published in 1629: Paradisis in Sole Paradisus Terrestris, (The title is a pun: it means "The earthy paradis of Park-in-Sun') Parkinson had a garden in Long Acre, near Covent Garden in London, and the book, which was brought out in a second, posthumous edition in 1656, and was based on his practical experience of gardening.

PAXTON, SIR JOSEPH (1803-1865)

Paxton, the son of a Bedfordshire farmer, began his career in 1823 as a gardener at the Horticultural Society's garden at Chiswick. In 1826 the Duke of Devonshire appointed him head gardener at Chasworth, England, where he redesigned parts of the garden and built pioneering glasshouses. By the 1840s he was designing parks, gardens, and glasshouses on a vide scale; he was kniphted for his achievement in building the Crystal Palace to house the Great Exhibition of 1851. He edited two gardening magazines, the Horticultural Registrer (1831–1834) and Pazton's Magazine of Bolaru (1834–1849), as well as founding The Gardeners' Chronicle (1841) with John Lindley (q.v.). His only books were A Practical Treatise on the Calibration of the Dahlia (1838), and A Poaker Bolanual Dictionary (1840).

REA, JOHN (FL. 1620s-1677)

John Rea was a nurseryman in Shropshire, and the author of Restoration England's principal book on ornamental plants: *Flora, seu de Florum Cultura* (1665; second edition, 1676). Rea designed a garden for Baroness Gerard at Gerard's Bromley in Staffordshire. Lady Gerard's chaplain, Samuel Gilbert, who eventually became Rector of Quant in Shropshire, married Rea's daughter Minerva, and inherited Rea's plant collection. Gilbert went on to write the major gardening manual of the next generation: *The Florist's Vade-Mecam* (1682, and four subsequent editions).

REDOUTÉ, PIERRE-JOSEPH (1759-1840)

Redouté began his career as a botanical artist working for botanists like L'Héritier de Brutelle and Augustin Pyramus de Candolle, before he found a prominent patron in the empress Joséphine, for whom he illustrated two books on the rare plants in her garden. As his fame grew, he was able to eat as his wom publisher for grandiose projects in which his name appeared on the title page, instead of the botanists he hired to write the texts. His three major works were *Lx Lillaides* (1802–1816), an eight-volume work on bubb; the three-volume *Les Roses* (1817–1824); and *Choix des Plus Belles Fleurs* (1827). These are some of the world's finest examples of colour-printing, but the process was so expensive that Redoute never made a great profit from them. Opposite (left to right):

Peter Barr, John Gerard, John Lindley, Sir Joseph Paxton, James Veitch.

ROBINSON, WILLIAM (1838-1935).

Born in Ireland, Robinson trained as a gardener before becoming the horticultural correspondent for *The Times*, covering the Great Exhibition in Paris in 1867. His first two books were based on his French observations. In 1871 he founded a weekly magazine, *The Garden*, and in 1879 another, *Gardening Illustrated*. His books included *The Wild Garden* (1870), *Alpine Flowers for English Gardens* (1871), and *The English Flower Garden* (1833) and fourteen later editions). By the beginning of the twenniteh century he had become Englands major gardening writer.

ROLLISSON, WILLIAM (C1765-1842).

William Rollisson founded the Springfield Nursery at Tooting, then south of London, in the 1790s. He collected Cape heaths in South Africa, and began the first deliberate programme of plant hybridising, breeding hundreds of Cape heath varieties by the 1820s. Thereafter the turned his attention to orchids, which became a mainstary of the firm under his son, also William, who died in 1875. The nursery was closed in 1879, shortly before the death of George Rollisson, the last partner, who had spent his last fourteen years paralysed.

SWEET, ROBERT (1782-1835)

Sweet worked in his brother's Bristol nursery before moving to a series of similar jobs in London. From 1815 to 1819 he was foreman for Reginald Whitley (c1754-1835), who introduced white Chinese peonies to England, and then from 1819 to 1826 for James Colvill (1777-1832), a specialist in Cape bulbs. While working for Colvill he began publishing works on newly introduced plants, following the model of H. C. Andrews (q.v.), but hiring professional aritists: *Germaicaeu* (1820-1830); *From Australiaeu* (1827-1836); *Cistinae* (1825-1830); and *The British Flower Garden* (1823-1837). In 1826 he was charged with receiving plants stolen from Kew, but acquitted; in his later verse he became mentally unstable.

TOURNEFORT, JOSEPH PITTON DE (1656–1708)

Tournefort studied botany and medicine in Montpellier, taking his degree in 1682. The following year he took up a post at the Jardin de Rei in Paris, where he was to rise to the rank of Professor of Botany. He travelled throughout Europe collecting plants in the 1680s and 1690s, including a journey to Spain and Portugui in 1688-1689, but his major expedition was to the Near East in 1700–1702. His account of the journey was translated into English in 1718 as A Voyage into the Levant. Two years before he died he was made a Professor at the College Royal. His Institutiones Rei Botanicae (1700) outlined the first widely accepted system of classification for plants.

TRADESCANT, JOHN, THE ELDER (C.1570–1638) & YOUNGER (1608–1662)

The elder Tradescant was gardener to the Earl of Salishury, both at Hatfield House, Hertfordshire, and in London; he also designed and minitained gardens for Sir Edward Wotton, the Duke of Buckingham, and others. He made two plant-collecting expeditions, to Russia in 1618, and to North Africa in 1620. In 1630 Charles I made him responsible for the royal garden at Oatlands, Surrey, and in this role he was succeeded in 1638 by his son, also named John. The younger John made three journeys to 'Virginia', i.e. the British colonies in North American, in 1637, 1642, and 1654, and helped to introduce many American plants. In 1638 he published *Museum Tradescantianum*, an account of the rarities in his personal museum; after his death this collection was acquired by Elias Ashmole to form the basis of what is now the Ashmolean Museum in Oxford.

VEITCH

A family of nurserymen. James Veitch (1792–1863) left the family nursery in Devon and bought the already famous nursery of Knight and Perry in Chelsea in 1853. The firm soon became perhaps the world's most famous nursery for plant introductions and breeding. It was at the Veitch nursery in Chelsea that the first hybrid orchid was breed in the 1850s by John Dominy; John Seden raised the first hybrid tuberous begonia there. Veitch employed such famous collectors as William and Thomas Lobb and Charles Maries. James's son John Gould Veitch (1839–1870) collected plants in China and Japan in the 1860s, as did his son James Herbert Veitch (1868–1907). The last director, Sir Harry James Vietch (1840–1924), closed the nursery in 1914.

WEINMANN, JOHANN WILHELM (1683–1741).

(1083 - 1741).

Weinmann was a wealthy apothecary in Regensburg, Germany, He built up a collection of botanical drawings: among the artists he hired was the young Georg Dionysius Ehret (1708–1770), later to become the most famous botanical artist of the eighteenth century. In 1734 he began to publish an immense illustrated work on cultivated plants entitled *Phytamthoza*, hiring the botanist J. G. N. Diderichs to write the text. Frustratingly, none of the illustrations are attributed to their artists. Weinmann died before the book was completed in 1747.

LIST OF ILLUSTRATIONS

All images sourced from the Lindley Library of the Royal Horticultural Society. Please note that some of the images appearing in this book are details from the existing artworks.

3 Nerine cultivar, from drawings made by Lilian Snelling (1879-1972) for her patron, Henry John Elwes, in the 1910s, 4 Abraham Munting, Phytographia Curiosa (1704). 7 Royal autograph of Queen Victoria, the Lindley Library. 9 Jacob Breyne, Exoticarum (1678). 10 (left) Vredeman de Vries, Hortorum Viridiarorumque Elegantes et Multiplicis Forma (1583); (right), Crispijn van de Passe, Hortus Floridus (1614) 13 (left), Jan Commelijn, Nederlandtze Hesperides (1676), artist Nicolaes de Vree; (right), Journal of Horticulture (1875). 14-15 Winter aconite from the Hortus Floridus (1614) of Crispijn van de Passe. 18 Stephen Switzer, Ichnographia Rustica: or, The Nobleman, Gentleman, and Gardener's Recreation (1718)21 Lilium martagon, from Viridarium Reformatum (1719) by Michael B. Valentini, 22 Arum maculatum from a drawing by Pierre-Jean-François Turpin (1775-1840). 23 Arum orientale ssp engleri from a drawing by John Paul Wellington Furse (1904-1976). 24 Arum dioscoridis from John Sibthorp, Flora Graeca (1806-1840), illust. by Ferdinand Bauer. 25 Fritillaria meleagris from drawings by Pieter van Kouwenhoorn (fl. 1630s) 26 Anemone nemorosa from a drawing by Pierre-Jean-Francois Turpin (1775-1840), 27 Adonis annua from a drawing by Pierre-Jean-Francois Turpin (1775-1840). 28-29 Lavandula from a coloured copy of the Kreutterbuch (second edition, 1586) by Pierandrea Mattioli, edited by Joachim Camerarius (artist unknown). 30-31 Digitalis grandiflora; Digitalis

purpurea from the original drawings by Ferdinand Bauer, made for John Lindley's Digitalium Monographia (1821). 32-33 Lilium martagon; Lilium candidum from drawings by Pieter van Kouwenhoorn (fl. 1630s). 34 Lilium candidum vas. purpureum from the Hortus Nitidissimis (1750-1792) of Christoph Jakob Trew (artist unknown). 35 Crocus sativus from Choix des Plus Belles Fleurs (1827) illust, by Pierre-Joseph Redouté. 36 Scilla liliohyacinthus from the Hortus Romanus (1772-1784) of Giorgio Bonelli 37 Bellis perennis cultivars, from a coloured copy of Anthologia Magna (1626) by Theodor de Bry. 38-39 English auriculas from Aurikel Florg by F. A. Kannegieser (1801). 40-41 Auriculas: Bertles' 'Royal Sportsman' and Redman's 'Metropolitan' both from The Florist's Delight (1789-1791), written and illust. by James Sowerby. 42 A polyanthus: Willett's 'Duke of Cumberland' from The Florist's Delight (1789-1791), written and illust. by James Sowerby. 43 Alpine auricula 'A. F. Barron' from the Floral Magazine for 1880, illust. by John Nugent Fitch (1840 - 1927)44 Primula vulgaris from English Botany (1790-1814), illust, by lames Sowerby with text by Sir lames Edward Smith. 45 Erythronium denis-canis from a drawing by Pieter van Kouwenhoorn (fl.1630s). 46-47 Erythronium denis-canis from the Hortus Floridus (1614) of Crispijn van de Passe. 48 Ornithogalum nutans from a drawing by Pieter van Kouwenhoorn (fl. 1630s). 49 Narcissus jonguilla from the Leçons de Flore (1820) by

Jean-Louis-Marie Poire and Pierre-Jean-François Turpin, and illustrated by the latter. 50-51 Narcissus from *Plantae per Galliam*. *Observature* (1714) by Jacques Barrelier (artist unknown). 52 Narrisus penadosarnisus from *Edwardt' Ilerdal* (1770), written and illustrated by John Edwards: 53 Narrisus x isomparabilis' from Magasin für Bhomter (1803–1809), illust. by August Pfeiffer (text by Olof Swardz).

54 Narcissus taxetta from Magasin för Blomster (1803–1809), illust. by August Pfeiffer (text by Olof Swartz).

55 Galanthus 'Atkinsii' from a drawing made in 1908 by Edward Augustus Bowles (1865-1954). 56-57 Carnation cultivars from anonymous German drawings of the seventeenth century, from the collection of Christian Wenzel van Nostitz-Reineck (1649-1712). 58-59 Dianthus cultivars from anonymous German drawings of the seventeenth century, from the collection of Christian Wenzel van Nostitz-Reineck (1649-1712). 60 Gould's 'Duke of York' carnation from The Florist's Guide (1827-32) by Robert Sweet, illust. by Edwin Dalton Smith 61 Dianthus barbatus from Edwards' Herbal (1770), written and illustrated by John Edwards. 62-63 Two pinks: Davey's 'Juliet' (left), and Ford's 'William of Walworth', both from The Florist's Guide (1827-32) by Robert Sweet, illust. by Edwin Dalton Smith. 64 Geranium pratense from the Herbier Générale de l'Amateur (1816-1827) by J. C. M. Mordant de Launay and J. L. A. Loiseleur-Deslongchamps, illust. by Pancrace Bessa. 65 Aquilegia vulgaris var. flore-pleno from Edwards' Herbal (1770), written and illustrated by

66 Allium moly from an anonymous German drawing of the seventeenth century. 67 Allium moly from Les Liliacées (1802-1816) illust. by Pierre-Joseph Redouté. 68 Helleborus niger from Medical Botany (1790) by William Woodville, illust, by James Sowerby 69 Gagea lutea and Armeria maritima from a drawing by Pieter van Kouwenhoorn (fl. 1630s). 70 Lathurus odoratus from Choix des Plus Belles Fleurs (1827) illust. by Pierre-Joseph Redouté. 71 Lathurus odoratus cultivars from a chromolithograph published in Le Jardin in 1908 72 Hollyhock from A Selection of Flowers (1821-1822), written and illust. by Valentine Bartholomew. 73 Delphinium from The Ladies' Flower-Garden of Ornamental Perennials (1843-44) by Jane Loudon (artist unknown). 74 An unnamed pansy cultivar from Les Pensées (1869) by Jean-Pierre Barillet-Deschamps (artist unknown). 75 Viola tricolor 'Grandiflora', from Flora by Hendrik Witte (1880). illust, by A. I. Wendel 76-77 Carling acanthifelia from Carlo Allioni, Flora Pedemontana (1785). illust. by Francisco Peyrolery. 78 Helianthemum canescens Iname obsolete], from Robert Sweet, Cistineae (1825-1830), illust. by I. Hart. 79 Cistus × purpureus from Robert Sweet, Cistineae (1825-1830), illust. by M. Hart. 80 Campanula medium 'Calycanthema' from The Floral Magazine for 1873, illust, by James Andrews 81 Gentiana acaulis from a drawing by Pieter van Kouwenhoorn (81630s)

John Edwards.

Repository (1797-1815), written and

82 Lilium bulbiferum from Edwards' Herbal (1770), written and illust. by John Edwards.

83 Geum rivale from the Botanisches Bilderbuch (1794–1901) by Johann Friedrich Peter Dreves and Friedrich Gottlob Heyne.

 84–85 Narcissus from Crispijn van de Passe, *Hortus Floridus* (1614).
 89 Anemones from Crispijn van de

Passe, Hortus Floridus (1614). 90 Garden scene from Daniel Rabel, Theatrum Florae (1633).

92–93 Cyclamens from *Phytanthoza* (1734–1747) by Johann Wilhelm Weinmann.

94–95 Cyclamens; roses *Paradisi in Sole Paradisus Terrestris* (1629) by John Parkinson (artist unknown).

96 Roses with *Nigella damascena* from a drawing by Michiel van Huysum (c.1704–1760).

97 Rosa sulphurea, from Les Roses (1817–1824) by Pierre-Joseph Redouté. 98 Fritillaria imperialis from Edwards' Herbal (1770), written and illustrated by John Edwards.

99 Crown imperial with a tulip, from De Koninglycke Hovenier (1676), illust. by Hendrik Cause.

100 Fritillaria persica from Nicolas Robert, Variae ac Multiformes Florum (c.1660).

101 Fritillaria imperialis, from a drawing by Pieter van Kouwenhoort (fl. 1630). 102 Iri: sparia, from a drawing made in 1824 by John Curtis (1791–1862). 103 Iris persica, from The Compleat Forist (1747) (artist unknown). 104 Crosse sasiannes, from the Botanical Magazine for 1803, illust. by Sydenham Teast Edwards.

105 Colivirum antummale, from Les Litanére (1802–1816) illust, by Pierre-Joseph Redouté. 106 Crecus cultivars from Phytanthoian (1734–1747) by Johann Wihlelm Weinmann (artist unknown). 107 Anemone cultivars from Phytanthoia (1734–1747) by Johann Wihlelm Weinmann (artist unknown). 108–109 Anemone cultivars from

Phytanthoza (1734-1747) by Johann Wilhelm Weinmann (artist unknown), 110 Anemone cultivars from the Florilegium (1612) of Emanuel Sweert. 111 Tulip cultivars from the Florilegium (1612) of Emanuel Sweert. 112-113 Tulips from drawings by Pieter van Kouwenhoorn (fl. 1630s). 114-115 Tulip 'Orange Duc Thol' from a drawing attributed to August Wilhelm Sievert (died 1751). 116 Tulip 'Lord Holland' from The Florist's Guide (1827-1832), by Robert Sweet, illust. by Edwin Dalton Smith. 117 Tulip 'Peregrinus Apostolicus' from The Florist's Delight (1789-1791), written and illustrated by James Sowerby. 118 Hyacinth 'Koning van Groot Britanien' from the Hortus Nitidissimis (1750-1792) of Christoph Jakob Trew (artist unknown) 119 Hyacinth cultivars from the Florilegium (1612) of Emanuel Sweert. 120 Hyacinthus cultivar, from Choix des Plus Belles Fleurs (1827) illust, by Pierre-Joseph Redouté. 121 Hyacinth cultivars from Phytanthoza (1734-1747) by Johann Wilhelm Weinmann (artist unknown). 122 Hyacinth 'Lyra Grandis' from The Florist's Guide (1827-1832), by Robert Sweet, illust. by Edwin Dalton Smith. 123 Hyacinth 'Prince Albert Victor' from The Florist and Pomologist for 1867, illust. by James Andrews. 124 Ranunculus 'Le Mélange des Beautés' from The Florist's Guide (1827-1832), by Robert Sweet, illust. by Edwin Dalton Smith. 125 Ranunculus 'Vereatre', from The Florist's Guide (1827-182) by Robert Sweet, illust, by Edwin Dalton Smith. 126 Ranunculus 'Gadwin Douglas' from The Florist's Guide (1827-1832), by Robert Sweet, illust, by Edwin Dalton Smith 127 Ranunculus 'Cupid', from The Florist's Guide (1827-1832), by Robert Sweet, illust, by Edwin Dalton Smith,

128 Lychnis chalcedonica from a drawing

by Pieter van Kouwenhoorn (fl. 1630s).

129 Silene coeli-rosa, from the Botanical

by Sydenham Teast Edwards. 130-131 Poppy cultivars from Phytanthoza (1734-1747) by Johann Wilhelm Weinmann (artist unknown). 132 Scabiosa from Phytanthoza (1734-1747) by Johann Wilhelm Weinmann (artist unknown). 133 Tanacetum coccineum (pyrethrum) cultivars from The Illustrated Rouauet (1857-1864), edited by E. G. and A. Henderson, illust. by Augusta Innes Withers 134-135 from De Koninglycke Hovenier (1676), illust. by Hendrik Cause, 139 Aloe vera, from Abraham Munting Phytographia Curiosa (1704) 140 unidentified plant from Exoticarum (1678) by Jacob Brevne. 142 Kniphofia uvaria, from a series of drawings by Pierre Ledoulx (1730-1807) and other artists, made between 1792 and 1815, depicting plants in the garden of I, van Huerna of Bruges. 143 Agapanthus africanus from Les Liliacées (1802-1816) illust, by Pierre-Joseph Redouté. 144-145 Nerine cultivars, from drawings made by Lilian Snelling (1879-1972) for her patron, Henry John Elwes, in the 1910s 146-147 Zantedeschia aethiopica from the Botanical Magazine for 1805, illust. by Sydenham Teast Edwards. 148 Crinum bulbispermum from an anonymous drawing of the early nineteenth century. 149 Sparaxis grandiflora from Les Liliacées (1802-1816) illust. by Pierre-Joseph Redouté. 150-151 Crinum augustum from Priscilla Susan Bury, A Selection of Hexandrian Plants (1831-1834) 152-153 Crinum pedunculatum and a hybrid crinum from Priscilla Susan Bury, A Selection of Hexandrian Plants (1831-1834), 154-155 Brunsvigia grandiflora from the Botanical Revister (1830), illust, by M. Harr

Magazine for 1795, probably illustrated

156-157 Protea repens from the Botanist's

illustrated by Henry Charles Andrews. 158-159 Protea compacta and Protea cordata from the Botanist's Repository (1797-1815), written and illustrated by Henry Charles Andrews. 160-161 Statelia chyteata and Statelia deflexa, from Stapeliarum in Hortis Vindobonensibus Cultarum Descriptiones (1806-1820) by Nicolaus Joseph Freiherr von Jacquin. 162-163 Stapelia glauca and Stapelia pedunculata, from Stapeliarum in Hortis Vindobonensibus Cultarum Descriptiones (1806-1820) by Nicolaus Joseph Freiherr von Jacquin. 164-165 Stapelia campanulata from Stapeliae Novae (1796-1797) by Francis Masson 166 Othonna hulbosa from Exoticarum (1678) by Jacob Brevne. 167 Lobelia speciosa from The British Flower Garden (1823-1838) by Robert Sweet, illust, by J. Hart, 168 Erica obbata from Coloured Engravings of Heaths (1794-1830), written and illustrated by Henry Charles Andrews. 169 Erica cerinthoides from Exoticarum (1678) by Jacob Breyne. 170-171 Erica coronata and Erica vestita, from Coloured Engravings of Heaths (1794-1830), written and illustrated by Henry Charles Andrews. 172 Gladiolus carneus from the Hortus Sempervirens (1796-1830) of Johann Simon Kerner. 173 Gladiolus undulatus from Les Liliacées (1802-1816) illust. by Pierre-Joseph Redouté 174 Gladiolus primulinus from the Botanical Magazine (1906), illust, by Matilda Smith 175 Gladiolus Gandavensis hybrid from Paxton's Magazine of Botany (1844). 176 Amaryllis belladonna, from a drawing by John Paul Wellington Furse (1904-1976) 177 Gladiolus primulinus hybrids, from Revue Horticole for the year 1910. 178-179 Babiana nana from the Botanist's Repository (1797-1815),

written and illustrated by Henry Charles Andrews 180 Pelargonium inquinans from Neue Arten von Pelargonien (1825-1831) by Leopold Trattinick 181 Pelargonium triste from Canadensium Plantarum (1635) by Jacques Cornut. 182-183 Pelargonium cultivars from A Treatise on the Cultivation of the Pelargonium (1847), by Edward Beck, illust. by Sarah Ann Drake (left) and Samuel Holden (right). 184 Gerbera jamesonii from the Botanical Magazine (1889), illust. by Matilda Smith 185 Gazania splendens from The Illustrated Rouquet (1857-1864). edited by E. G. and A. Henderson, and illustrated. by Charlotte Caroline Sowerby. 186 Nemesia strumosa from the Botanical Magazine (1893), illust, by Marilda Smith 187 Crocosmia aurea from Flore des Serres et des Jardins d'Europe for 1850-1851 188 Freesia cultivars from the Revue Horticole for the year 1907. 189 Saintbaulia cultivars from the Revue Horticole for the year 1901. 190-191 Aloe varievata and A. sabonaria from Phytanthoza (1734-1747) by Johann Wilhelm Weinmann (artist unknown). 192-193 Helianthus annuus from Crispijn van de Passe, Hortus Floridus (1614). 196 Canna indica, from the Herbarium Amboinense (1741-1750) of Rumphius (Georg Eberhard Rumpf) 199 Passionflower, from Jardin d'Hyper (1616) by Jean Francau. 200 Passiflora × caeruleo-racemosa. from the Transactions of the Horticultural Society for 1830 (artist unidentified) 201 Passiflora caerulea, from the Traité des Arbres et Arbustes (1801-1825) by Duhamel du

Monceau, revised by J. H. Jaume Saint-Hilaire et al., illust. by Pierre-Joseph Redouté. 202-203 Hippeastrum striatum from Priscilla Susan Bury, A Selection of Hexandrian Plants (1831-1834). 204-205 Hippeastrum aulicum (left) and H. psittacinum (above), from Priscilla Susan Bury, A Selection of Hexandrian Plants (1831-1834). 206 Fuchsia magellanica from the Traité des Arbres et Arbustes (1801-1825) by Duhamel du Monceau, revised by Jaume Saint-Hilaire et al., illust, by Pierre-Joseph Redouté. 207 Fuchsias, from Les Promenades de Paris (1867-1873) by Adolphe Alphand, illust. by P. Lambotte. 208-211 Victoria amazonica, from Sir William Jackson Hooker, Victoria Regia (1851). 212 Buddleja globosa from the Botanical Magazine for 1791, illust. by Sydenham Teast Edwards. 213 Calceolarias, raised by Mr Green, head gardener to Sir Edmund Antrobus at Cheam, Surrey, from the Florist's Journal for 1841 214-215 Calceolaria cultivars (above) from The Illustrated Bouquet (1857-1864), edited by E. G. and A. Henderson, illust. by Charlotte Caroline Sowerby, and (right) from Flore des Serres et des Jardins d'Europe for 1847. 216 Two petunia cultivars, with an achimenes, from The Illustrated Bouquet (1857-1864), edited by E. G. and A. Henderson, and illust. by Charlotte Caroline Sowerby, 217 Verbena cultivars from The Illustrated Bouquet (1857-1864), edited by E. G. and A. Henderson, and illust. by James Andrews. 218 The Duke of Devonshire's hybrid Nymphaea, from the Botanical Magazine (1852), illust. by Walter Hood Fitch. 219 Canna indica, from an anonymous nineteenth-century

drawing.

220–221 Gunnera scabra from Flore des Serres et des Jardins d'Europe for 1869–1870.

222 Polianthes tudersus from Choix des Plus Belles Fleurs (1827) illust. by Fierre-Joseph Redoute. 223 Tropaoslum majus from. Medical Botang (1709) by William Woodville, illust. by James Sowerby. 224 Sakuis patens from the Transactions of the Horticaltural Society for 1842, illust. by Sarah Ann Drake.

225 Lupinus perennis from the Botanical Magazine for 1793, illust. by Sydenham Teast Edwards. 226-227 Tradescantia virginiana and varieties, from drawings by Pieter van Kouwenhoorn (fl. 1630s) in the RHS Lindley Library (left) and from Phytanthoza (1734-1747) by Johann Wilhelm Weinmann, right. 228-229 Helianthus annuus (left) from Abbildung aller Oekonomischen Pflanzen (1786-96), written and illustrated by Johann Simon Kerner, and (right) from a drawing made in 1816 by James Sowerby (1757-1822) 230-231 Lilium superbum from Plantae Selectae (1750-1765) by Christoph Jakob Trew, illust, by Georg Dionysius Ehret. 232 Oenothera biennis, from volume 23 (1896) of H. G. L. Reichenbach's Icones Florate Germanicae, written and illust. by E.G. Kohl. 233 Aster novae-angliae from La Flore et la Pomone Française (1828-1833), written and illustrated by Jean-Henri Jaume Saint-Hilaire. 234 Rudbeckia pinnata from a drawing by James Sowerby (1757-1822), for the 1822 volume of the Botanical Magazine. 235 Rudheckia hirta from L'Art de Peindre les Fleurs à l'Aquarelle (1834) by Augustine Dufour. 236 Agave americana from

Phytanthoza (1734-1747) by Johann Wilhelm Weinmann. 237 Cereus eriophorus from Abbildung und Beschreibung Blühender Cacteen (1838-1850) by Ludwig G. C. Pfeiffer and Christoph Friedrich Otto. 238-239 Cereus curtisi (left) and Echinocactus pfeifferi (right) from Abbildung und Beschreibung Blühender Cacteen (1838-1850) by Ludwig G.C. Pfeiffer and Christoph Friedrich Otto. 240 Dahlia 'The Sovereign' from a drawing by James Sillett (1764-1840). 241 Double dahlia from Choix des Plus Belles Fleurs (1827) illust, by Pierre-Joseph Redouté. 242 Dahlia 'The Queen', from The Parterre (1842) by James Andrews. 243 Dahlia 'Picta Formisissima' from the Horticultural Journal for the year 1833, after a drawing by Alfred Chandler. 244-245 Pompon and lilliput dahlias from The Illustrated Bouquet (1857-1864), edited by E. G. and A. Henderson, illust. by Augusta Innes Withers (pompon) and Charlotte Caroline Sowerby (lilliout) 246 Eschscholzia californica from Floral Illustrations of the Seasons (1829) by Margaret Roscoe. 247 Gaillardia picta from The British Flower Garden (1823-1838) by Robert Sweet, illust. by S. Humble. 248 Nemophila insignis from The British Flower Garden (1823-1838) by Robert Sweet, illust. by J. Hart. 249 Coreopsis grandiflora from Floral Illustrations of the Seasons (1829) by Margaret Roscoe. 250 Penstemon avatus from Floral Illustrations of the Seasons (1829), by Margaret Roscoe. 251 Tagetes erectus from Raccolta di Fiori Frutti e Agrumi (1822-1825), by Antonio Targioni-Tozzetti. 252 Calochortus macrocarpus,

drawing made for publication in *The New Plantsman* (1994) by Lawrence Greenwood.

253 Calochortus albus and C. pulchellus, made in 1833 from

drawings by Sarah Ann Drake.

254 Nopalxocia ackermannii from the Botanical Register (1830), illust. by M. Hart.

255 Euphorbia pulcherrima from Paxton's Magazine of Botany (1838), illust. by Samuel Holden.

256 Gilia tricolor, from The British Flower Garden (1823-1838) by Robert Sweet, illust, by Frederick W. Smith.

257 Zinnia elegans from Flore des Serres et des Jardins d'Europe (1858).

258 Alternanthera versicolor from

Illustration Horticole (1865), illust. by P. Stroobant.

259 Iresine herbstii from the Floral Magazine (1865), illust. by James Andrews

260 Begonia × sedeni from the Florist and Pomologist (1869), illust. by Walter Hood Fitch.

261 Begonia rex from The Illustrated Bouquet (1857–1864), edited by E. G. and A. Henderson, illust. by Iames Andrews.

262-263 Nerium odorum, from a drawing (c.1780s) by Augusta Smith.

266 Anemone 'Honorine Jobert' from a drawing by Ruth Collingridge (1920s). 269 Banksia coccinea from Illustrationes Florae Novae Hollandiae (1813) by Robert Brown, illust. by Ferdinand Bauer.

270 Hibiscus rosa-sinensis from a drawing by Georg Dionysius Ehret (1708–1770). 271 Hibiscus rosa-sinensis from a series of drawings by Pierre Ledoulx

(1730-1807) and other artists, made between 1792 and 1815, depicting plants in the garden of J. van Huerna of

Bruges. 272 Hemerocallis flava from Les Liliacées (1802–1816) illust. by Pierre-Joseph

Redouté 273 Impatiens balsamina from the Flora

Indica Malabarica (1678–1703) by Adriaan Rheede tot Drakestein. 274 Likma Inacifikam "Flora Pleno" from the Florit and Pomologic (1871) illust, by Walter Hood Fitch. 275 Likma specinaum from Flora Japonica (1835-1870) by Philipp Franz von Siebold, illust, by Sebastian Minsinger. 276 Il fydraugen anerophylle 'Orakse' from Flora Japonica (1835-1870) by Philipp Franz von Siebold, illust, by Sebastian Minsinger.

277 Iris sanguinea from the Hortus Sempervirens (1796–1830) of Johann Simon Kerner.

Smon Reinet. 278–279 Hydramga japonizu (left) and H. marapphila: Belzonii (right) from Fora Japonici (1855–1870) by Philipp Franz von Siebold, illuszt, by H. Popp. 280–281 Cambling japonizu "Anemonitori" (left) and "Variegata" (hight) from Illustrations of the Natural Order of ... Camelliner (1830–1831) by Alfred Chandler and William Beattie Booth, illuszt, by Alfred Chandler. 282–283 Camellia japonizu cultivars (left) from a farwing by Caroline Maria

Applebee (died 1854), and (right) from the Transactions of the Horticultural Society for 1830, illust. by Augusta Innes Withers.

284 Banksia serrata from the Botanist's Repository (1797–1815) written and illust, by Henry Charles Andrews. 285 Dryandra longifolia from Flora Australasica (1827–1828) by Robert Sweet, illustrated by Edwin Dalton Smith.

286 Patersonia lanata from Flora Australasica (1827–1828) by Robert Sweet, illustrated by Edwin Dalton Smith.

287 Leschenaultia biloba from the Botanical Register (1842) illust. by Sarah Ann Drake

288 Hebe (formerly Veronica) colensoi from Curtis's Botanical Magazine (1893)

illust. by Matilda Smith. 289 Grecillea rosmaniflora from Flora Australasica (1827–1828) by Robert Sweet illust by Edwin Dalton Smith

Sweet, illust. by Edwin Dalton Smith. 290–291 Chrysanthemum indicum, from *Keikwa-hyakkugiku* [One Hundred Chrysanthemums] by K. Hasegawa

(1891).

292 Chrysanthemum 'Gloria Mundi' from a drawing by Walter Hood Fitch (1817-1892).

293 Chrysanthemum 'Alfred Salter' from *The Chrysanthemum* (1855) by John Salter, illust. by James Andrews. 294 A Japanese anemone-flowered chrysanthemum, from the 1886–1887 catalogue of the firm of Norman Davis of Camberwell.

295 Hosta lancifolia from The Ornamental Flower Garden by Robert Sweet, illust. by Frederick W. Smith.

296 Rosa gallica var. officinalis from Les Roses (1817–1824) illust, by

Pierre-Joseph Redouté. 297 Rosa × borbonica from Les Roses

(1817-1824) illust. by Pierre-Joseph Redouté.

298 Rose 'Duchesse de Morny' from Roses et Rosiers, a collective publication (1872), illust. by Maubert.

299 Rosa × Iheritieriana from Les Roses (1817-1824) illust. by Pierre-Joseph Redouté.

300 Rosa banksiae from a drawing by an anonymous Chinese artist,

commissioned in the 1810s-1820s by John Reeves.

301 Rose 'Maréchal Niel' from Roses et Rosiers, a collective publication (1872), illust. by Maubert.

302 Paeonia suffruticosa cultivar from a drawing by an unknown Chinese artist, commissioned in the 1810s–1820s by John Reeves.

303 Paeonia officinalis from Choix des Plus Belles Fleurs (1827) illust. by

Pierre-Joseph Redouté. 304-305 Paeonia suffruticosa cultivar from the Botanist's Repository

(1797-1815) written and illust. by Henry Charles Andrews.

306-307 Rhododendron falconeri (left) and Rhododendron wightii (right) from the Rhododendrons of Sikkim-Himalaya (1849-1851) by Sir Joseph Dalton

Hooker, illust. by Walter Hood Fitch. 308 Clematis florida from the Botanist's Repository (1797–1815) written and illust. by Henry Charles Andrews. 309 Clematis florida 'Bicolor' from the Botanical Register (1838) illust. by Sarah Ann Drake.

310 Iris japonica from a drawing attributed to August Wilhelm Sievert (died 1751).

311 Iris laevigata from a drawing made by a Miss Williamson for Ellen

Willmott during the years 1904–1908, apparently from varieties flowering in her garden at Warley Place, Essex. 312–313 *Iris kaempferi* cultivars, from a catalogue of the Yokohama Nursery

Company issued c.1900. 314 Meconopsis grandis from a drawing made in 1916 at the Royal Botanical

Garden, Edinburgh, by Lilian Snelling (1879–1972). 315 Allium caeruleum from the Botanical

315 Altum caeruleum from the Botanical Register (1840) illust. by Sarah Ann Drake.

316 Aspidistra elatior from Atlas des Plantes de Jardins et d'Appartements (1896) by Désiré Bois.

317 Aspidistra lurida, from The Botanical Magazine (1824) illust. by John Curris. 318–319 Aesdynanthus speciosus (left) and A. grandiflorus (right) Paxton's Magazine of Botany (1847 and 1838 respectively), the former illust. by Samuel Holden.

320 Renealmia racemosa from a drawing made in 1823 by John Henry Lance. 321 Alpinia speciosa from a series of 100 drawings by unknown nineteenth-century Chinese artists. 324 Mezzotint engraving of Sir John Hooker, after Frank Stone.

JNDEX

Page numbers in *italics* refer to captions/illustrations

Achimenes 216 Adonis 16 annua 26, 27 vernalis 26 Aeschryanthus: grandiflorus (A. parasiticus) 319, 319 speciosus 318, 319 splendidus 319 Agapanthus africanus (A. umbellatus) 143, 143 Agave americana 194, 236, 236 Allium 16 86 caeruleum 314 315 cernuum 197 moly 66, 67, 67 Alor 136, 139 sabonaria disticha 191, 191 variezata 190, 190 rieng 190 Albinia renealmia racemosa 320, 320 speciosa 320, 321 Alternanthera versicolor 258, 258 Amaryllis 10, 137, 155 belladonna 153, 176, 176 Anemone 13, 16, 86 calcedonica 89 coronaria 107 De Caen strain 110 cultivars 107, 107, 108. 108. 109, 110, 110 'Honorine Jobert' 266 japonica (A. hupehensis) 267 nemorosa (wood anemone) 16. 26, 26 'Allenii' 26 pavonina 107, 108 Aquilegia 16 chrysantha 64 vulgaris var. flore-pleno 64, 65 Armeria maritima 68, 69 dioscoridis 24, 24 maculatum 22, 22 orientale ssp. engleri 22, 23 Aspidistra: elatior 316, 316 lurida 316. 317 Aster (Michaelmas daisy) 10 novae-angliae 197, 232, 233 novi-heloii 232

tradescantia 232 Auricula 16, 17, 38–9, 39 'A.E. Barron' 42, 43 alpine 41, 42, 43 'Metro-Politan' 41, 41 'Royal Sportsman' 40, 40 'Rule Arbiter' 40 Babiana nana 178, 178, 179

Ranksia 11. 265 coccinea 269 integrifolia 284 serrata 284, 284 bedding 12-13, 13, 198, 251, 258 Begonia 13, 138 rex 260, 261 × sedeni 260, 260 Bellis perennis cultivars 36, 37 books 16-19 botanical drawing 6 breeding 12 Brunsvigia 137, 153 grandiflora 154-5, 155 Buddleia 197 globosa 212, 212 cacti 136, 198 Calceolaria 12, 138, 195, 212, 213, 214, 214, 215 biflora 212 corymbosa 212 integrifolia 212

Callicarpa dichotoma 185 Calochortus 198 albus 253, 253 macrocarpus 252, 253 pulchellus 253, 253 Camellia 11, 12, 265 japonica: 'Anemoniflora' 280, 281 'Chandleri Elegans' 282 cultivars 282, 282, 283 'Variegata' 281, 281 Campanula medium 'Calycanthema' 80, 80 Canna indica 194, 196, 219, 219 Carlina acanthifolia 76-7, 77 Carnation 8, 12, 16, 17 cultivars 56, 57, 57 'Duke of York' 60, 60 Malmaison 57 Cereus curtisi 238, 239 eriophorus 236, 237 Chrysanthemum 12, 264, 265 267 'Alfred Salter' 292, 293 anemone-flowered 294, 295 'Gloria Mundi' 292, 292 indicum 200_200_1

Clematis 267 florida 308, 308 'Bicolor' 308, 309, 309 × iackmanii 309 montana 308 patens 308 Colchicum 86 autumnale 104, 105 Coreopsis: coronata 248 grandiflora 248, 249 Crinum 10, 137 augustum 150, 150-1 bulbispermum 149, 149 hybrid 153, 153 pedunculatum 152, 153 Crocosmia 141 aurea 186, 187 Crocus 8, 86 cultivars 106 106 sativus 35, 35 susianus (C. angustifolius) 104 104 vernus 104 crown imperial see Fritillaria imperialis Cyclamen 4, 8, 86, 92-3, 93, 94.94 persicum 87, 93 daffodil ser Narrissus Dahlia 12, 195 double 240, 241 lilliput 244, 245 Picta Formosissima' 243, 243 pompon 245, 245 'The Queen' 242, 243 'The Sovereign' 240, 240 davlilv see Hemerocallis Delphinium 16, 20, 73, 73 elatum 73 Dianthus 16-17 see also Carnation; Pink barbatus (sweet william) 12. 17 61 61 carvophyllus 17, 57 cultivars 58-9, 59 gratianopolitanus 17 plumarius 17 plumosus 62 Divitalis: grandiflora (D. ambigua) 30, 31 purpurea 31, 31 double flowers 8, 16, 19 Dryandra 265 longifolia 285, 285

Cietus 19

× burbureus 79, 79

Echinocactus pfeifferi 239, 239 Epiphyllum ackermannii 255 Erica 137 cerinthoides 168, 169 coronata 170, 171 obbata 168, 168 vestita 171, 171 Eryngium giganteum 77, 91 Erythronium 8, 86 denis-canis 16, 44, 45, 46, 46.7 grandiflorum 198 Eschscholzia californica 198, 246. 247 Euphorbia pulcherrima 255, 255 evening primrose see Oenothera florists' flowers 10, 12 Freesia 141 cultivars 188, 189 refracta 189 Fritillaria 8, 16, 86 imperialis (crown imperial) 86, 90, 98, 98, 99, 101, 101 meleagris 25, 25 persica 100, 101 Fuchsia 12, 195 fulgens 206 megallanica 206, 206, 207 Gagea lutea 68, 69 Gaillardia aristata 198. 246 × grandiflora 246 picta 246, 246 pulcella 246 Galanthus (snowdrop) 91 'Atkinsii' 55, 55 gardens 16th-century 10 17th-century 10, 21, 90 18th-century 13, 18 19th-century 13 Chinese 268 Japanese 268, 313 Gazania 141 rigens 185 splendens 185, 185 Gentiana acaulis 81. 81 sino-ornata 268 Geranium: pratense 64, 64 robertianum 64 Gerbera 141 iameronii 184 185 Geum: chiloense 83 rinal 82 82 Gilia 198

Gladiolus 137-8 carmeus 172, 172 Gandavensis (Ghent) hybrid 174.175 nanus see Babiana nana primulinus 174, 174, 176 Primulinus hybrids 174, 176. 177 undulatus 173, 173 Grevillea 11, 265 rosmariniflora 288, 289 Gunnera manicata 220 scabra (G. chilensis) 220. 220-1 Hehe colensoi 289, 289 speciosa 267 Helianthemum canescens 78, 79 umbellatum 19 Helianthus (sunflower) 10 annuus 192-3, 194, 228, 229 220 Helleborus niger 68, 68 Hemerocallis (daylily) 13. 268, 295 flava 272, 272 fulva 264, 272 herbaceous borders 20 Hibiscus 264 rosa-sinensis 270, 270, 271, 271 syriacus 87 Hippeastrum 176 aulicum 204, 205 psittacinum 205, 205 reginae 205 striatum 202, 203 vittatum 205 Hollyhock 16, 19, 20, 72, 73 Hosta 13, 267, 268 fortunei 295 lancifolia 295, 295 plantaginea 295 Hyacinthus 8, 13, 16, 86, 88, 223 cultivars 119, 119, 120, 120.121 Koning van Groot Britanien' 118, 119 'Lyra Grandis' 122, 122 Prince Albert Victor' hybridisation 12, 13, 137 Hydrangea 265, 267 japonica 278, 278 macrophylla (H. hortensia): 'Belzonii' 278, 279 'Otaka' 276, 277

tricolor 256, 256

Impatiens 13, 138, 141 balsamina 264, 273, 273 walleriana 141 Iresine herhstii 258, 259 Iris 12, 267 clarkei 277 germanica 102 japonica 310, 311 kaempferi (I. ensata) 268 cultivars 312, 313, 313 laevigata 310, 310 persica 102, 103 sanguinea 277, 277 sibirica 277 sieboldii 268 spuria 102, 102 Kniphofia 10, 137, 138 waria 142, 143

landscape gardens 10-11 Lathyrus: odoratus (sweet peas) 20, 70, 'Lady Spencer' 70 Lavandula 28-9, 29 Leschenaultia 265 biloba 287, 287 'Major' 287 Lilium (lily) 8, 86, 267 auratum 267 bulbiferum 82, 82 candidum 32, 33 var. purpureum 34, 34 × hollandicum 82 japonicum 275 lancifolium (L. tigrinum) (tiger lilv) 265, 274, 274 × maculatum 82 martagon 21. 32. 32 speciosum 275, 275 superbum 197, 230-1, 231 Lobelia 137, 138 cardinalis 194 erinus 167 fulgens 195 speciosa 167. 167 splendens 195 Lupinus: arboreus 225 berennis 225, 225 polyphyllus 198, 225 Lychnis 19, 133 chalcedonica 87, 128, 128 coronaria 128 flos-cuculi 87

Meconopsis: betonicifolia 314 var. baileyi 268

Michaelmas daisy see Aster Narcissus 16, 50-1, 51 daffodil 16, 20, 51, 52, 53 × incomparabilis 53, 53 jonquilla 48, 49 odorus 84-5 Poetaz group 55 poeticus 55 pseudonarcissus 51, 52, 52, 53 taxetta 54 55 Nemecia 141 insignis 248, 248 strumosa 186, 186 Nerine 10, 138 cultivars 144, 144, 145 Nerium odorum 262-3 Nigella 96 damascena 87 Nopalxochia ackermannii 254.255 nurseries 11 Nymphea: flava 219 hybrid 218, 219 tuberosa 219 Oenothera (evening primrose) 10, 194, 197, 198 biennis 232, 232 orchids 198 Ornithogalum 8, 86 nutans 48, 48 umbellatum 48 Othonna bulbosa 166, 166 Paeonia (peony) 12, 20, 265 lactiflora 302 marcula 302 officinalis 302, 303 suffruticosa cultivars 302, 302. 304-5 305 Pansy 19, 74, 74, 75 Papaver (poppy) 19 cultivars 130, 130, 131 rhoeas 130 somniferum 130 parterres 195-7

Passiflora (passionflower)

Patersonia lanata 286, 286

cultivars 182, 182, 183

inquinans 180, 181

Pelargonium 10, 12, 13, 137,

× caerulea-racemosa 200, 200

caerulea 200, 201

194, 199

138 195

grandis 314, 314

medicinal plants 13

mesembryanthemum 9 10

triste 181 181 zonale 138, 181 Penstemon cobaea 250 hartwegii 250 ovatus 250, 250 peony see Paeonia Petunia 12, 13, 138 cultivars 216, 216 integrifolia 195 nyctaginiflora 195, 216 violacea 216 Pink 16-17 'Iulier' 62 62 'William of Walworth' 63, 63 plant introductions 8-13 plant names 322-5 Poinsettia 255, 255 Polianthes tuberosa (tuberose) 194, 222, 223 Polyanthus 16, 42 'Duke of Cumberland' 42, 42 poppy see Papaver Primula 268 denticulata 264 japonica 267 sinensis 265 veris 17 39 vulgaris (primrose) 8, 44, 44 Protea 10, 11, 137 compacta (P. formosa) 158, 158 cordata 158 159 neriifolia 157 repens 156-7, 157 Ranunculus 8, 13, 86, 88 'Cupid' 127, 127 'Gadwin Douglas' 126, 127 'Le Mélange des Beautés' 124. 124 'Vereatre' 124, 125 Rhododendron 11, 12, 20, 198, 264. 268. 324 falconeri 306, 306 ponticum 91, 306 wightii 307, 307 Rosa (rose) 13, 19, 20, 95, 95, 96, 264, 265 × alha 95 banksiae 265, 300, 300 Bengal 264 × borbonica 297, 297 Bourbons 297 298 × damascena 95 var. versicolor 95 'Duchesse de Morny' 298. 298 foetida 96

peltatum 181

'Tom Thumb' 182

× gallica 95 gallica var. officinalis 296, 297 'Hume's Blush 298 Hybrid Tea 298 × Iheritierana 298, 299 'Maréchal Niel' 301, 301 moschata 297 Noisettes 297, 298 'Parson's Pink China ' 297 'Princesse Hélène' 298 Slater's Crimson China' 297 sulphurea (R. hemisphaerica) 96, 97 Tea 298 Rudbeckia 10, 197 hirta 235, 235 pinnata 234, 235 Saintpaulia 141 cultivars 189 189 ionantha 189 Saleia coccinea 225 fulgens 195, 225 patens 195, 224, 225 'Cambridge Blue' 225 splendens 195, 225 Scabiosa 19, 132, 133 atroburburea 133 caucasica 91, 133 Seilla liliohyacinthus 36, 36 peruviana 36 coeli-rosa 128, 129 snowdrop see Galanthus societies 10, 12, 16, 17-19 Sparaxis 137 fragrans 149 grandiflora 149, 149 Stapelia 10, 136 campanulata 164, 164-5 chypeata 160, 161 deflexa 161, 161 glauca 162, 162 pedunculata 162, 163 Streptocarpus rexii 141 succulents 137, 194, 198, 258 sunflower see Helianthus sweet pea see Lathyrus odoratus sweet william see Dianthus harhatus Tagetes 194 erectus 251, 251

erectus 251, 251 patula 251 Tanacetum coccineum 133, 133 Tradescantia 10, 197 × andersoniana 226 virginiana 226, 227

Tritonia aurea see Crocosmia aurea Tropaeolum: 'Golden Gleam' 223 lobbianum (T. peltophorum) 223 majus 223, 223 minus 194, 223 tuberose see Polianthes tuberosa Tulipa 8, 16, 86, 87-8, 90 cultivars 110. 111. 112-13 exhibition categories 88 'Lord Holland' 116, 116 media 86 'Orange Duc Thol' 114, 114-15 'Peregrinus Apostolicus' 116, 117. 117 praecox 86 'Semper Augustus' 87 stellata 264

Verbena 12, 13, 138 bonariensis 217 cultivars 217, 217 incisa 195, 217 petrosima 195, 217 phlogiflora 217 Victoria amazonica (V. regio) 7, 195, 208–9, 210, 211, 211 Viole: cornuta 74 litera 74 'Crandiflora' 74, 75

Wardian case 11 Welwitschia mirabilis 141 wild garden 20 winter aconite 15 woodland garden 20

Zantedeschia 10, 137 aethiopica 146, 147 elliottiana 147 Zinnia 195 pelegans 256, 257

(CKNOWLEDGMENTS

The publisher would like to thank Dr Brent Elliott and the staff of the RHS Lindley Library, most especially Jennifer Vine, the Picture Librarian, and Sally Kington, the Daffodil Registrar. Thanks also to Susanne Mitchell and Sir Simon Hornby for their generous assistance, to photographer Nick Moss from Rodney Todd-White & Son, Dorothy Frame, Nikky Twyman and Karen Watts.